HIGH MOUNTAIN MEADOW WITH LOOSESTRIFE, by Douglas Atwill
60" × 56" (152 × 142 cm). Acrylic on canvas. Private collection.

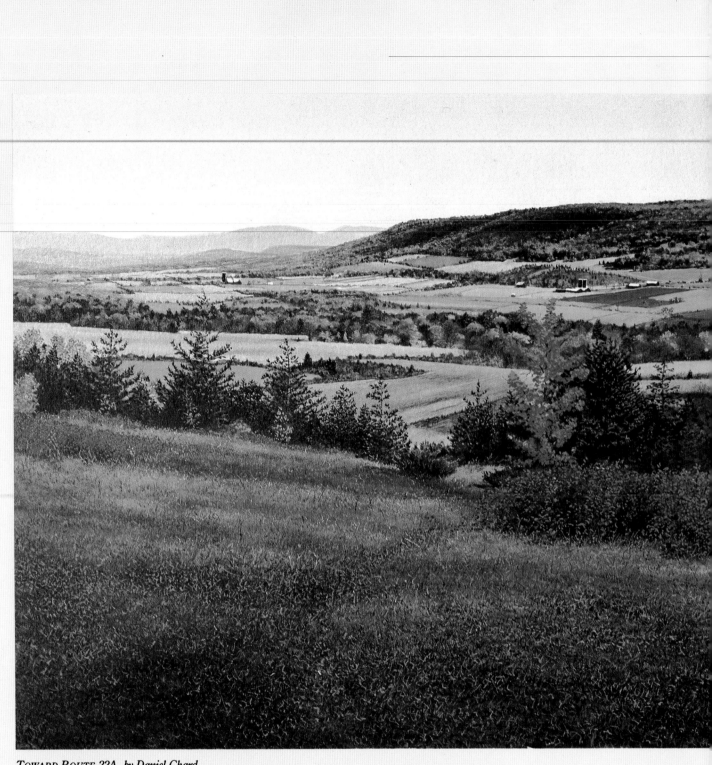

TOWARD ROUTE 22A, by Daniel Chard
8¹/₂" × 22" (22 × 56 cm). Acrylic on paper. Courtesy of O.K. Harris Gallery, New York City

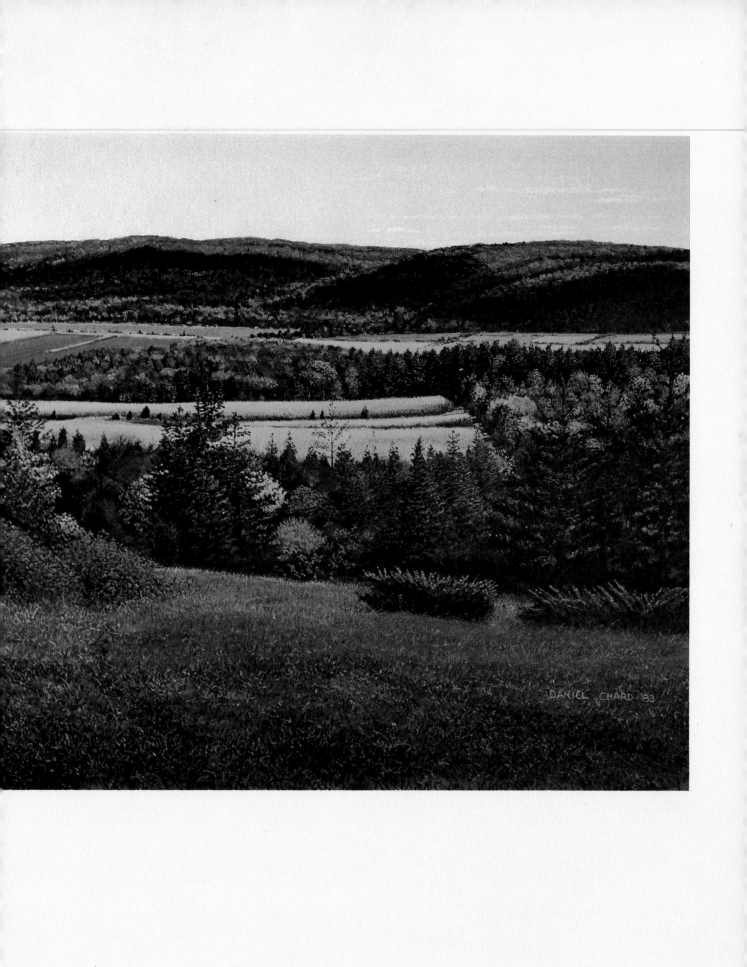

Martha Armstrong
Douglas Atwill
Morris Berd
Allen Blagden
Gerald Brommer
Daniel Chard
William Dunlap
David Fertig
Sideo Fromboluti
Michael Hallinan
John R. Koser
Bruce Marsh
Alex Martin
William McNamara
Roger Medearis
Don Rankin
Mary Salstrom
Lee Seebach
Nora Speyer
Mary Sweet
John Terelak
Dana Van Horn
George Wexler

Painting the LANDSCAPE

By Elizabeth Leonard

WATSON-GUPTILL PUBLICATIONS, NEW YORK

First published 1984 in New York by Watson-Guptill Publications,
a division of Billboard Publications, Inc.,
1515 Broadway, New York, N.Y. 10036

Library of Congress Cataloging in Publication Data

Leonard, Elizabeth.
 Painting the landscape.

 Includes index.
 1. Landscape painting—Technique. I. Title.
ND1342.L44 1984 751.4 84-15228
ISBN 0-8230-3655-3

Distributed in the United Kingdom by Phaidon Press Ltd., Littlegate
House, St. Ebbe's St., Oxford

Manufactured in Japan.

First Printing, 1984
1 2 3 4 5 6 7 8 9 10/89 88 87 86 85 84

ACKNOWLEDGMENTS

This book could only have come about through the generous cooperation of many people. Most of all, I am grateful to the twenty-three artists whose work is featured here. They cheerfully and thoughtfully answered my many questions and took time away from what matters most to them—their art—to share their views on painting and their technical expertise.

I acknowledge with gratitude the efforts of the staff at Watson-Guptill. Special thanks are due Mary Suffudy, who developed the idea for this book and whose unfailing patience, editorial guidance, and encouragement started me off and kept me going. I would also like to thank David Lewis for his enthusiastic support; Candace Raney, who carefully edited the text. Finally, I would like to thank my husband.

Contents

DOGWOODS, by William McNamara
22" × 30" (56 × 76 cm). Watercolor on paper. Private collection.

Introduction

What makes landscape painting so special? What draws artist after artist outdoors to explore the land, the sky, and how the two work together? Perhaps the answer lies in the very nature of the landscape.

Unlike artists who concentrate on still lifes or on portrait or figural paintings, the landscape artist is dealing constantly with change—the changes the different seasons bring, the changes brought about by shifts in the weather, even the changes that occur as the sun moves across the sky. Trying to capture a world that is constantly in a state of flux is a demanding, yet infinitely rewarding task.

This book explores how twenty-three contemporary landscape artists view the world around them. More than that, it invites you to take up the challenges that these artists face.

APPROACHES TO LANDSCAPE PAINTING

What better way to learn about painting the landscape then to get to know the work of some of the finest landscape artists at work today? Traditionally artists have learned from their fellow artists, by talking to them about art, by looking at pictures together, and, perhaps most important, by studying each others work. In this book you will become intimately acquainted with twenty-three artists. You'll learn what they aim to do and then how they accomplish their goals. The artists discuss the materials they rely on—paints, supports, and brushes— then let you look at the way they work.

You'll be able to follow the steps the artists take as they begin a painting. You'll get a chance to look at actual preliminary sketches and color and value studies. Some of the artists have even provided you with step-by-step demonstrations.

One of the most helpful facets of this volume is the projects that the artists set up for you to try. These projects will involve you deeply in how and why a painting grows and develops. Because each artist looks at art from a different point of view, you'll have a chance to explore many new approaches and, no doubt, you'll see doors open that you may never have known existed before.

Each of the artists included in this book has a strong personal style. Even though stylistic and thematic differences set them apart from one another, many of them share similar preoccupations. Here are some of the most important ones.

TWO TRADITIONAL POINTS OF VIEW

George Wexler and Roger Medearis can trace their roots back to the mainstream of American art. Wexler considers himself a descendant of the Hudson River School; Medearis studied under the great American artist Thomas Hart Benton.

Wexler lives near the Hudson River and draws his inspiration from many of the same vistas that must have inspired his artistic ancestors. As he explores the Hudson River Valley and the Catskills, he searches for scenes that are interesting to him artistically and that stir him emotionally. Working from nature, he lets his well-developed instincts guide him as he executes his oil paintings.

Roger Medearis's view of nature is gentle, unassuming, and filled with a subtle, lyrical mood. To Benton he owes his methodology—the way he develops a painting and builds up his vision of the landscape. Starting with three-dimensional models, as he was taught by Benton, Medearis then moves on to numerous studies before he begins his final work. In a finished painting, nothing—not even a brushstroke—suggests the presence of the artist. The paintings are so smooth and so subtle that they almost seem to be views from a window.

THE STRUCTURE OF LANDSCAPE SPACE

How a painting is composed, or structured, is a primary concern for many artists, one that draws together painters whose work shares little else in common. Mary Salstrom, who works with strong, brilliant color and loose, fluid strokes, and Daniel Chard, whose paintings are characterized by their cool, organized feel, are both fascinated by pictorial space.

Salstrom's concern with composition isn't obvious at first. Her use of color is so powerful and dynamic that the underlying structure of her paintings is only gradually discovered. To develop the structure of a painting, she relies on several compositional devices. Once they are set into motion, Salstrom is free to work instinctively.

Daniel Chard's paintings are strikingly realistic; they are pure, uncluttered visions of how the land might be. Chard painstakingly develops each composition, studying how the volumes in it relate to one another. The visual data he experiments with are drawn from actual sites and from photographs taken there. In his finished paintings, Chard's manipulation of landscape elements is never obvious. So attuned is he to human perception that he is able to construct scenes that seem truer than those he began with in nature.

EXPLORING LIGHT AND COLOR

Artists as diverse as Alex Martin, John Terelak, Lee Seebach, and Michael Hallinan are all fascinated with color and with how light affects the surfaces it strikes.

Martin's large oils are filled with masses of warm and cool colors and light and dark values. In each painting, he explores how light moves through air and floods over the land; through his use of color, he relates the sky to the land below. Martin's finished paintings have a grand, heroic sense to them. They are romantic explorations of landscape that stir the viewer strongly, summoning up those magical moments when sunlight transforms the atmosphere and the world around us.

What John Terelak wants to achieve in his painting is a sense of harmonious color. In each work, he wants every color to relate to those around it and for the final painting to be tied together by one dominant, yet subtle, tone. To that end, he continually balances the colors he puts down and, from time to time, pulls them together through the application of coats of toned glaze. In the end, Terelak's paintings are filled with a rich, golden patina.

Lee Seebach cares, of course, about composition, draftsmanship, and value relationships, but when he approaches a scene, he thinks of just one thing: color. Working intuitively, he dissects a scene in terms of interconnected masses of color. He begins with thin turpentine washes to establish the general value scheme of a painting, then immediately starts to build up areas of thicker, stronger color. The results are as fresh and unstudied as Seebach's approach.

Tropical light and color have long fascinated Michael Hallinan, who paints the sun-drenched landscapes set in southern California and northern Mexico. Attracted to the works of Gauguin, Hallinan likes to build up a rich, lush tropical feel as he explores how light effects form. Whether a painting is filled with specific tropical references — palm trees, for example — or is simply packed with strong, bold color, the world he works in and the settings he explores are instantly recognizable.

11

EXPERIMENTING WITH NEW TECHNIQUES

Three watercolorists — John Koser, Gerald Brommer, and Don Rankin—build up their landscape paintings using fresh techniques.

Koser's departure from the traditional resulted from his frustration with the quality of color he was achieving as he painted. He found that when he mixed his colors on the palette, the colors looked dead when he put them down on paper. At the same time, he saw that on the palette itself, delightful hues resulted as pigments ran together. Translating what he saw on his palette to paper required no small amount of skill. The technique Koser eventually invented consists of hurling first water then paint at the paper, then letting the colors mix on the support.

Don Rankin is also concerned with color—with its resonance and depth. Instead of executing a watercolor quickly and spontaneously as is usually advised, he painstakingly lays down layer after layer of transparent wash. He's found that their cumulative effect is much more profound than that achieved when one wash is laid down quickly. Working primarily with warm, clear earth tones, Rankin succeeds in painting landscapes that seem to glow from within.

Gerald Brommer's point of departure from the traditional involves the surface that he paints on. For the past few years, Brommer has been experimenting with a new collage technique. In it, he glues twenty or more kinds of rice paper onto a partially painted watercolor; he lets the glue dry, then completes the painting on the new surface. Brommer finds that the bits of Oriental paper absorb paint differently than plain watercolor paper and that they break up the surface in a fresh and engaging way. What he succeeds in doing with his collage technique is injecting his works with an almost sculptural quality, one that adds new strength and power to his already polished paintings.

ABSTRACTED LANDSCAPES

To scratch a scene to its essence, then to depict the essential qualities of that particular landscape, absorbs many artists at work today. Their approaches are as different as their finished paintings.

Martha Armstrong's works seem so fresh and spontaneous that it's difficult to understand, at first, how much study goes into every view that she paints. For Armstrong, continued exposure to a site allows her the freedom to get rid of superfluous details and concentrate on essentials. Each of her paintings is the result of a distillation of many hours of experience.

Mary Sweet's work captures large-scale, abstract patterns. Drawn from the American Southwest, her subjects are filled with strong, unusual colors and a bold sense of design. Sweet searches for her subjects on wilderness trips, recording those that inspire her in sketches or in photographs. As she paints them, she tries to create as smooth and clean a surface as possible. The resulting paintings have a crisp, angular look that strongly calls up the rocky cliffs and rushing water of the spots she explores.

INTIMATE VIEWS OF THE LAND

Many landscape paintings depict the grand and heroic—vistas glimpsed from a mountaintop or rivers sweeping back endlessly to the horizon. Other paintings are intimate; they present scenes that anyone would feel comfortable with and at home inhabiting. Intimacy doesn't necessary mean a close-up view. In some paintings, intimacy is conveyed by specific references to the creature comforts or by little touches that make the heroic seem personal.

The world that David Fertig conjures up lies right outside his studio doors. In his paintings, Fertig concentrates on scenes that are near his home, usually in his garden. It wasn't always so. In the past, Fertig explored distant sites and wrestled with the problems he found in the unfamiliar. When he decided to stay close to home, he discovered that his attention could be applied to that which matters most to him, the painting process. What results from this exploration of the familiar are paintings far richer and far more satisfying than those he ever did before.

Dana Van Horn turns to landscape as a relief from the figural oils that are his daily concern. Working with pastels, he searches out settings that have a strong personal appeal, places that he would like to live and work in. Even when Van Horn depicts a distant vista, he tries to bring the foreground into sharp relief and to include elements that make the scene human. He prefers to work with subjects set in the middle distance, far enough away to present a sweep of land but no so distant that the personal touch is lost.

EXPLORING THE PATTERNS THAT LIE IN NATURE

William McNamara, Bruce Marsh, and Douglas Atwill are all concerned with the patterns that run through the world around us, but each approaches the subject from a different point of view.

For McNamara, pattern is a complex, difficult element, one that takes a long time to discern and hours of labor to render. Work-ing with watercolor, he selects a scene, then carefully tries to unfocus his attention from any particular spot. Working slowly, he explores his subject with a small brush, working all over the paper, moving from lights to darks. A constant goal of McNamara's is to keep the entire surface lively, filled with the complex minutia that makes up the overall scene.

Marsh's approach resembles McNamara's. Like McNamara, Marsh is concerned with the complexity of pattern, particularly the patterns that occur in aquatic environments. Unlike the many artists who choose subjects that are heroic in scale, Marsh prefers to explore one small area at a time. Typically he selects a tidepool or a bit of pond. Working either with oils or watercolors, he slowly builds up the surface of his paintings. For Marsh, perception is as fascinating as his actual subject matter. His goal is to unravel the mystery of his own perceptions, than to render them accurately in paint. When every square inch of a canvas or paper is equally vibrant and equally packed with information, he considers a work finished.

Douglas Atwill's landscapes explore large-scale patterns. Atwill draws his inspiration from the land around Santa Fe, New Mexico, and his paintings could come from no other spot on earth. Each one gets across the crisp, abrupt feel of the American Southwest. Atwill paints fragments of a scene; he crops his subjects in unusual ways, severing trees, cutting off rock formations, and abruptly slicing rushing streams in half. His cool palette and bold, angular lines instantly convey the patterns that run throughout the land that he inhabits.

CAPTURING THE UNEXPECTED

Even realistic landscapes become marvelous when they contain unlikely references or bits of visual information that unfold slowly. The paintings of both Allen Blagden and William Dunlap contain these unexpected touches.

Working in watercolor, Blagden usually depicts rural scenes. He often sets buildings high on the horizon, silhouetting them against a flat, dull sky; the buildings take on a sense of power and mystery because they so strongly dominate the scene. In some works, Blagden explores unexpected moments in nature, moments, for example, when falling snow transforms a busy city.

William Dunlap's long roadscapes capture the way the world looks today to so many people; it's a world viewed from a car as the car speeds along a highway. Dunlap's scenes look so real that it takes some time to realize that the subjects he paints don't actually exist. He builds them up from favorite

motifs that he uses over and over again. The same buildings appear in many of his paintings, the same dogs in many others. Even within a single painting, Dunlap may experiment with several of the same elements. These visual puns give Dunlap's paintings a strong sense of the unexpected.

SUMMONING UP THE SPIRITUAL THROUGH LANDSCAPE PAINTING

Sideo Fromboluti believes that painting is a mystical experience, one that transports him to another world and time. As he paints, he tries to keep his mind and senses open to the sensations that rush by him. Working with thick, dense oil, Fromboluti builds up approximations of what he senses — the crackle of lightning or the pale light of the moon, for example. It is important for Fromboluti to know his subjects intimately and to spend enough time with them to become receptive to their spirit.

Like Fromboluti, Nora Speyer strives to capture the essence of a scene, the spirit that lies behind the obvious elements in a landscape. Her canvases are packed with thick, sensuous passages of paint, giving them a rich, three-dimensional quality. The bold freedom of Speyer's paintings doesn't come about haphazardly; it's only by spending hours or even weeks studying a subject that she can inject her paintings with so much energy and vitality.

USING LANDSCAPE PAINTING TO PROPHESY A NEW WORLD

For Morris Berd, subject matter is as important as style. His canvases are filled with glimpses of the peaceful, ordered world of Pennsylvania's Mennonite and Amish communities, carefully rendered in a flat, linear style.

Berd's disenchantment with urban life led him to move to the Pennsylvanian countryside. There he found a vision of what the world could be like were men guided by a respect for the land and for one another. As Berd explored new, rural themes, he found his painting style changing, too. No longer were his works filled with highly charged, frenetic lines. Instead, they became calm, harmonious views of a simple, joyful way of life.

Berd believes that those who view his paintings will see in them the way that the world could be. For him, learning about an alternate way of life proved transforming. The strength and clarity of his paintings— their powerful simplicity—may well help reorient those who view them, or at least provide moments of refuge from the distractions of modern life.

George Wexler:
A Hudson River Painter

George Wexler's paintings are all derived from actual landscapes. Wexler usually spends several days each spring driving around the Hudson Valley and Catskill Mountains. Stopping at areas that have spatial and topographical qualities that stir him emotionally, he makes quick pencil and charcoal sketches and takes some black-and-white Polaroid shots.

Back in his studio, he studies the drawings and snapshots and reduces the number of possible motifs to about three or four places in which he plans to work. Then he returns to the areas and decides whether he will paint there in the morning or afternoon, or on a gray day, or any combination of these.

Once he starts painting, he divides up his week and works on five or six paintings simultaneously. He returns to the subjects every day, usually camping out in a tent-trailer. This routine continues until fall.

The length of time a painting takes depends upon size, complexity, and unforeseen problems. A few of Wexler's large paintings are completed in his studio during the winter months.

WORKING METHODS

Wexler's palette consists of titanium-zinc white, Naples yellow, zinc yellow, cadmium yellow light, cadmium yellow medium, cadmium yellow deep, flesh, cobalt green, cerulean blue, cobalt blue, ultramarine, Thalo blue, Winsor violet, magenta, chromium oxide, cadmium green, sap green, terra verte, viridian, Thalo green, olive green, yellow ocher, raw sienna, burnt sienna, Indian red, raw umber, burnt umber, and Mars black.

His brushes are bristles and sables. He starts painting very loosely with large brushes, then progressively moves to smaller ones. To finish a painting he uses Winsor and Newton series 12, nos. 00 to 2.

Wexler begins with drawings and photographs and usually with a small oil study. To capture architectural details such as distant buildings, he even uses binoculars. Next he lays in a rough underpainting, then moves in on smaller details. In some areas, he allows the underpainting to show through later layers of paint; in other areas, he covers the underpainting totally. For Wexler, there is no particular set order. He roams all over his palette as his instincts and the needs of his painting dictate.

View from Mohonk Farm

40″ × 50″
(102 × 127 cm)
Oil on canvas
Collection of the
Metropolitan Life
Insurance Company,
New York City

In View from Mohonk Farm, *Wexler wanted to capture the quality of the late afternoon light and to emphasize the feeling of space by introducing a complex foreground. Before he began this work, he had done a smaller painting, one that he wanted to develop further. The size of the large painting was determined by a gift from a friend—an early American stretcher.*

In the painting process, the large oil underwent a fairly radical change. Wexler had always wanted a strong foreground so he began by including a large bush up front. When winter came he stopped working on the painting, dissatisfied with the way it was developing.

The painting lay around Wexler's studio for about two years, until one winter when Wexler gave himself just one week to bring the painting to life. He began by painting out the bush he had concentrated on previously, then he added a new one.

To capture the feel of the bush in late summer, Wexler invented the foreground, putting it together from memory and from some rhododendron branches. He began by putting the branches in a can, keeping them at eye level; then he moved them up and then below eye level. Painting what he saw as he manipulated the branches, he added the strong foreground that he had wanted when he first began to work.

When Wexler thought that the painting was nearly complete, he pulled it together by lightening lights and darkening darks and by making the edges softer or harder.

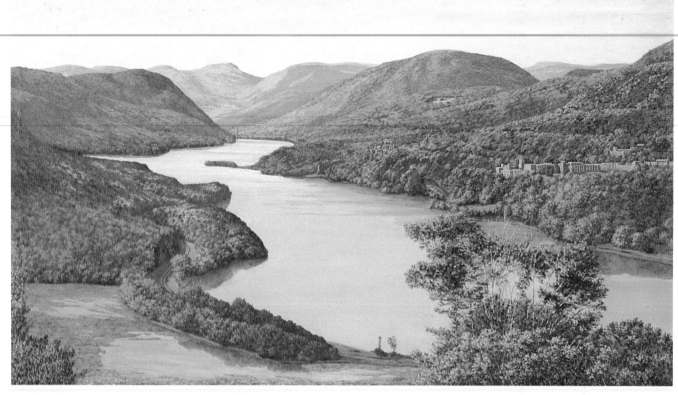

WEST POINT FROM COLD SPRING

33″ × 48″
(84 × 122 cm)
Oil on canvas
Kemper Collection,
Kansas City, Kansas

The deep space, complexities of shape, atmospheric effects, and range of elements in this panoramic scene drew Wexler to it. Generally he works with his farthest distance first, then progresses forward in an overall scattered manner.

The twenty or so colors that Wexler uses are mixed here in a complex fashion based on his intuition and experience. When he paints, he simultaneously balances color, shape, form, texture, and mood.

Suggested Project

When you study landscape painting, it may be hard to understand how works as rich as those that Wexler does ever come into being. To unravel the mystery, try copying one of the paintings that you see here.

At first everything may seem easy—it may seem simply to lie on the surface. Soon you'll find, though, that copying a painting's surface detail alone isn't enough. It's a lesson that every artist who copies another eventually learns.

Copying piques your curiosity, forcing you to analyze why a good painting works. You'll learn to mix colors that you'd never dream of trying by yourself and to try new compositional effects.

Most important, you'll learn how elusive a concrete, real landscape can be and how difficult—and challenging—it is to build one up in paint.

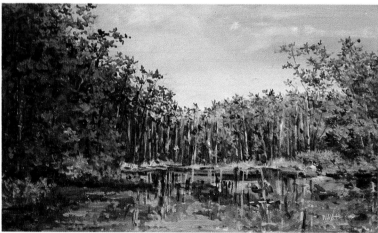

CANAAN POND

5″ × 8″
(13 × 20 cm)
Oil on Masonite
Courtesy of the
Fischbach Gallery,
New York City

Wexler sees Canaan Pond every day. To capture it directly, he approached it with a minimum of planning or preparation. This painting was the first he had done after a three-month hiatus while he was waiting for his arm to recover from an injury. Wexler decided to ease his way back into painting by working on a group of very small oils. This is one of them.

Wexler's concept for this painting came from the quality of the morning light, the silence that filled the spot, and the possibility of getting in a little fishing— the light was his most important consideration.

As always, Wexler began by sketching the scene, then he moved on to a warm underpainting. When he was satisfied with the basic composition, he built up the forms slowly, layer by layer. The size of the painting was dictated by the intimacy of the scene, which didn't call for a very large surface. At the same time, the subject's complexity kept him from working too small.

Wexler's greatest difficulty lay with the water and the growth that crept over it. In the early stages it looked fine, but then began to seem steadily more unconvincing. He repainted these areas many times and, in the process, changed—and improved—his original concept.

MORNING AT WAPPINGER'S CREEK

28″ × 38″
(74 × 97 cm)
Oil on canvas
Private collection

ROGER MEDEARIS:
LYRICAL REALISM

Roger Medearis's paintings are filled with a gentle lyricism. In them he captures the simplicity and poetry of the land around him.

Medearis's design sense was formed under the influence of Thomas Hart Benton and Grant Wood. Although the two had very different styles, Medearis found in their work absolutely true visions of the American landscape. In his studies with Benton, he learned to analyze the paintings of the Renaissance masters, converting their painting into three-dimensional compositions of cubes, spheres, and cylinders. He became conscious of depth and weight through constructing clay models of the scenes he chose to paint. For years, he built these models as a method of composing—some of them intricate compositions that included thirty to forty figures. Medearis began painting with egg tempera, then later changed to acrylics, which handle much like tempera. Recently he has begun to work wth alkyd paints.

In each painting, Medearis likes to present one idea as clearly and simply as possible, couched in surroundings that are very detailed yet subordinate to the one purpose. Put another way, what he's after is a simple, instantly recognizable idea placed in a setting complex enough to be read at leisure like a book. This works best for him on a small, intimate scale.

WORKING METHODS

Medearis works with a limited palette: cobalt and ultramarine blue, raw sienna, raw umber, alizarian crimson, Indian red (red oxide in acrylics), lemon yellow, cadmium yellow light, yellow ocher, sap green, titanium white, and ivory black.

When he works with egg tempera or acrylics, he uses small round brushes except when he's painting the sky. For it, he scrubs on the paint with wider flat bristle brushes or their synthetic equivalent. For the alkyd paintings, he uses small flat brushes in addition to the others. Medearis prefers to work on a very hard surface, one with the smooth texture of an eggshell. He likes untempered hardboard or canvas that is stretched over, not bonded to, a panel.

He approaches each painting in a similar fashion. After he has drawn the subject, he usually does a small color study, then transfers the drawing onto the panel, then underpaints it, usually with India ink washes. Finally, he begins applying paint. In his landscapes, he usually does the sky first, then the larger areas, and finally the smallest details.

The pencil drawing that starts the whole process is carefully planned and completed. A copy is made around 6″ × 9″ or 8″ × 12″ and is bonded to a panel that has been coated with acrylic gesso. This becomes the color study. If design changes occur during the color study, the pencil drawing is usually revised.

Next, Medearis traces the drawing onto the panel or canvas then gives his full attention to the execution of the painting.

For his acrylics, he prepares the panel with six to eight coats of gesso. The dry gessoed surface is then sprayed with water, and sanded smooth while wet, with a fine waterproof sandpaper. In his large paintings, the panel is attached to a ¾″ wood support.

When Medearis works with acrylics, he dilutes them until they are very thin—almost soupy—then applies them in almost a drybrush fashion. Many layers are scumbled over one another, interspersed with transparent glazes. His strokes are never liquid or free flowing, and the final surface is very smooth, with no texture of the paint apparent and with no references to the artist. He wants the final painting to seem as clear as a view from a window. At the very end, he varnishes the painting with pure acrylic spirit varnish—a mixture of about one-third gloss and two-thirds matte.

In his alkyd paintings, Medearis mixes Winsor and Newton's alkyd colors with their Liquin painting medium. Usually he adds mineral spirits to thin the color further, and sometimes he adds a little bit of oil to retard drying.

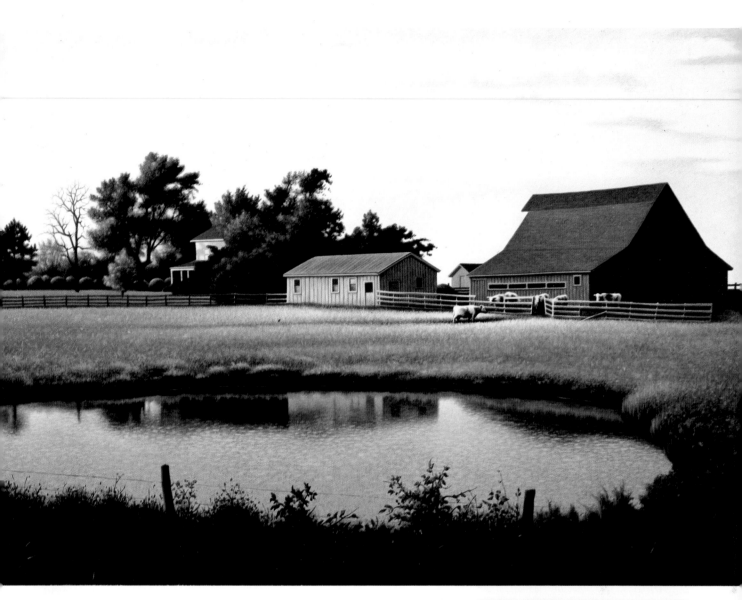

SPRING-FED POND

16″ × 24″
(41 × 61 cm)
Acrylics on hardboard panel
Collection of Mr. and Mrs. Tom Johnson

This early fall scene set in Missouri captures the mood of childhood in the country or in a small town. It has an arresting quality—there's a strange and mysterious familiarity to it. Medearis was fascinated by the reflections in the water. Preserving that excitement, while modifying all the elements in the scene to create a sense of harmony throughout, was his challenge.

Here Medearis began with the pool of water, but with all other elements of the design in mind as well. He worked from dark to light, trying to keep the darkest areas thinner and more transparent. In the light areas, the paint was applied slightly more heavily but never thickly.

In the close-up at right, every element has a calm, untroubled feel. Medearis reduces his compositions, making them as sparse as possible. Even when he includes animals, like the cows in this work, he arranges them carefully, making them appear placid and untroubled.

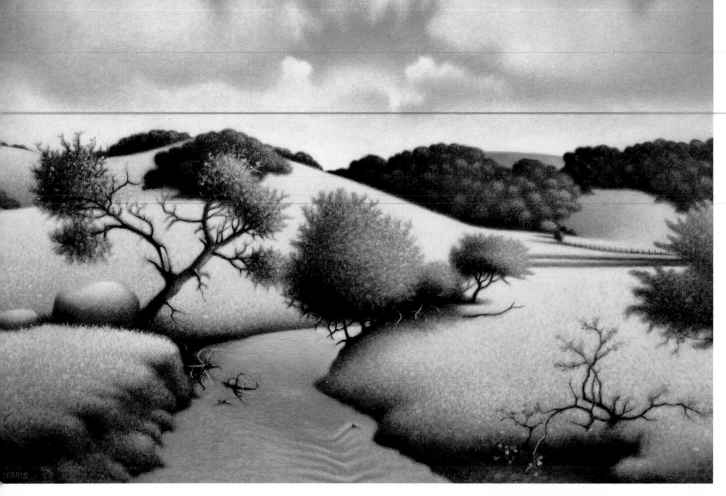

AFTER THE RAIN

12" × 18 5/16"
(30 × 46 cm)
Alkyd and oil on
hardboard panel
Collection of Betty
Medearis

Medearis was excited by this scene because of the wonderful feeling that occurs when it has stopped raining. The clouds are breaking up and cool light reflects from the wet green grass. The main reason for the painting, though, was the desire to capture the warm ocher color of the muddy rain water running off into the stream.

In After the Rain Medearis decided to change the position of the large rock on the left. Before he altered the painting, he executed the rock on a piece of clear acetate, then put the acetate into place to study the effect.

In every painting, difficulties occur. Medearis believes that recognizing them, then overcoming them, makes the difference between a successful painting and one that fails. In this work, he found it very difficult to get the large tree on the left just right.

In the detail at right, the smooth, glasslike surface results from Medearis's painting technique. Here, he scumbles semi-opaque passages and interweaves them with transparent glazes. These applications are very thin and very numerous.

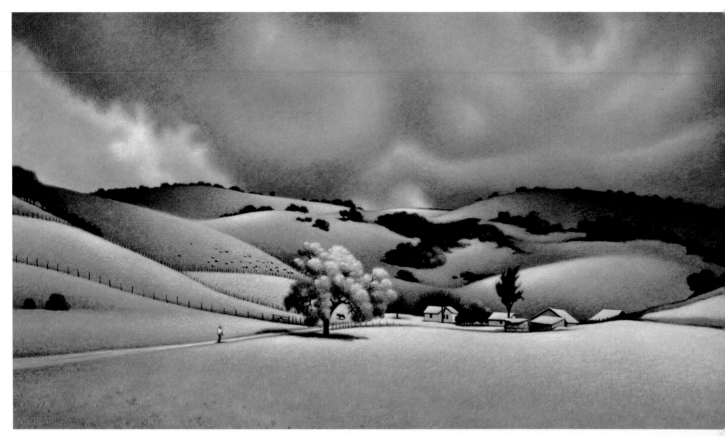

APPROACHING
SHOWERS

10¼" × 18⅜"
(26 × 47 cm)
Alkyd and oil on
hardboard panel
Collection of Betty
Medearis

Medearis wanted Approaching Show-ers *to be a small poem about gentle spring rain. On a trip to central California, he was walking down a country road, watching the clouds gather in the distance. The mixture of clouds, shadows, and light and the rain that began to fall as he walked, intrigued him. The rhythmic patterns formed by the hills, trees, and clouds, and the warm greens of the grass, seemed to Medearis to express the joy of spring.*

Medearis began on the panel with a line drawing, which he developed further with India ink. Using the ink, he covered the surface with a very precise wash drawing. Next he applied numerous thin coats of alkyd paints mixed with small amounts of oil paints to slow the drying time slightly.

In the close-up at right, the small bit of red used to render the barn enhances the green that fills most of the painting. The grassy slopes behind the buildings are intentionally kept soft and fluid. Every detail in this painting is built around the contrast between sunlight and shadow.

MUSTARD
FLOWERS

12½" × 18½"
(32 × 47 cm)
Alkyd and oil on
hardboard panel
Private collection

In California in the spring, wild yellow mustard flowers bloom throughout the hills and valleys. Medearis's aim here was to capture the brilliant color of these commonplace flowers. Both the receding road and the warm foreground set against the cool background draw the viewer into the painting.

Mustard Flowers is one of the few works Medearis has begun without first executing a color study. He felt when he began that he had the finished work clearly in mind. As always, he started by drawing the design on the panel. Next he laid in a full range of values with India ink washes, then used cobalt blue over the washes to create a monochromatic version of the finished painting. He added the flowers in white,

then glazed them with yellow. All of the colors were developed with transparent glazes.

In the finished painting, the surface is absolutely smooth, without any suggestion of brushstrokes or impasto. The result is a dreamlike, almost surrealistic mood; there is no hint of the artist who painted the picture.

In the detail on the facing page, the colors are much as Medearis originally planned them to be. He used more transparent glazes here than he customarily does and less semi-opaque scumbling than usual. To develop the warmth of the foreground, he found he had to use much more red glazing in the foreground than he had anticipated.

Suggested Project

Build a small dioramic sculpture from Plastelene or clay based on a landscape—not a finished sculpture, and not necessarily a permanent one. What you want is a simple, unfinished, even childlike construction of the scene you plan to paint. Once constructed, paint it with acrylics in the colors you plan to use in your painting.

This exercise isn't a new idea; artists have been using it for centuries. When Thomas Hart Benton discovered that the Renaissance master Tintoretto had constructed models for his very complicated paintings, Benton began to do the same. During his fifty years as a painter, he built clay models for all of his murals and most of his easel paintings. Gainsborough "would place cork or coal for his foregrounds, make middle grounds of sand and clay, bushes of mosses and lichens, and set up distant woods of broccoli." Artist-illustrator Maxfield Parrish carefully built small models of wood and rocks and stone.

Building a model helps you to compose and simplify. Try holding an electric light over the sculpture and study the various effects created as you move the light about. You'll see how light falls over the three-dimensional compositon, giving the scene a peculiar sense of reality. To see how it can help you work out tonal values, try making a value study based on the replica.

Medearis believes that the most valuable result of this study is the way it makes you conscious of the real depth and weight of the elements in a landscape. There's a lot more to realism than simply surface detail—three-dimensional form is primary.

How the Landscape is Structured

MARY SALSTROM: SPACE AND COLOR

Mary Salstrom's paintings are built up of both strong and subtle color contrasts, which provide the supporting structure for her carefully planned compositions.

Thoughtfully examined, each work reveals Salstrom's concern with pictorial space. In some, light and dark bands alternate, gradually leading the viewer into the landscape. In others, rhythmic diagonal movements create a dynamic recession into space.

Although Salstrom works with very real subjects, she sees correlations between her paintings and poetry, mythology, and archetypal images. Usually these elements are unconsciously developed and only become clear to her after a painting is completed. There's a strong sense of romance present in them, too, whether it be in an oblique reference to King Arthur or a nostalgic memory of childhood days.

WORKING METHODS

Salstrom's palette consists of lemon yellow, aurora yellow, Indian yellow, Naples yellow, cadmium green, chromium green oxide, cobalt green, viridian, Prussian blue, cerulean blue, cobalt blue, ultramarine, alizarin crimson, cadmium red light, vermillion, and titanium white. She has about thirty bristle brushes in all sizes from 1" down. For foliage she often uses a fan brush or a fresco liner and for details she prefers small sables. Salstrom almost always paints from nature or from paintings done at the site. She works on a white lead ground.

Salstrom sets her colors up on a wooden palette that she has painted white, which helps her relate the colors to the white ground she paints on. Along the top of the palette, she lines up small amounts of each color. In front of each, she puts another small portion mixed with white so that a middle value will be available as soon as she starts to paint.

Before she begins a work, she almost always works on the composition in a series of sketches. Small color studies help her discover possible hue and value solutions before she attacks the larger painting. On the canvas itself, she lays in either a charcoal drawing or a very thin drawing with paint. The larger the painting, the more likely she is to begin with soft, vine charcoal; she finds that harder charcoal is difficult to erase and that soft charcoal allows her to change the composition with ease. To anchor the drawing, she looks for three equidistant vertical points near the center of the scene; these are easily identifiable places in the landscape. Next, she lays in the long diagonals that run through the composition; their location is judged in relation to the three points.

When she begins to paint, she studies the colors in the landscape and mixes piles of paint on her palette. As she does this, she places neighboring colors next to each other forming "color chords," which Salstrom defines as "pleasing combinations of two or more colors that relate to the colors I see in the landscape." She sometimes mixes as many as twenty different tones, always working to establish equivalent relationships but never attempting to match colors exactly. Salstrom works light to dark, and thin to thick, trying to balance both colors and surface textures and to relate them to those she sees in the landscape.

Salstrom estimates what will be the darkest and lightest tones in the painting, then tries to put down a spot of the darkest tone to give her something to work against. Most often, she paints in the very first or very last hours of the day, those times that she regards the distribution of shadow and light most interesting.

SPRING BECOMING SUMMER, ILLINOIS

36" × 36"
(91 × 91 cm)
Oil on canvas
Collection of James E. and Lillian McCanse

Capturing the colors and feel of both spring and summer, this painting prompted Salstrom to begin a series of four works depicting the transition between the seasons. The traditional concept of the four seasons is an archetypal one that has been explored in music, poetry, and myth the world over.

In Salstrom's painting, the delicate greens and yellow-greens of spring are just on the verge of giving way to heavier summer foliage. Occasional spots of a deep reddish color indicate the seed cones of the sumac trees that appear during summer. In the foreground, the warm yellowish grass looks like that found in May or June while in the distance the trees that cluster around a group of buildings have an atmospheric quality that might be seen after a spring shower.

Color isn't the only element that hints at the movement between the seasons. The children and horse represent the romantic memory of a child's delight when summer approaches and the days grow longer.

Salstrom worked on this painting for over two summers and in that time the composition remained basically unchanged. However, there were originally four figures in the painting—the two children that remain, plus two more in the foreground. No matter what Salstrom tried, the two figures in the front of the picture never seemed to become part of the landscape. Finally she deleted them and discovered that the children and the horse were the painting's focal point.

Salstrom's understanding of color adds to the luminosity of Spring Becoming Summer. *Through value contrasts, the white pony makes the foliage seem darker and through hue contrasts, the red of the running figure sets off the greens that surround it. The shade of red was carefully chosen through trial and error. If the red was too bright, it would have pulled the figure toward the foreground; if it was too dark, it would have seemed too heavy.*

Paint application matters, too. Because the figure is rendered with strokes that echo those used to depict the surrounding foliage, a feeling of motion is achieved. If the figure or the foliage had been painted with clearer outlines or with more methodical strokes, it would have seemed static.

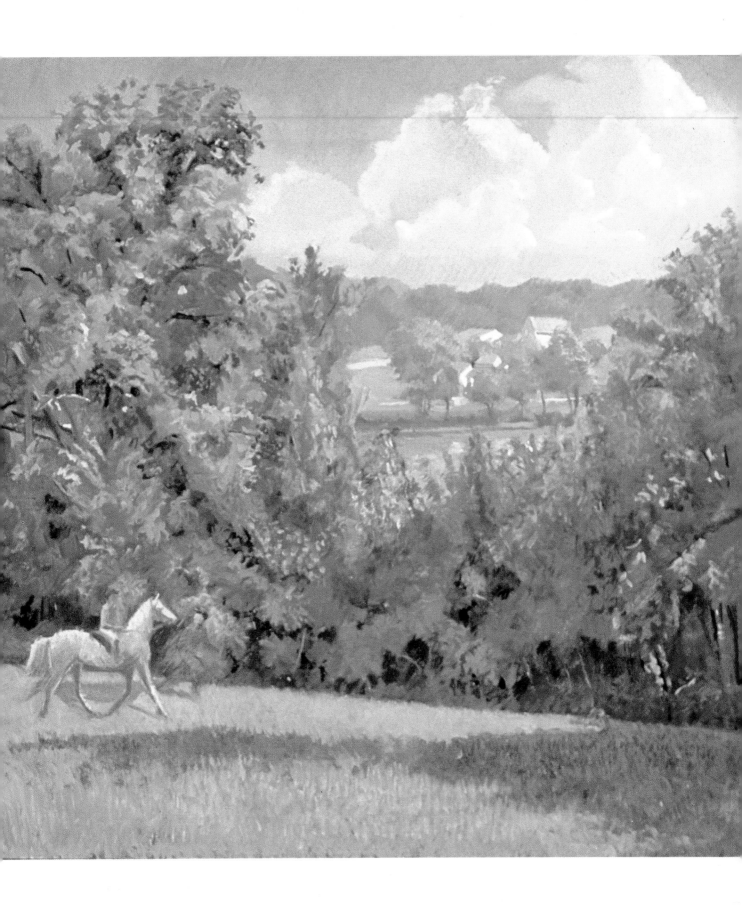

How the Landscape is Structured

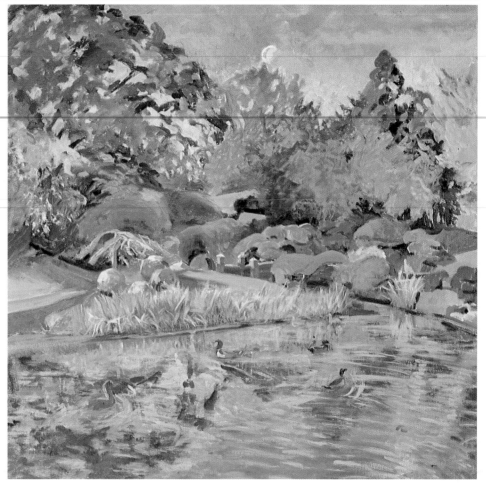

Salstrom frequently begins by painting one or more small color studies. This one is 12" × 12", a ninth of the size of the final painting. In studies and preliminary sketches, Salstrom begins to envision the final composition. They help her explore the subject so that she has a clearer idea of what she wants to do when she begins the larger painting.

Here the basic composition and color scheme have been worked out, allowing her great freedom and spontaneity when she began to work on the final painting. The study also helped her successfully include a wide variety of hues, one of her goals when she began. When a study captures the essence of a subject, it allows Salstrom to do some of the final painting in the studio—an invaluable aid when a painting is set in a specific time of day and the lighting remains correct for only a brief period of time.

SUMMER
BECOMING
FALL,
BROOKLYN
BOTANIC
GARDENS

36" × 36"
(91 × 91 cm)
Oil on canvas
Collection of Dr. and
Mrs. Aristide Henri
Esser

Salstrom executed this painting on crisp, sunny mornings during late September and October and as she worked, she watched the seasons change. Here the rich deep greens of late summer coexist with the yellows, reds, and golds of early fall. In the painting, Salstrom wanted to recreate the actual experience of the transition from one season to the next. She established rhythmic movements through the use of a variety of brushstrokes; the strong diagonals that rush through the picture create an active space.

Specific references to fall appear in the work. The surface of the water is broken by small waves that the ducks create as they glide along. The ducks themselves are hardly noticeable at first; they are camouflaged in the painting just as they are in nature in autumn. The spirit of change is also represented by the low morning moon that appeared one day.

All of the paintings in the changing seasons series are square. Salstrom chose the square because, like the circle, it suggests the idea of wholeness.

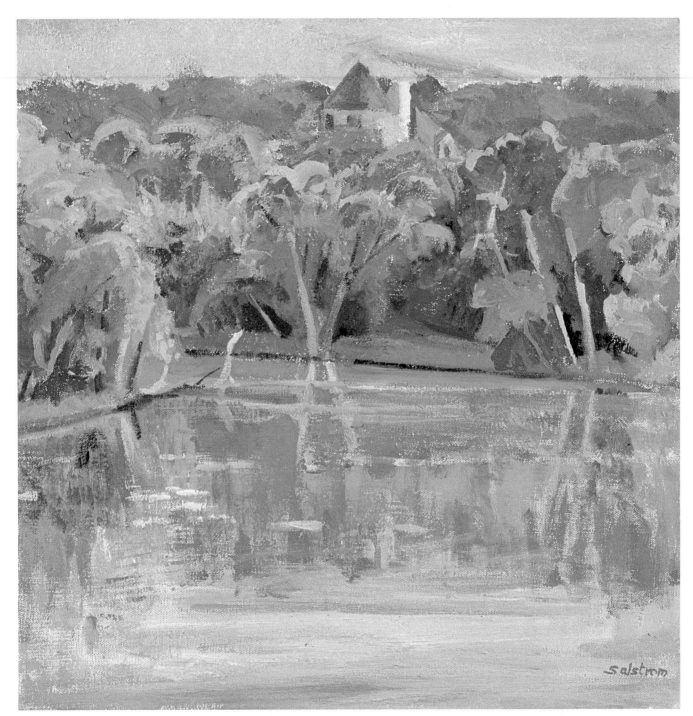

STRONGHOLD CASTLE AT TWILIGHT, ILLINOIS

12" × 12"
(30 × 30 cm)
Oil on canvas
Collection of the artist

Stronghold Castle *is a small work, just 12" × 12", and is one of three studies Salstrom has done of the same subject. She painted it on nine consecutive evenings. Because it is a small work, she mixed "color chords"—a group of three or more colors that enhance each other—for the whole painting and worked very quickly at twilight. She started by simultaneously indicating the trees and their downward reflections. Next she roughed in the tone of the distant hills and the castle. Following that, she added the tones of the sky and water simultaneously. Not until she* had indicated all parts of the painting did she begin to establish more defined contrasts and relationships.

An important consideration in this painting was establishing a balance between warm and cool tones. For instance, the color of the light is complementary to the color of the shadows in the trees. This gives the painting warmth despite the many cool blues and greens. A sense of mystery is achieved through use of strong value contrasts between the dark shadows of the trees and the lightness of the lake.

In this painting and in the other two studies of the subject, Salstrom experimented with moving the horizon line forward and backward. Here she moved it up to compare the sense of distance obtained by including a larger expanse of water with the more intimate, closer feeling of the castle when the horizon was lower. She also increased the size of the castle's main tower to better express its prominence. The result is a pleasant balance between the building and its natural surroundings.

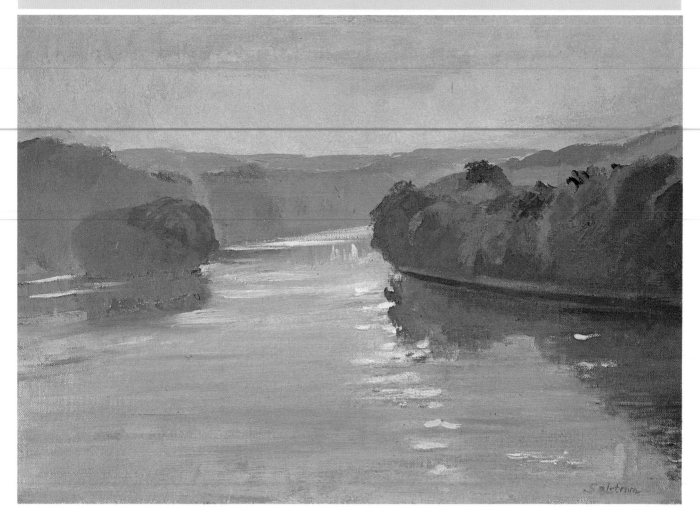

**ROCK RIVER
DAWN FROM
CASTLE ROCK,
ILLINOIS**

10" × 14"
(25 × 36 cm)
Oil on canvas
Collection of the
artist

A misty dawn seen from a high point along the river inspired Salstrom to paint Rock River Dawn from Castle Rock, Illinois. *It was an especially challenging subject since the mist softened the volume of the land masses. To make the painting work, Salstrom had to show how light and atmosphere affect appearance of surfaces in the landscape.*

Salstrom arrived at the site just at dawn every morning and worked for one-and-a-half to two hours each time. She began by drawing the major diagonal movements on the canvas with charcoal. To keep the painting flexible, she did not cover the entire canvas with opaque paint during her first session. Away from the site, she studied what she had done and during the second session made minor changes in the composition.

In Rock River Dawn, *Salstrom es-*tablished the darkest tones right at the start. Because the dark land mass on the right that separates the water from the sky is so important, she began there. The line under this land mass is considerably darker than any other spot in the painting and provided a reference point as the middle tones were added. The lightest tones are the sparkles that appear on the tips of the waves.

The texture of the paint strokes helps create the appearance of the river. Salstrom began with thin masses of tone, painting the sky and river in relation to one another. Next she established the reflections of the island and the shore, which helped her achieve a sense of volume in the water. Thicker strokes of paint convey the rhythmic movement of flowing water.

When it came time to render the sparkles of light on the tips of the waves,

Salstrom considered whether she should use red or white. Red would help capture the reddish light at dawn, but white was chosen because it is more luminous and worked better with the colors of the water. If she had chosen red, there would have had to be a stronger green cast to the water. The value of the water would also have had to be darker since red light is darker than white light.

To achieve the pinkish glow that suffuses the sky, Salstrom underpainted the sky with pink (a mixture of cadmium red, alizarin crimson, and white), then scumbled the bluish tone over it the next day when the pink paint was dry. When Salstrom was content with the balance between the sky and water, she knew the painting was almost done. Her finishing touches were the addition of a few highlights on the left and right sides of the river.

Suggested Projects

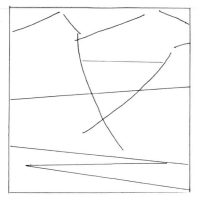

A. Major diagonals

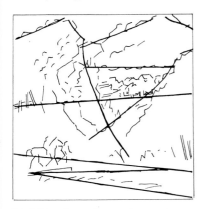

B. Major diagonals superimposed on schematic diagram of painting

C. Schematic diagram

1. Choose a landscape with strong diagonal movements. When you begin your preliminary drawing, consciously start the composition by setting down the diagonal forces. This tool will give the picture a sense of depth and will create a lively feel. Not only that, the diagonals will lead the eye backward into the picture space. The diagrams A, B, and C show you how Salstrom established the composition of *Spring Becoming Summer* using diagonal movements.

2. Try using the grid Salstrom uses to paint a large version of a small painting you have done. Choose the small painting carefully; make sure that it is one that will work well on a larger scale. The two surfaces should have the same proportions. You can plan the size of the larger canvas accurately by multiplying the length of the small work's height and width by the same number. If possible, return to the site of the small painting as often as possible and use the information you find there as well as your smaller painting.

Stretch white string over the small painting to form the grid, keeping the string in place with masking tape. On the large canvas, sketch the grid in using soft vine charcoal and a straight edge.

Next rough in the composition with vine charcoal, concentrating on major lines and masses. Don't use the grid in a mechanical way; use it as a guide the way nature is a guide. Once scale and placement have been established, the large canvas begins to grow on its own as paint is applied.

3. To infuse her works with a sense of order and harmony, Salstrom begins each work by selecting three equidistant points along the center of the canvas. These points relate to easily identified places in the landscape. (See diagram D.)

Next, at diagram E, she indicates the major diagonals present in the scene and the major forms, showing how they relate to the three points. This diagram shows the amount of drawing present on the canvas before she starts to paint. The final diagram (F) reveals how forms develop during the painting process.

Try building up a landscape using this method. You'll find that selecting the three points is a great help in establishing a working scale of nature—a way of creating an orderly, yet lively, composition that will hold together.

D. 3 equidistant points relating to easily identified places in landscape

E. Indication of major diagonals and major forms as they relate to 3 points (this is the amount of drawing on canvas before painting)

F. Painting process involves development of forms

DANIEL CHARD:
A CONCEPTUAL APPROACH

In Daniel Chard's paintings every line, every land mass, every building seems so inevitably placed that it's hard to realize that the locations he freezes often don't exist. By the time Chard completes a painting, the elements that got him started have totally changed. The locations he paints are only a starting point from which he creates his paintings. The paintings do look like specific places, but to Chard the subject matter is only something to manipulate.

For years Chard has studied the paintings of those he most admires— Degas and van der Weyden to name just two—trying to understand how others have created and organized successful illusions of space. To Chard it's much more important to arrange and structure volumes as convincingly as possible on the surface he works than to deal simply with composition. Always conscious of the difficulty involved in rendering three-dimensional space on a flat surface, Chard probes and studies the way the mind and eye perceive space, then he attempts to translate what he has learned onto paper.

Chard is certainly a realist painter; his landscapes seem so true and finely wrought that any other label would seem absurd. More important to Chard than realism, however, is the way he constructs the spaces that find their way into his paintings. In every work, he organizes the picture plane as simply and clearly as possible. The realities he creates are, perhaps, more coherent than those that truly exist.

WORKING METHODS

Chard's palette consists mostly of earth tones—he relies heavily on the umbers and siennas and on earthy greens. Very few high-toned reds or yellows find their way into his paintings. He works with just one kind of brush, a no. 0 or 1 Kolinsky red sable, but also lays in paint with his fingers. Using his hands, he establishes organic, random patterns that are far less obvious and more true to nature than those created with brushstrokes.

In the past, Chard has worked mainly on 300-pound, hot press paper. Its smooth surface is neutral; it doesn't call attention to the painting process. More and more recently he has begun to work on hardboard or Masonite; he finds that his colors seem brighter and crisper on this smooth, hard surface than they do on paper.

For Chard, planning the direction the painting will take is essential. He explores a potential site thoroughly, taking numerous photographs from as many angles as possible. For Chard, photographs are the simplest way to gather together visual information. Photographs can be amassed far more quickly than sketches, allowing Chard to spend more time on the actual painting process. Photography also allows him to freeze various lighting conditions, and, through the use of various lenses, to manipulate the proportions of his subjects.

Working from photographs Chard manipulates and edits the information that the picture contains until he arrives at an image of acceptable interest and organization. For Chard, transforming the randomness of nature while remaining true to what it is all about—its basic rhythms and patterns and volumes—is what matters the most. A thoroughly convincing illusion of space is central to his painting.

Chard's earliest paintings were just 3″ × 13″. Gradually they have grown larger. Now he is working with larger images, including those 16″ × 36″ and 18″ × 28″.

Whenever Chard finds an interesting town, he looks for a place with an overlook. In Pittsford, Vermont, he discovered a cemetary that looks down at the view seen in this work. The scene captivated Chard; its fascination lay in a combination of the white houses, the shade trees, and the opportunities for angular perspective.

Parts of the composition were easy. Chard knew that the buildings would carry a strong sense of perspective and structure. For the horizon on the left, he invented a distant vista. The biggest challenge came with the grass in the foreground. Capturing the roll of the plain was especially difficult.

As in all of his paintings, Chard's goal was to articulate the space as clearly as possible. The illusionistic space moved from the distant left to the foreground on the right. The pattern of the grass—its organization and design—emerged during the painting process as Chard tried to capture how it looked.

Chard began by establishing the basic volume of the buildings and the plane of the garden, then he worked out the grass. The foliage and grass in the middle ground and foreground were laid in with dark grays, browns, and greens. Next Chard added light greens. Working with acrylics, Chard finds that foliage placed against the sky must be worked out with darks before he develops the lights. The sense of place Chard achieved in Pittsford is unique for him. With this painting he came closer to recording an actual location than he had anticipated. Certain features contributed to his success. There is a warm, traditional feel to the houses with their tidy backyards, and the buildings create a clear sense of volume. Even people unfamiliar with landscape painting feel at home looking at Pittsford.

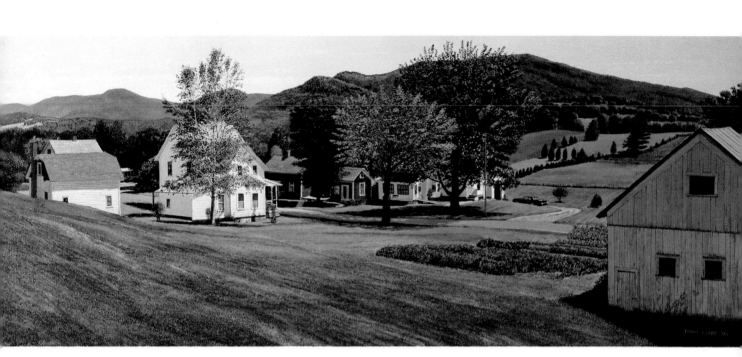

PITTSFORD

9½″ × 25″
(23 × 64 cm)
Acrylic on paper
Courtesy of O.K.
Harris Gallery, New
York City

DETAIL. Working with acrylic presents special problems. It dries darker than it goes down, and tonal relationships aren't easy to remix. The subtle variations necessary to create atmospheric perspective like that you see here may require that you premix large batches of color before you start to paint. To develop slow, gradual tonal variations, Chard uses thin, transparent layers of color.

31

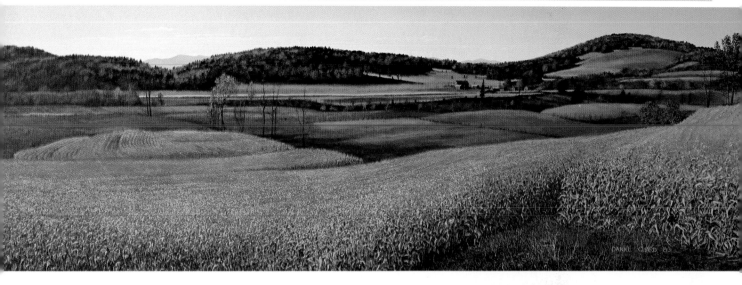

CORNFIELD

8½" × 24"
(22 × 61cm)
Acrylic on paper
Courtesy of O.K.
Harris Gallery, New
York City

It's unusual in Vermont to find a field of corn that hasn't been cut when the leaves have started to turn from green to orange. For Chard, more important than the color was the texture of the cornfield and how it helped establish the structure of the landscape.

The strong horizontals in the landscape act as an axis for the overall painting, preventing the rolling, flowing quality of the corn from weakening the painting's structure. Once this axis is established, the painting appears more cohesive.

The complex texture of the corn was an especial challenge for Chard. Although an important—essential—element in the painting, it couldn't become more important than the overall shape of the field. Before Chard began to paint, he photographed the cornfield from several points of view. Right away he decided to organize the painting around a horizontal line and to emphasize the flowing quality of the corn against the horizontal. He began the painting with the planes and mountains in the background, then he turned to the overall volume of the cornfield. The background was laid in with dark browns, grays, and greens; next he added the lights to the darks. Then he applied transparent washes of brown, orange, and gray, gradually developing contrasts.

DETAIL. What Chard wanted to do with the cornfield was to simulate its character, not copy it exactly. This improvisational approach has its risks; without experience and confidence working this way could result in meaningless abstraction. To set up the organic patterns of the field, Chard applied thin, transparent washes of acrylic with his fingers, working toward light and toward dark with a muted orange tone. The patterns created by his fingers were amplified with a no. 1 red sable brush.

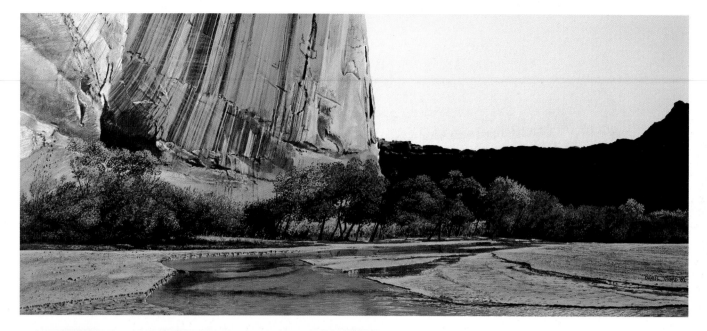

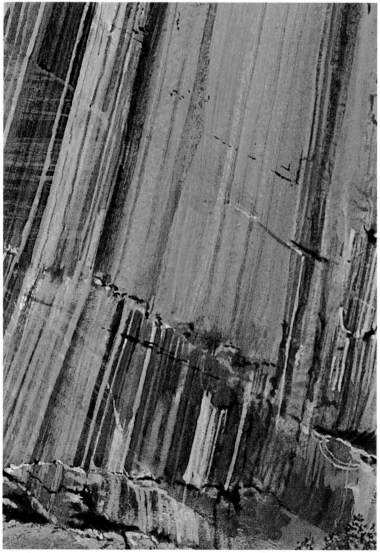

Chard's goal here was to create a convincing illusion of space by emphasizing the strengths he saw in the scene. The canyon floor with its winding stream was a dynamic pictorial force, as were the brown rocks and blue sky. The long shadows amplified the scene's volumes and the trees in the foreground helped to establish a sense of space.

Chard began by washing in blue for the sky and water, then he established the horizon. Next he blocked in the darks of the canyon walls. He used grays, browns, and oranges for the walls, applying the darks over light washes. By using transparent layers of color, he controlled the tonal values.

DETAIL. Chard began the canyon walls with a variety of light washes, then he applied darker washes of orange, brown, and gray to articulate the structure of the rock face. Similarly, the canyon floor began with light washes, then was built up with a gradual progression of darker tones. The contrast between the dark canyon floor and the stream contributes to the sober mood of the painting.

CANYON DE CHELLEY— NORTH

7¼" × 16¼" (18 × 41 cm) Acrylic on paper Courtesy of O.K. Harris Gallery, New York City

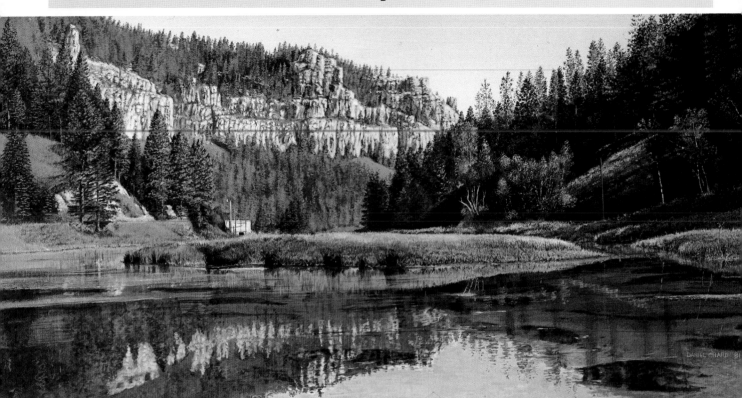

SPEARFISH CANYON— WEST

7¼" × 16"
(18 × 40cm)
Acrylic on paper
Courtesy of O.K.
Harris Gallery, New
York City

The transparency of the water and the reflections cast in it drew Chard to this scene. The dark organic patterns beneath the water provided a perfect opportunity to explore the clarity of the water itself. Far in the distance the canyon wall established a sense of scale and also made the landscape more varied.

The variety of elements in this scene appealed to Chard strongly. Very few natural situations involve water, rock, and trees caught in both sunlight and shadow. Chard clearly focused every element in the painting simultaneously, something the human eye is incapable of doing.

DETAIL. On each side of the painting, Chard established the hills and foliage, paying particular care to the dark trees on the right as they are silhouetted against the sky. For the trees he began with the darks then worked in the lights. Since so many greens come into play here in the trees and grasses as well as the water, it was especially important to control subtle changes in tone and texture. To establish the location of the trees in the middle ground and background, Chard tried to convey their texture.

Chard believes that photographs can be an important asset to the artist; they gather more visual information together than sketches could possibly provide. Working from photographs along with using acrylic paint like a drawing medium opens broad possibilities for increasing variety in painting imagery. To introduce you to the advantages photographs offer, three are analyzed here.

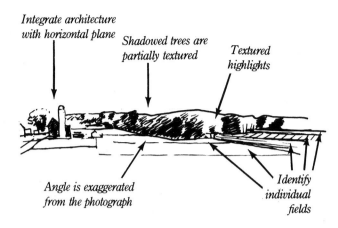

Integrate architecture with horizontal plane

Shadowed trees are partially textured

Textured highlights

Angle is exaggerated from the photograph

Identify individual fields

This photograph is so dark that the contrast between the trees and buildings is lost. Taking a variety of exposures reduces the chance of ending up with shots that are too dark or light to be of any use. Despite this photograph's weaknesses, it still contains a great deal of information.

The foreground is weak; there is no real transition between it and the background. Without a transition the foreground will appear flat, almost like a wall. In addition, the texture of the field is difficult to interpret and

it could be hard to integrate into the painting. Finally, the fields, buildings, and trees are all pretty much parallel and not too interesting visually. The sketch shows some solutions to the problems posed by the photo. Break up the field into individual zones. Emphasize the highlights and shadows of the trees. Finally, make the perspective of the field head in toward the farm buildings to integrate them with the rest of the scene.

The lines added here indicate a possible solution to the problem of the field, i.e., the addition of the fields and hedgerows work with the horizontal plane

Here the middle ground provides a major horizontal plane and supports the buildings, yet it's easy to lose sight of this plane's strength since it can easily fade into the rest of the field. The buildings themselves are interesting architecturally. They provide sharp contrast with the dark

green field and with the trees in the background. To study them further, telephoto shots or enlargements could be useful.

As the sketch suggests, the field in the foreground might be broken into individual fields to clarify the scene's space and increase interest.

Suggested Project

The photograph at right is stronger than those shown on the preceding page. The shadows cast down the hillside articulate the volume of the scene, define the ground's contours, and unify the buildings with the terrain. They also provide a progression from foreground to background and clarify the texture of the grass.

The photograph fails to indicate the architecture clearly, although it does show how to integrate the buildings into the landscape. An artist could either emphasize the buildings or allow them to be swallowed by the landscape.

Overall, this photograph is unified, with a dynamic composition. It provides a clear feeling of structure, which is essential in creating a strong painting. In the sketch, note the establishment of the horizontal plane with shadows, which go from the immediate foreground to the background.

For the project, choose a strong photograph and do a landscape painting from it. To eliminate the problem of translating proportions, make your painting the same size as the photograph. Don't think of doing a "painting;" treat the landscape much as you would a drawing, using the acrylic paint in a loose, sketchy manner.

Start (A) by laying in the overall arrangement of lights and darks, with thin layers of acrylic, keeping the image as basic as possible; don't rely on lines but think of volumes and areas. Next (B) lay in the cast shadows with washes. Try tapping the paint with your fingers just before it dries to add texture. If the paint has already dried, the surface will look flat and devoid of an organic, textured look. Now add the planes of any buildings that appear in your photograph. Next (C) block in the volumes of the trees with dabs of paint. Here a light green wash is added to the fields then partially blotted out. Now (D) reinforce the light greens with a darker transparent green. In order to develop the volume in the image, you need to work the painting dark against light and light against dark. By now most of the final image is down; the various surfaces only need to be developed or sharpened. At this point, if the painting isn't working, start over again. Many trial runs might be required before you feel you've captured the space and textures of your landscape.

Next develop the shapes. The final painting (E) shows how Chard might approach the subject. First, the edges of the volumes are clarified and contrast is strengthened. A brighter transparent green is added to the middle ground fields. Some horizontal lines are added to provide texture and contours to the field. Shadows are reinforced with limited variations and highlights are added to the left side of the trees and the edges of the shadows around the barns. Finally, for clarity, contrast is added with darks applied against lights and lights against darks.

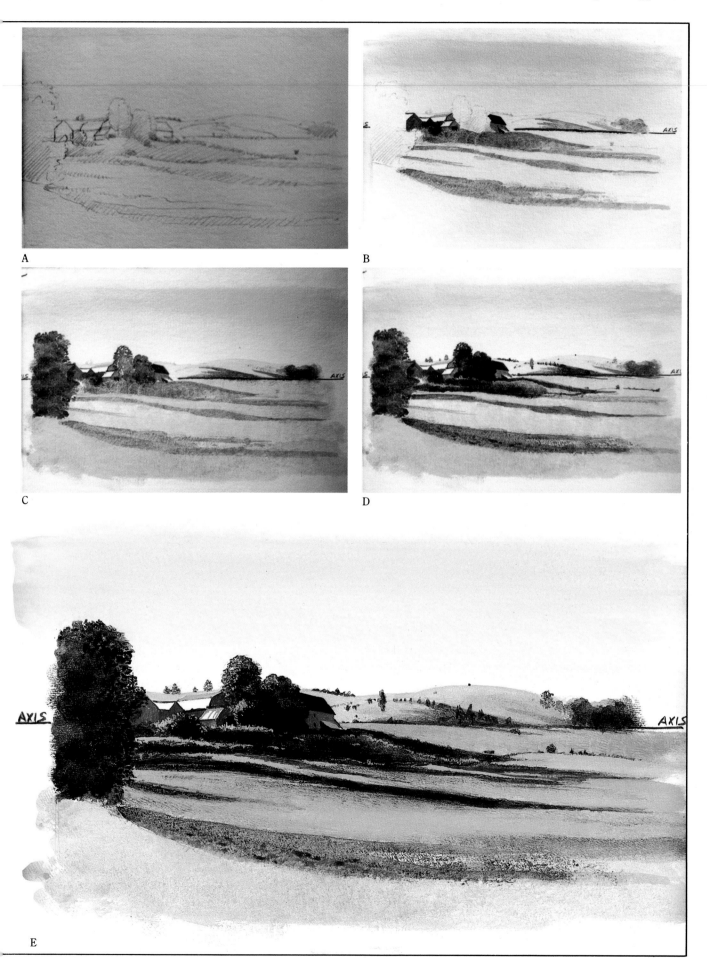

A

B

C

D

E

Exploring Color and Light

ALEX MARTIN: CAPTURING MOOD IN THE LANDSCAPE

For years, Alex Martin has explored light and color and his own strong reactions to the mood and mystery of the land. Inspired by the way light fills the sky at different times of day and in different seasons, his canvases glow with carefully balanced masses of warm and cool colors and light and dark values. Each painting is built up of luminous transparent passages of color that weave in and out, forming the large ephemeral shapes that fill the sky.

When working outside in the landscape, Martin is surrounded by many exciting images—in the sky, in the fields, and in water. He tries to begin every painting with an open mind and discover the landscape new each time. Sometimes he drives around in his truck, looking for a motif; other times he returns to a familiar place. He wants the landscape to excite him.

Gesture is at the heart of Martin's drawings, watercolors, and oil paintings. When he senses the gesture of a landscape, Martin feels able to capture the essence of a form and place. Through the quick response of the gesture, he gets in touch with the physical forces of the landscape—the movement and weight of the trees, the essence of the water, the movement and forms of the clouds.

Martin usually begins his most successful drawings and paintings thrilled about something he has seen in the landscape. A thrill gives his search—and later its execution in paint—the momentum he needs to create. In this inspired state of mind, Martin is willing to take chances and allow himself to become one with the landscape and the artistic process of capturing it.

WORKING METHODS

Martin works with a simple primary palette: cadmium red light, cadmium yellow light, cerulean blue, permanent blue, titanium white, permanent green light, alizarin crimson, permanent magenta, and, for his preparatory watercolors, indigo blue.

In his oils, he applies the paint with inexpensive flat brushes—the kind that house painters use. The smallest is ½″ wide, the largest 4″ across. Occasionally, for detailed work, he chooses a small, round sable brush.

Martin's large oil paintings often evolve from watercolors that he has done from life. He starts a big oil in his studio when he feels he has the idea for the oil clear in his mind. Once he's selected a subject, he usually does some watercolor studies—sometimes only one and sometimes forty or more—before he begins the large canvas. At the same time, he's likely to do a number of loose gesture drawings and wash drawings to capture the forces at play in the sky and to record its values. However, Martin has no consistent pattern in his preliminary work. If there were, he feels his painting would be devoid of discovery and passion.

As Martin works on his larger canvases, he redefines his original concept and translates his first impressions into something totally new. The painting then takes on a life of its own as Martin looks for a way to express a sense of light and color space.

When he begins to paint, Martin often covers the canvas with stains of color. Then, generally working from light to dark, he gradually introduces stronger, darker, and more brilliant tones. He plays with the transparency of paint, letting the intitial warm underpainting shine through the layers he applies later on. For years, Martin worked for weeks, or even months, on a single canvas. Recently he has been searching for a freer style, one that will not detract from a painting's freshness.

WATERCOLOR STUDY FOR SOFT LANDSCAPE

9″ × 12″ (23 × 30 cm) Watercolor on paper Collection of the artist

Many of the watercolors Martin executes outdoors later inspire him to do larger works in oil. This watercolor provided in part the inspiration for Soft Landscape. *Martin works with thin washes of color, which he applies loosely, allowing them to run into one another. Here he has flooded the sky with gold, crimson, and blue. As the washes dry, Martin allows some areas to have definite edges, which helps suggest the large shapes the clouds form in the sky. To indicate the ground, Martin uses denser, darker paint. The colors pick up many of those used to paint the sky, pulling the two areas together.*

SOFT LANDSCAPE

*60″ × 72″
(152 × 183 cm)
Oil on canvas
Collection of the
artist*

Soft Landscape *evolved from a water-color done right at the end of a thunderstorm, when the sky was bathed in late afternoon light. It then grew out of a series of three or four watercolors that Martin executed in his studio. In the final oil, he aimed for a very loose overall look, with free, abandoned brushtrokes.*

The sky is the starting point, then Martin turns to the land. He tries to find the interplay between the big soft sky and the wet lush land and to discover large areas of warm or cool colors that will pull the painting together. Here the mountains that run along the horizon line and the trees on the far left pick up the colors of the sky; the golds in the sky are echoed in the gold that washes across the ground.

The light melts down across the sky to the distant mountains, then floods across the field. The ground is made up of big planes of color that merge with one another. The mountains are rendered with blue and soft reddish-violet; they are the same value as the sky directly above them, allowing the sky to merge with the land.

The dark green masses on both sides of the ground contrast with the light central area; it is bathed with the same yellow as the sky above, again bringing the two areas together.

Exploring Color and Light

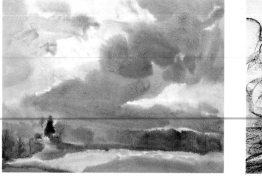

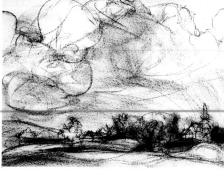

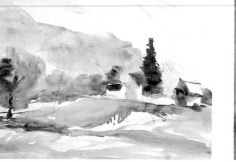

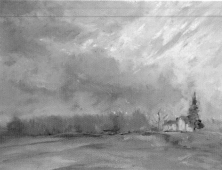

Early Spring Sunrise *was inspired by a watercolor Martin made in early morning in late April, just before the buds on the trees had begun to open. The watercolor captures the exhilarating feeling of dawn in the spring. For Martin, it's a time when things are awakening; it is hopeful, optimistic, and full of surprises.*

In the watercolor, and later in the oil, he wanted to capture the radiance of the sky and the streaks of light rushing through it that contrasted with the dark clouds rolling away. Warm and cool colors collide in the sky, just as they do on the ground, where the reddish-brown land is beginning to be covered with fresh new grass. It's the interplay of light and dark and warm and cool colors that give the painting a bittersweet sense.

Many of the ideas worked out in the oil painting (see facing page) were initially developed through sketches as Martin tried to simplify the foreground space and coordinate the trees and

buildings with it. He executed some large gestural drawings in compressed charcoal, as well as value studies to capture the rhythm of the sky and to balance the sky with the ground. Later he made an 18" × 24" oil sketch to develop the color mood.

The watercolor study for Early Spring Sunrise *was inspired by the light and color of an early April morning; it is one of the thirty to forty watercolors Martin has painted on the same spot. Just as in the large oil, the sky sets the mood of the painting—everything else must work with it. Here the color is set down boldly with sweeping strokes. The same colors that dominate the sky find their way into the ground below.*

Executed with compressed charcoal on a sheet of paper 18" × 24", Martin's gesture drawing captures the rush of movement in the sky. Some of the strokes are flowing and calligraphic. Others, done with the side of the graphite stick, indicate broad sweeping areas.

Martin often explores a subject with

loose drawings before he begins to paint. The sketches help him discover ways of simplifying shapes and of coordinating the land masses with the sky. In the final oil, everything—the foreground, buildings, and sky—has to work together as a unit, and these preparatory drawings help Martin clear away the problems he might otherwise encounter when he begins a large oil.

Through wash drawings, Martin begins to capture the rhythm of the sky and to coordinate the sky with the land. He is not only working with values; he is also searching for bridges between the two areas. In the drawing above, near the center of the paper, the cloud mass on the left is linked to the ground. The same bridge in color and value exists in the finished oil.

To develop the color mood of the painting, Martin did an oil study. Painted on a 18" × 24" surface, it is the same scale as the finished painting. Although the study resembles the large oil, each has its own life and vitality.

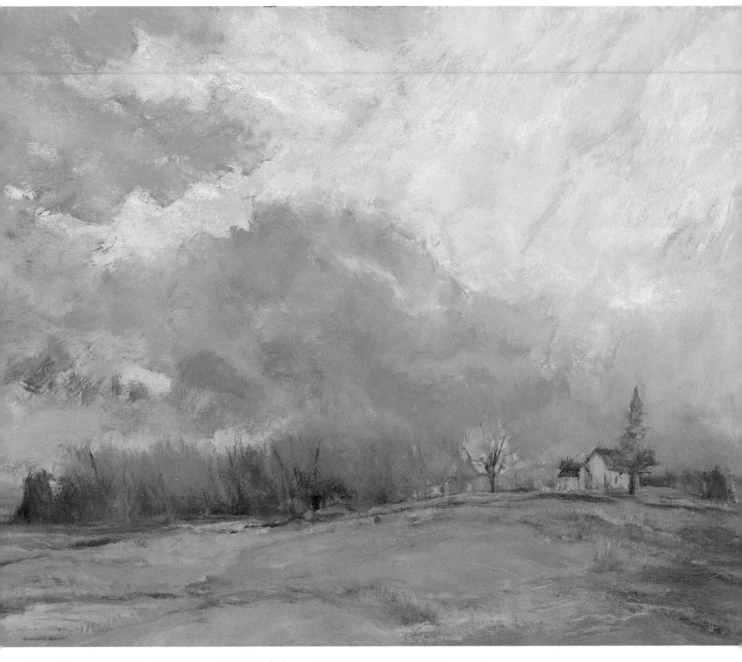

EARLY SPRING SUNRISE

48" × 60"
(122 × 152 cm)
Oil on canvas
Collection of the artist

When Martin began the final painting, he used large brushes and boldly massed in underpainting. The key underpainting color was created from cadmium yellow light mixed with white and a little cadmium red light. The underpainting gets redder near the land and continues to be tinged with red across the ground. While these colors were still wet, Martin laid in cerulean blue mixed with white and a touch of cadmium yellow light. The large break in the sky was created with permanent blue mixed with cadmium red light. These same warm and cool colors are mixed to create the wooded area.

By using a similar palette for the sky and the ground, Martin found a way to let the sky merge with the land. Here cerulean blue and yellow form the bridge between the two areas. The reddish brown of the trees is also continued toward the bottom of the painting in the grass.

AUGUST SUNSET II

40″ × 60″
(122 × 152 cm)
Oil on canvas
Collection of the
artist

*This oil was inspired by a watercolor
Martin painted on an August evening
as the sun was going down. His goal
was to express the feeling of brilliant
color that occurs in late summer, when
evenings are hot and humid, and when
intense light plays down on buildings,
glowing with the red of the dying sun.*

*He started with thin applications of
paint, then adding cool colors, he went
through several stages until he found
the shape relationships he wanted be-
tween the mountains and the cloud.*

*In the original watercolor, the sky
was soft and diaphanous. In the oil,
Martin pushed the planes of the land
into the sky so that the sky became
much more structured. When you move
from one medium to another, this kind
of change is often necessary. Here the
soft, fluid sky worked in the watercolor,
but not in the oil.*

*The painting began with the sky. A
warm underpainting was laid across
the entire surface, then cool colors were
put down on top of the warm ones. The
sky changed several times throughout
the process. As it developed, Martin
added thicker layers over the thin layers.
He was searching for a gutsy range of
paint and color so that the oil wouldn't
look like a watercolor.*

AUGUST SUNSET I

48″ × 60″
(122 × 152 cm)
Oil on canvas
Collection of Charles Simon

This landscape lies about one mile south of Martin's house in New Paltz, New York. It's an expanse of open land, filled with rolling fields; to the west lies the Shawangunk Mountain ridge. Over the years, Martin has made hundreds of watercolors and drawings of this space.

The large oil is based on an 18″ × 24″ watercolor that had a large blue, red, and gray sky, with a flourish of gold on the tops of the highest clouds—all the rest of the painting was in middle-to-dark values. As Martin explored the scene, the oil became a painting in its own right; it looks very little like the watercolor. Martin's aim was to evoke a sense of the scene's mystery and radiance.

He struggled for more than six months with this painting, learning as he worked a great deal about the luminosity and transparency of his oils. The painting grew and developed almost totally from his imagination and memory. Although at one point he was ready to destroy the painting, in the end he succeeded in sustaining a dreamlike idea of the place and its own mood. To capture the warmth and luminosity coming from the light behind the clouds, Martin began with a thin underpainting of warm lush color, which becomes warmer and redder as it nears the horizon line. At first, the paint was applied very freely, in large masses, high in the sky, movement and color were exagger-

ated to express how the light explodes behind the clouds.

After the initial underpainting, Martin began to add thicker, denser pigment. The blues, violets, and blue-greens work together, while the lighter colors act as accents against the cool violet veil that covers the scene. The light warm colors shine through those that are laid on later.

Originally there were more trees in the lower right side; they were eventually painted out. When you work with large shapes and the tensions between them, you often have to edit out details toward the end of a painting, especially if they call attention to themselves and break up the overall rhythm of color and light.

A

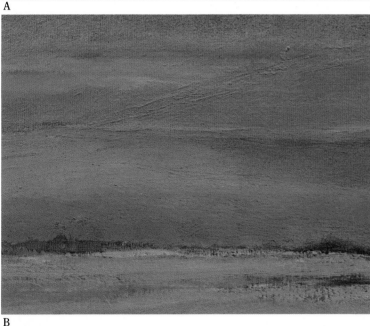

B

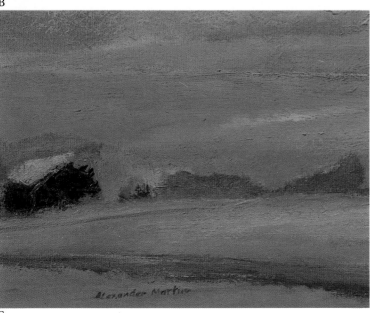

C

DETAILS. A. Martin achieves the rich, fluid effect you see here by beginning with thin layers of paint, then adding thicker passages as he continues to work. Here the warm golds—applied first and very thinly—shine through the cooler and thicker layers of blues and purples that Martin applied later.

B. Martin works with a palette mostly composed of primary colors. Even though the primaries are softened and mixed in the finished painting to form subtle secondary colors, in places it is possible to see Martin's original reds, yellows, and blues. Along the horizon, Martin stacks them boldly, achieving an almost abstract note.

C. Along the horizon, Martin's paint seems to become thicker and more tactile, almost as if to suggest the three-dimensionality of the trees and buildings. Right behind this building, a thinner layer of reddish pigment connects it to the reddish portions of the sky.

Suggested Projects

1. With the sky as your subject, do a series of gesture drawings—loose, expressive drawings that have a strong sense of movement and mood. With a piece of compressed charcoal, work loosely all over a sheet of rough newsprint 18″ × 24″. Choose an open location on a cloudy day when there is some wind moving through the sky. What you're trying to capture is a sense of how the clouds move and the general rush and direction of their shapes. Try to feel their actual weight, and to show it in your sketches. To gain a stronger feeling for clouds and how they move across the sky, repeat this exercise on several days. Other good subjects for gesture drawings are trees, fields, simple rock shapes, or water, such as ponds or streams.

2. After you have become familiar with a place and have worked at it on a number of occasions, both in black and white and in color, move away from the site and do some small color studies. The purpose is to work from memory using the information you have gathered through direct observation. Develop a theme of hue, value, and temperature. For example, you might want to try to execute a painting built around a blue-green hue, where a light middle value is the dominant value and the dominant temperature is cool. All colors should be mixed from the following tube colors: cadmium yellow light, cadmium red, cerulean blue, ultramarine blue, and titanium white. If using watercolor paints, you, of course, will not need the white.

3. Do a series of watercolor or oil studies based on one place. Treat your white paper or canvas ahead of time; paint a light, warm tone over its entire surface. Then, when the underpainting is dry, work darker, cooler tones of color into the painting, moving from light to dark.

Exploring Color and Light

JOHN TERELAK:
ACHIEVING COLOR
HARMONY WITH GLAZES

John Terelak's oils have the same intense, immediate quality that Terelak himself conveys when he talks about art. Painting and teaching painting fill his life; he is totally commited to his craft.

His oils are richly packed with layer after layer of thinly applied paint. Numerous small brushstrokes weave together to form a lush, integrated surface. Terelak repeatedly glazes his paintings to unify them. What he continually searches for is to capture is rich, vibrant hues that work together effortlessly.

Terelak's palette consists of flake white, cadmium yellow, yellow ocher, cadmium orange, bright red, ultramarine, and black. He puts one experimental color on his palette every month.

Terelak gathers the information that works its way into his paintings on numerous field trips. When a subject hits him full force he stops to sketch it or photograph it or to paint a small color study. Sometimes he blocks in the actual canvas on the spot then develops it fully back in his studio.

Outdoors Terelak considers himself a terribly messy painter. The excitement of beginning a work on an easel outside somehow always gets in his way. Although he never uses the same exact procedure twice, the following is typical of how he executes a painting.

First he draws in large simple shapes with a brush, trying to capture the overall composition. Quickly he begins to lay in the major shapes. Within two hours, the canvas is covered with semi-opaque color notes. For the next hours, Terelak adjusts the values and color harmony as well as clarifying the design. The next day in his studio, Terelak usually spends eight hours pushing and pulling the painting's design and colors from memory. If a painting has a large expanse of blue in the sky, he may mix a bit of that blue into most of the other colors in the painting to harmonize the entire work.

On the third day, Terelak concentrates on color. He vibrates different colors into areas that are dominated by one strong hue. If there is a large expanse of grass, for example, he breaks it up with the blue of the sky, which it reflects. He adds yellows to warm the greens, earth colors to reveal structure, and reds to complement the greens.

At about this point Terelak pays careful attention to details, such as the edges of the foliage and the structure of the trees. He flecks the painting with individual color strokes to make the surface more exciting.

By now, Terelak has often spent twenty hours on the painting. He hangs it on the wall and observes it as it dries. Two weeks later, he glazes the work with a mixture of copal and turp, which brings the colors back to life while giving the surface a warm patina. He goes over each inch of the painting, making sure that every detail is as he wants it to be. After such prolonged involvement with the painting, he usually feels insecure about what he has achieved. Months later, though, he may look at the work afresh in a show and, incredibly, see that he has accomplished exactly what he was aiming for when he first began.

STEPHANIE

24" × 36"
(61 × 91 cm)
Oil on stretched linen canvas
Courtesy of Grand Central Art Gallery, New York

Prompted by the fresh, romantic feel of spring, Terelak wanted to paint a very high-key work using white and pastel tones. The composition came, in part, from an overexposed slide he had taken five years earlier. He frequently uses slides as a point of departure when he is planning a painting, and by the time he has finished with them, the information they contain is usually completely altered.

Terelak wanted the atmosphere of the painting to be filled with a soft patina of broken color. He achieved this look by layering many broken strokes on top of one another, then by letting the paint dry before he glazed and repainted the surface.

From the beginning, the general composition seemed right to Terelak. After a life mostly devoted to painting, *he has learned to trust his instincts. When a work seems on target, he never tampers with its direction.*

Terelak began Stephanie *by toning the canvas with yellow and white. For about half an hour, he worked on establishing the major rhythmic lines of the composition. Next he premixed six colors, all light in value, to a creamy consistency and began to lay them in swiftly with a no. 4 filbert brush. As he painted he alternated vertical and horizontal strokes, using a light warm green for the foliage, a warm off-white for the buildings, ocher-white for the foreground, purplish-white for the verticals, rose-white for the flowers, and soft white for the sky.*

For the next three to four hours, Terelak adjusted the tones. At the end of the day, he softened the painting with *a palette knife and by hitting it with a paint rag to blur it even more. What he wanted was a soft, ephemeral look. After five days had passed, Terelak added a semi-transparent glaze that contained cadmium orange and white with a touch of yellow over the entire surface. For the next five hours, Terelak drew with color all over the painting, continuing to use cross-hatched strokes.*

Terelak's next step was to add glazing to areas of the painting, transparent blue in the sky, for example. He continued to make minor changes in color over the whole surface. For ten hours or more, he refined each area, adding details and touches of color. The total effect of the painting is what he concentrates on at this stage; it must be a coherent whole, not just a mass of individual parts.

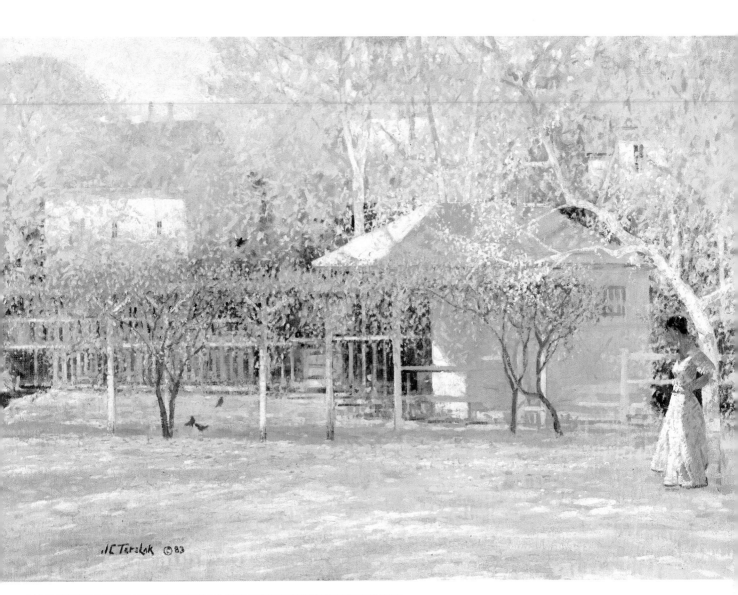

DETAIL. Every inch of Terelak's work is filled with a complex mass of overlapping brushstrokes. Here you can see the number of layers of paint that he applies to achieve such a rich, integrated surface. Because of the care Terelak has taken to balance values, all the different pastel tones merge effortlessly into one another.

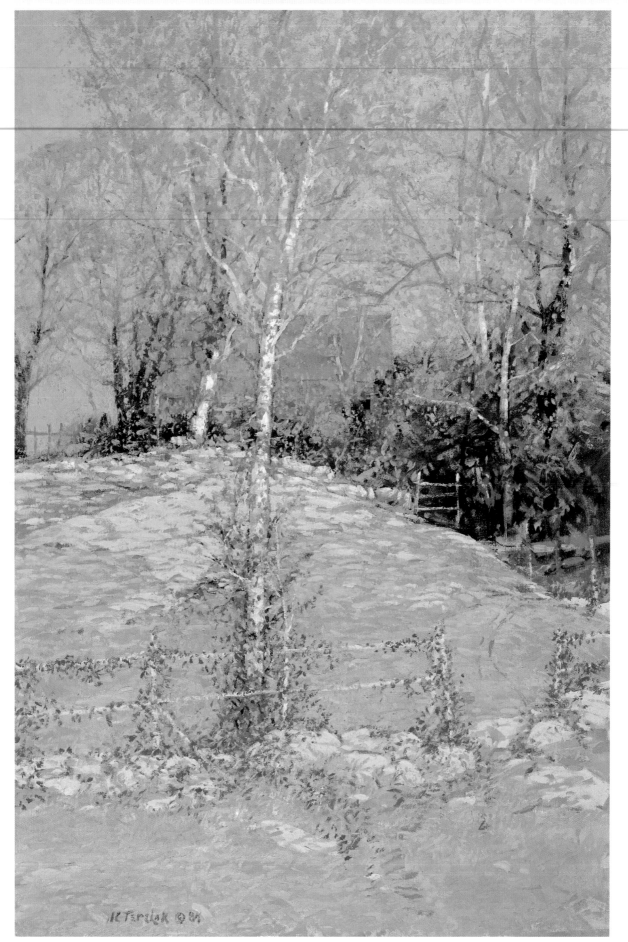

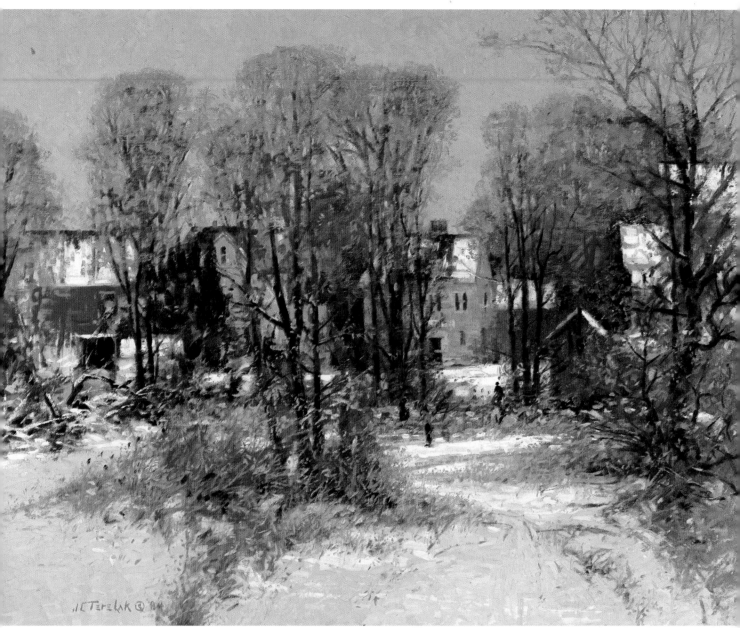

VIEW FROM THE
STUDIO

30" × 40"
(76 × 102 cm)
Oil on stretched linen
canvas
Courtesy of Grand
Central Art Gallery,
New York

View from the Studio *developed
rapidly, in just two days. Working
furiously, stopping only occasionally to
eat, sleep, or purposely pull himself
away from the studio, Terelak painted
what he saw outside his window. He let
the color, shape, form, and atmosphere
that he saw guide him totally as he
painted. The studio setting let Terelak
use a fairly elaborate technique, one
that probably would be impossible to
follow with all the distractions found
out-of-doors.*

*To capture the cold tone that domi-
nated the scene, Terelak began by
staining the canvas with a light ultra-
marine. This move made the whole
painting process much easier, since with
it he established the dominant color note
for the painting.*

AUTUMN
TRANQUILITY

36" × 24"
(91 × 61 cm)
Oil on stretched linen
canvas
Collection of the
artist

*When Terelak began this painting, he
wasn't sure exactly where he was head-
ing. He chose a vertical format to
accommodate the large trees in the fore-
ground, then began by trying to capture
the bare essence of the scene with a
quick drawing in oil on the canvas.
Working rapidly, he next covered the
entire surface with overlapping, semi-
opaque strokes of color. Refining the
painting, getting it to have a warm
vibrancy, took Terelak many days.
Slowly he drew the different parts of the
painting together, continually trying to
maintain the ambiance that surrounded
him when he first saw the subject.*

49

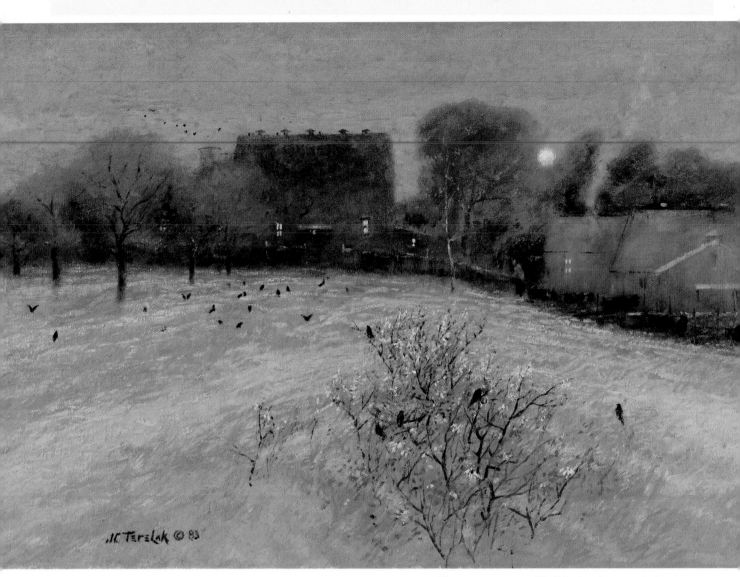

TWILIGHT

24" × 36"
(61 × 91 cm)
Oil on stretched linen
canvas
Courtesy of Gallery
at Nichols Hill,
Oklahoma City,
Oklahoma

Twilight *is a fantasy painting, one built up totally from Terelak's imagination. He developed his concept by sketching different shapes on paper, many of them pulled from works he had previously done. He chose a canvas with an opaque, deep reddish-gray ground because it had a romantic feel to it. To achieve the kind of depth and mystery that he wanted, Terelak knew that he would have to apply many layers of muted color and glazes to the canvas.*

DETAIL. *The original composition was planned without the blackbirds, which Terelak added at the very end. They were applied over a final glaze of rose-ocher that is not especially conspicuous. Despite the fact that the glaze isn't obvious, it made the entire painting much richer and helped suggest the light cast by the setting sun.*

Suggested Projects

1. Choose several of your old paintings and experiment with glazes using the techniques that Terelak uses. Normally he glazes a dark transparent color over a lighter opaque one. Sometimes, though, he does just the opposite, adding white to make the glaze semi-transparent. His basic glazing solution is 60 percent copal and 40 percent turpentine. Don't be afraid to experiment on your paintings; you can always remove the glaze with turpentine.

2. Do anything to break away from your habitual modus operandi. If you normally paint realist works, try using an abstract approach. Experimenting with something totally new may loosen up your painting and sooner or later you'll find that what you've learned has become part of your repertoire.

3. Become an expert in your art. Read books on art that challenge your intellect: books on aesthetics and the philosophy of criticism, as well as books on criticism itself. To organize your thoughts and your working process, books on psychology—even self-help books—can be invaluable. Artists' biographies will help you understand how other artists have developed. Poetry will unveil how words can build up a mental picture. Constantly look at work by other artists—the best work you can find—and associate with people who understand the importance of art. Most of all, be true to yourself amidst all the compromises of modern life.

DETAIL. *Lying against the carefully muted reddish-orange sky, the sun seems to almost jump off the canvas. Terelak left it bright to act as a foil for the rest of the painting. The trees and buildings are gentle and mysterious, with their edges intentionally softened.*

Terelak used several glazes in Twilight. Before the final rose-ocher glaze, he had already applied a transparent yellow glaze and an orange glaze to the sky, each time to develop the painting's color harmony and to give the work a warm, rich patina.

Exploring Color and Light

LEE SEEBACH:
THE PRIMACY OF COLOR

What pulls Lee Seebach toward the subjects he paints are masses of strong, interlocking color. He believes that color is primary. What sounds a little vague at first becomes crystal clear when you look at his paintings. They sing with so much freshness and spontaneity, with so much pulsating color, that it's hard to miss his message. Seebach's emphasis is on the colors inherent in a subject, not on draftsmanship or composition per se; his results are rich, painterly, and unstudied.

Seebach selects what he paints from his day-to-day experiences. Living in Taos, New Mexico, he is constantly exposed to the sun-filled world of the American Southwest. When he sees something full of color and excitement, he reacts positively to it, then he captures it in paint.

A new subject is always dazzling to Seebach. His first impressions are full of excitement, but overstudied they wear away. To counteract this, he moves quickly, trying to capture what he sees immediately.

WORKING METHODS

Seebach's palette consists of Permalba white, cadmium yellow light, cadmium yellow deep, cadmium orange, cadmium red light, alizarin crimson, yellow ocher, raw sienna, Venetian red, burnt sienna deep or burnt umber, ultramarine blue deep, cobalt blue, phthalocyanine blue, phthalocyanine green, viridian, chromium oxide green, and ivory black. Outdoors, he lays his colors on a neutral palette—one he's spray-painted in a mid-tone gray. His brushes are filberts, nos. 2, 4, 6, 8, 10, and 12; he also uses triangular painting knives.

When he starts in on a painting, Seebach lays in transparent turpentine washes, immediately establishing the lights and darks and the perspective lines. He feels that it's important to determine the range of values early in the painting. Normally, he works dark to light, and from thin paint to thicker.

The thin, transparent oil washes dry quickly, making it easy to move on to the next stage. If he's unsure about a color that he's applying, he tends to exaggerate it slightly. Exaggeration not only gives him something to react against, it also helps him express the feelings that the scene evokes in him.

After this preliminary stage, he lays in the darker areas. As he works, he follows the color patterns that drew him to the subject in the first place.

Seebach stands at arm's length from his canvas. Working this way, he hardly ever gets caught up in one detail; rather, he directs the painting as a whole. Throughout the painting process Seebach constantly moves back; a little distance helps him see where a painting is going.

THE KNOWLES'
HOUSE

20" × 24"
(51 × 61 cm)
Oil on Masonite with
white lead ground
Private collection

The brilliant rush of color created by the Jacaranda tree in full bloom drew Seebach to this scene. He began painting with thin turpentine washes, then moved on to the darks and the shadowy areas. Finally he applied opaque color.

The following step-by-step demonstration illustrates a typical procedure that Seebach uses in his larger outdoor paintings.

STEP 1. Seebach starts with very thin turpentine washes. Here the sky is rendered with cobalt and ultramarine blue. With yellow ocher and ultramarine, he builds up the low-lying trees in the middle ground. The foreground begins with yellow ocher, then Seebach adds chromium oxide green, ultramarine, and Venetian red. Finally, he establishes the building and the large dark tree with Venetian red, raw sienna, and ultramarine.

At this stage, it's important to capture the correct colors—the colors that seem strongest right away.

STEP 2. Here Seebach begins by getting down the darkest shadows that lie on the buildings and the very bright light on the roof. Once done, he's established the painting's full range of values. Now opaque color is packed into the sky. In the areas where the building or trees collide with the sky, the blue paint is applied quite thinly, so that he can work back into the painting later. Moving to the middle ground, Seebach develops the light areas and the shadows. Finally, he builds up the patterns in the foreground.

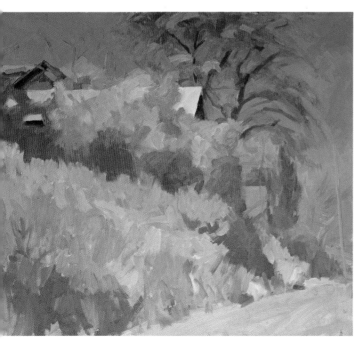

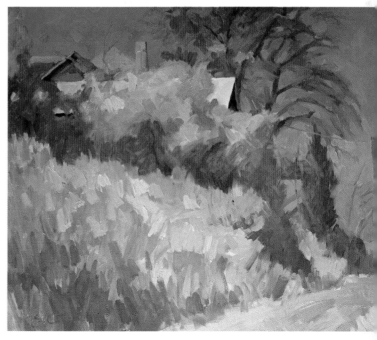

STEP 3. Now Seebach tries to work over the entire surface. The preliminaries are completed; there's something present to which he can react. In the distance, the bare tree becomes darker and more defined. The colors in the middle ground become brighter and more dense. Finally, Seebach explores the patterns that play across the foreground.

STEP 4. At first it seems as though not much happens here. Take a closer look—the touches Seebach adds bring the painting into focus. In particular, see how the tree in the backgrond changes as he makes simplified masses of dark color stand out clearly against the sky. Small touches in the foreground are equally important. Note how he strengthens the lavender that runs along the roadside and breaks up the colors of the hillside with short, energetic strokes.

Exploring Color and Light

THE FLOOD
HOUSE

20″ × 24″
(51 × 61 cm)
Oil on Masonite with
a white lead ground
Private collection

OLD STRUCTURE

22″ × 28″
(56 × 71 cm)
Oil on Masonite with
white lead ground
Collection of the
artist

In The Flood House, *Seebach was drawn to the dazzling color of the scene and the interest and beauty of the old house's architecture, as well as to the unusual perspective and overcast light. All of the colors and textures he explored stemmed from his strong reaction to what he saw. As always, he concentrated on the juxtaposition of colors and how the colors work together.*

Here, for example, he brings pale yellow and lavender together with strong, intense green. When Seebach thought the painting was nearly complete, he moved in and concentrated on the pale trees in the foreground.

THE
McCLINTOCK
HOUSE—
PHOENIX

16″ × 20″
(41 × 51 cm)
Oil on Masonite with
white lead ground
Private collection

The late-afternoon light shining down on this house drew Seebach to it; the sun intensified its color, making it more vibrant and exciting than it might appear in midday light. His goal was simply to capture its beauty.

The painting is a little smaller than many of his works, just 16″ × 20″, a size he chose because his time was limited.

In Old Structure, *the quality of the light and, of course, the color inspired Seebach. He began with thin, transparent turpentine washes, then moved on to the darker, shadowy areas of the painting. Finally, he applied opaque paint.*

In the trees that spring out alongside the house the spontaneity of the brushwork is clear. Each strong and vital stroke has an immediate power.

Suggested Project

To get in touch with color in an immediate and personal way, work with it alone. For a while, forget about composition and how well you draw. Instead, try to look at a scene simply in terms of the hues in front of you.

Working from life, make small oil sketches about 12″ × 16″. The object is to study and learn how colors look in nature and how they come together in your paintings. Working this way you can gather visual information and learn to understand how you relate to the colors around you.

It's often hard to leave all of your notions about how a finished painting should look behind you; try to gain some freedom by forgetting about brushes. Apply your paint directly with a painting knife. You won't be tempted to fuss up your work with little finishing touches. Just look at what you see and slap down the colors that spring into view.

Don't spend too much time on these color sketches. They shouldn't take more than an hour, and many will last only fifteen minutes or so. When you feel you've pulled all the readily available color information from a subject, give it up. There are plenty more subjects waiting to be discovered.

Sometimes you'll be surprised to find that things just don't work—one color may jar with another, or you'll find that you've forgotten all about values. If you find the sketch weak, go back and think about what went wrong and how to correct the problem in your next project.

Exploring Color and Light

MICHAEL HALLINAN: CAPTURING EFFECTS CREATED BY SUNLIGHT

Michael Hallinan rarely intellectualizes about his paintings; he believes that landscapes should be self-explanatory. Since his earliest days as an artist he has been drawn to tropical settings, and in his paintings he explores how sunlight affects different surfaces. In all of his work, he balances strong brilliant hues against one another.

The world that Hallinan captures in paint is based mostly in California and Mexico, the two places he lives in throughout the year. His subjects, which are as simple and unaffected as a beach scene or an alleyway, are transformed by Hallinan into rich, lush worlds full of pulsing color and bold brushwork.

WORKING METHODS

Hallinan's basic palette consists of burnt umber, raw sienna, yellow oxide, cadmium yellow medium, Hooker's green, cadmium red medium, dioxazine purple, ultramarine, cerulean blue, and titanium white. When his subject matter calls for them, he adds cadmium orange, burnt sienna, Thalo green, and Acra violet.

He uses just three brushes, a no. 4 flat, a no. 6 flat, and a small detail/signature brush.

Hallinan often works from sketches and photos. The sketching helps him solve drafting problems and soften photographic perspective while the photos jog his memory about color. Recently he has begun to make color studies with pastels.

Treating the canvas is necessary for acrylic to spread like oil, so Hallinan begins by priming the canvas with gesso or modeling paste—the latter's cheaper. He tones the gesso with a warm middle tone, usually a pink one, though he sometimes uses raw sienna if a scene will have a lot of blue in it. Hallinan finds that acrylics tend to dry cool and that a warm ground works against this tendency. The pink ground also gives the landscape painter a color edge; since red is the complementary color of green, when bits of the red-based underpainting break through the green they make the greens more interesting and vibrant.

After laying in the ground, Hallinan executes a rough drawing on the canvas using a mixture of burnt umber and dioxazine purple acrylic. Next he lays in the dark tones, then, finally, the lights. The middle tones have already been established with the warm underpainting. The actual progression is rarely this simple; there is invariably a lot of going back and forth from dark to light and from warm to cool tones. What Hallinan aims for is a dynamic push-pull relationship between the darks and lights. Hallinan most often begins laying in the darks at the top of the canvas, then he works downward. He rarely mixes more than two colors together—whenever he has tried to mix more than two, he has ended up with mud. Using fairly large brushes, Hallinan works rapidly mostly using a wet-in-wet technique to keep his edges soft and his touch loose.

LAGUNA ALLEYWAY

22" × 28"
(56 × 71 cm)
Acrylic on canvas
Collection of Phil Biron

In Laguna Alleyway, *Hallinan explored the effect of dramatic late-afternoon sun on a simple landscape. Although he basically follows the colors he sees in nature, he tends to accentuate some, particularly those found in the shadows. Here, for example, the shadows that run across the alley have been laid in with a strong bluish-purple tone. To reinforce the glow of the afternoon light, he added a final wash of cadmium orange over much of the surface. Compositional changes included moving the eucalyptus trees in the foreground into the painting to add vertical strength to the work.*

Like many of the works Hallinan does on location, this one is 22" × 28". On location he rarely chooses a surface larger than 24" × 30"; there are enough problems working out-of-doors without having to manipulate a huge canvas. When he was working on Laguna Alleyway, *for instance, it suddenly began to rain, forcing him to complete the painting quickly.*

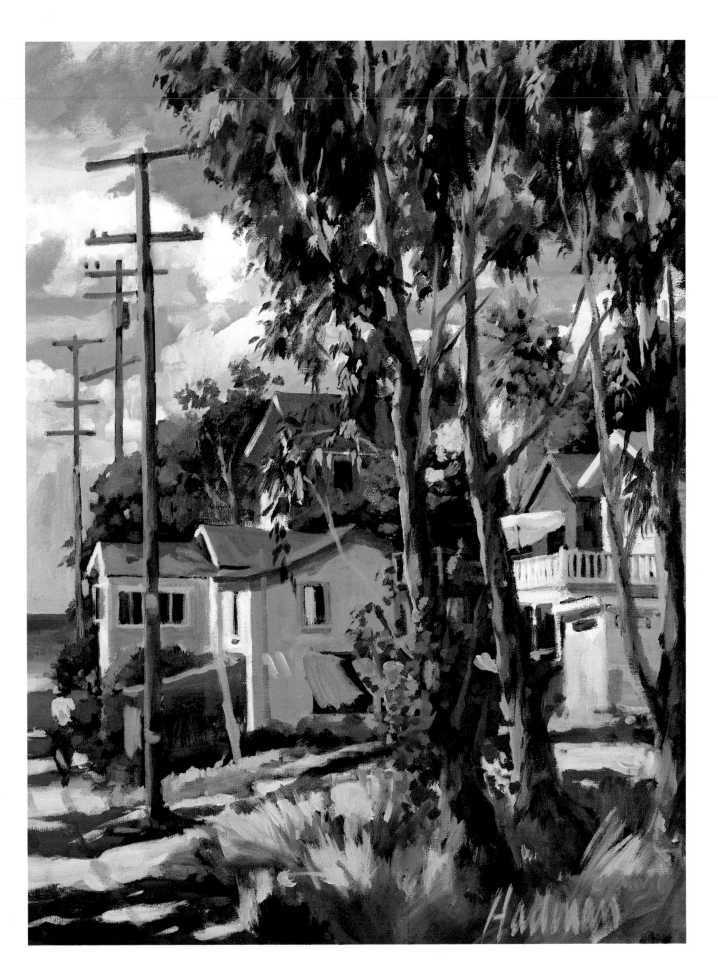

Exploring Color and Light

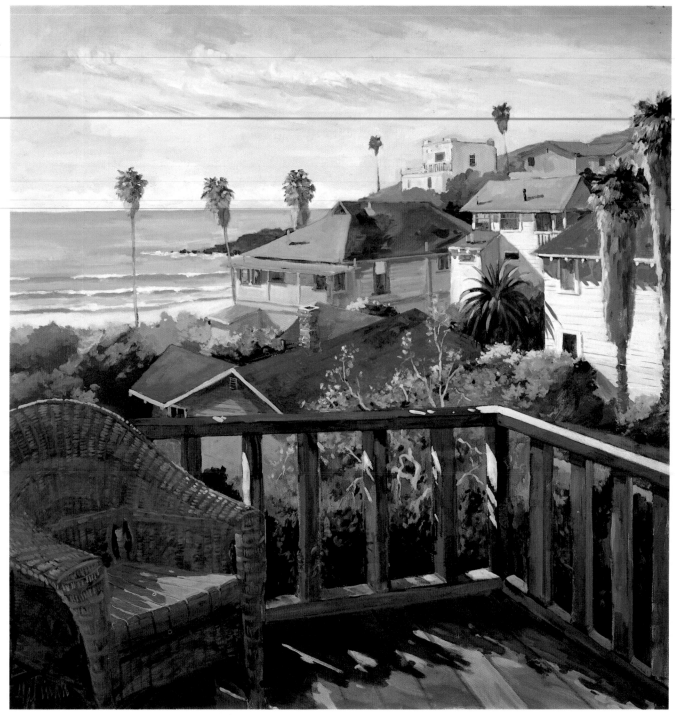

CABO SAN LUCAS

24″ × 30″
(61 × 76 cm)
Acrylic on canvas
Collection of Steve
Brown

In Cabo San Lucas, *Hallinan wanted to fill what could have been a quiet scene with a lot of motion. As the surf rushes forward to the right, clouds sweep left across the sky. The angle of the boat further emphasizes the circular sweep that Hallinan has created. As he worked on the painting, Hallinan discovered that the flow of energy across the surface had become too strong. He added the children to give the eye a chance to stop and take in the painting as a whole.*

Because the water, sand, and sky were all about the same value, Hallinan accentuated the deep blues and purples. By doing so, he successfully divided the painting into general areas of interest. To get across the feel of the shallow water in the foreground, he added Thalo green, first to the sand, then, later, to the blue of the water. By making the pool in the foreground lighter and greener than the rest of the water, he managed to show how shallow the pool was. Toward the end of the painting, he softened the clouds, pushing them back into the distance.

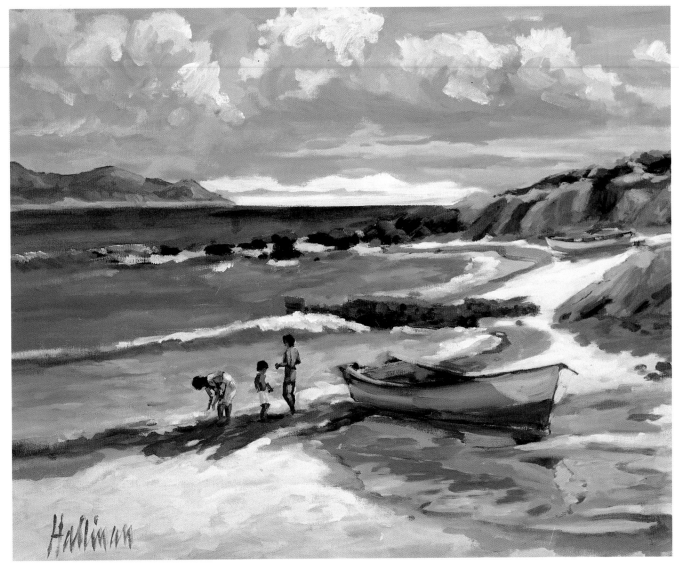

CATALINA HOUSES

48" × 48"
(122 × 122 cm)
Acrylic on canvas
Collection of the
Children's Hospital,
Orange County

What inspired Hallinan to do a painting of this scene in the first place was the strong nostalgic mood created as late afternoon sunlight played down on these old California houses. He did several sketches of the scene, then began to work on the painting back at his studio.

The pink gesso and cadmium red underpainting that Hallinan began with can be seen throughout this work. Hints of it surface from behind the cerulean blue sky and stronger passages of it dominate the foreground and middle

ground. Hallinan chose cerulean blue for the large expanse of sky because it is warmer than the other blues in his palette. A cooler tone would have worked against the radiant mood he was trying to create.

One of the problems this composition posed was how to include the porch railing without making it seem a barrier to the rest of the landscape. His solution was to soften the edges of the railing; by doing so, the railing became integrated with the entire painting.

Exploring Color and Light

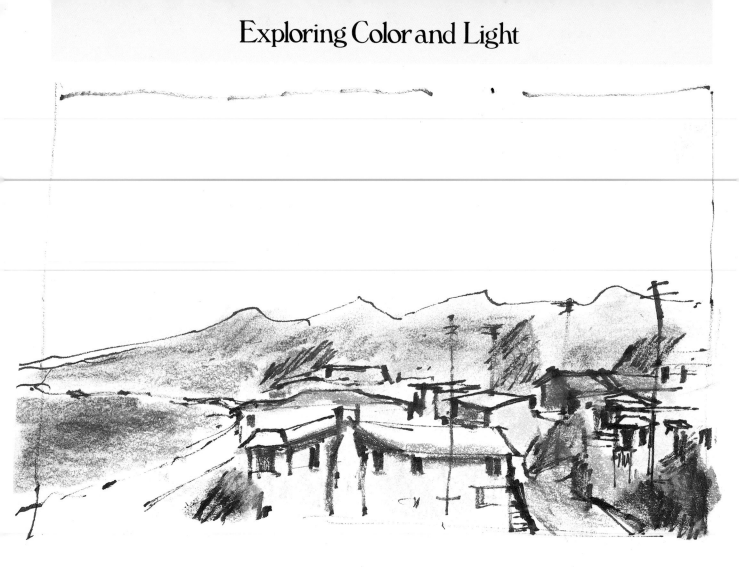

Suggested Projects

1. If strong, bold colors like those Hallinan uses appeal to you, yet you find that you are a little timid when it comes time to put them down, experiment with rapid pastel sketches. The two shown here are typical of the ones Hallinan finds himself doing more and more frequently. They usually take him just ten to fifteen minutes.

First sketch the basic composition with a pencil or marker, then, with pastels, lay in large masses of color. Don't stick to your sketch too rigidly—it's just there to act as a general guide. As you work, you'll find that you can blend pastels together much like you mix acrylics and that the two media aren't as totally different as they seem at first.

Try doing several pastel studies of a subject before you paint it. Use the studies to help you work out the color scheme and to solve potential problems with color. Determine what middle tone will be most effective as an underpainting and also pick out the areas that will be the lightest and darkest in the finished painting.

2. Try painting a landscape using Hallinan's method. It is invaluable for people trying to break away from tight, detail-oriented work; and it can also help you build up a strong unified composition rather than one that breaks into many smaller paintings.

Begin by laying in a middle-tone underpainting. Plan ahead of time and let it represent large areas of the landscape. When you start to establish the darks, use large brushes and lay in big chunks of local color. You'll find that a big brush keeps your work from becoming too tight or fussy. Save your highlights for last. Because the middle tones are established from the very beginning, your painting will take shape more rapidly and clearly. Any flaws in planning will become obvious right away.

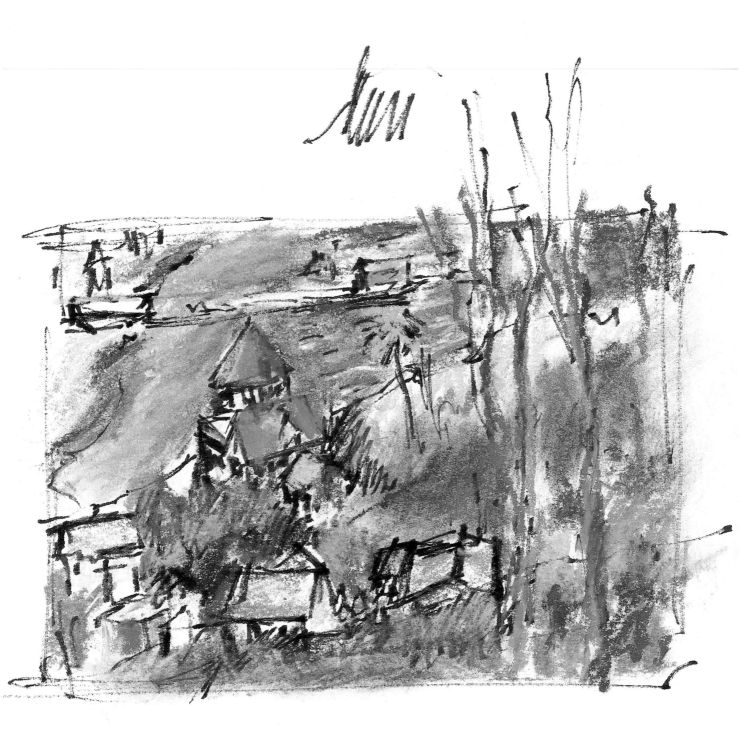

GERALD BROMMER:
COLLAGE TECHNIQUES

Gerald Brommer's mastery of color, value, and composition shines throughout all of his work. Basic watercolor techniques form the backbone of his paintings, but experimentation is a powerful force for Brommer. In almost half of his paintings, he combines traditional watercolor with collage, covering the partially worked surface with a variety of handmade Oriental rice papers. He then completes the painting on the newly built surface.

In any one of his paintings, Brommer may turn to sponges, tissues, sticks, or pieces of cloth to add or wipe away his pigment. None of his unorthodox methods call attention to themselves; they fit into his work logically, helping him to create what he sets out to create—successful, evocative paintings.

WORKING METHODS

Most of Brommer's paintings are built of earth tones, with brighter colors reserved for accents. His palette consists of Payne's gray, French ultramarine, cobalt blue, and cerulean blue; olive and Hooker's green light; burnt and raw umber, burnt and raw sienna; yellow ocher, new gamboge, cadmium yellow lemon, cadmium yellow light, and cadmium yellow medium; cadmium orange, vermilion, cadmium red light, scarlet lake, alizarin crimson, and permanent magenta.

He employs a full array of flat and round brushes ranging in size from large to small. Typically he begins a work with a large round pointed brush, then turns to flat aquarelles. Eventually small round sable brushes come into play to add details. At times, he may also use bristle brushes and toothbrushes and a variety of broken, cut, and scrubby brushes.

Brommer doesn't stop with his brushes. To build up texture he lays in large areas of paint with chunks of natural sponges. He often blots up color with tissues or rags, then uses anything else—his fingers and fingernails or sticks—to pull out details.

D'Arches 300- or 400-pound cold press or rough are his preferred papers. For his collage paintings, Brommer uses twenty or more kinds of handmade Oriental papers, some transparent, others opaque, some heavy, others thin and delicate. Some are white and others earth-toned.

Brommer often records his subjects with film and thumbnail sketches, shooting and drawing them from many angles. Back in the studio the slides do more than jog his memory of color and light; they allow him to recall the impulse that drew him to the subject in the first place.

Working from the slides and drawings, Brommer then executes numerous sketches. The first ones are usually simple realistic renderings of the composition. Next, in a series of value drawings, he begins to rearrange the darks and lights. Finally, he plays with the composition, moving details about and deciding on a focal point.

Brommer hardly ever sketches on the actual watercolor paper with pencil. Instead, he quickly lays in the major lines of composition with a light neutral wash, typically mixed from yellow ocher and burnt sienna, and applied with a large round, pointed brush. This initial brush drawing gets him involved in the painting process right away.

Next, he takes a 1″ flat brush or a large rounded sable one and fills the sheet with local color. He works all over the surface, each brushstroke calling for another to balance it. Since the entire painting is built up from the very beginning, it usually remains in control. Brommer starts with light values, then keeps adding washes and glazes to provide necessary contrast.

Once the entire composition has been established, Brommer begins to lay in color with chunks of natural sponge if texture is to be an important part of the work. Their rough, uneven surface creates a rich, dappled effect. For emphasis, he drybrushes over the sponged areas, then pulls washes over large portions to unify the surface of the painting.

Finally, Brommer turns to detail. Using small brushes, or sometimes even a fingernail or stick, he lays in or pulls out whatever is necessary to complete the painting.

When texture is a key part of a painting—and for Brommer it usually is—he often enriches the tactile feel of a work through collage. As always, he begins his painting with a quick wash sketch, then proceeds to build up the entire surface of the painting with areas of local color. Next he takes a variety of handmade Oriental papers—sometimes more than 20—rips them apart, then glues them all over the watercolor sheet. The white glue that he uses creates a barrier between the original watercolor surface and the applied papers, and makes the Oriental papers less absorbent. Brommer lets the glue dry. Then, over the new surface, he drybrushes color. In some places, the original color shines through; in others, where the Oriental paper is thicker and more opaque, the color is muted.

When Brommer begins a painting, he knows what it is that attracted him in the first place and knowing when to end a work often relies on this initial knowledge. If, for example, the impetus for a work is the tension between the foreground and background, Brommer continually gauges the effect he is achieving. When the tension becomes strong, he knows that he is nearing the finishing point.

CLIFFSIDE / POINT LOBAS

15" × 22"
(38 × 59 cm)
Watercolor and rice
paper collage
D'Arches 300-pound
cold press paper
Private collection

This painting combines traditional watercolor techniques with an innovative application of collage. After Brommer has established the basic composition and colors of a painting, he glues torn pieces of rice paper to the watercolor sheet, then once the glue has dried, he works over the surface with a drybrush technique.

Here the texture of the rocky cliff and its strong yellow and bluish-gray color are what first attracted Brommer to the subject. Since he wanted to emphasize the texture of the rocky cliff, he decided right away to execute the painting using his collage technique.

Composition was one of his challenges. He wanted the visual movement to run upward, ending at the crest of the hill. He knew that abruptly changing the values would push both middle ground and background dramatically back into the picture plane, so he intensified the glaring light that bathed the middle ground.

After studying several slides and executing one sketch, Brommer laid in the diagonal line that forms the crest of the hill using a large round brush and a pale wash of yellow ocher and burnt umber. Starting with light values of local colors, he filled the sheet quickly with large flat shapes. Next, he intensified the color, putting down layer after layer of transparent washes to emphasize visual movement and establish the basic forms. As soon as he had reached that point, Brommer began gluing small pieces of rice paper to the surface; he used about twenty kinds of paper during this stage. When the glue had dried thoroughly, he carefully drybrushed in details and reinforced areas that had lost their impact when the rice paper was applied.

In the finished painting, the foreground jumps forward, pushed out not only by the composition itself, but by the strong contrast between the vibrant foreground, light-washed middle ground, and pale background. In Cliffside/Point Lobas, Brommer proved to himself that a sense of deep space can be sharpened using strong contrasts in value and intensities of color.

DETAIL. Close up, you can see the richly textured surface created as bits of rice paper were applied to almost the entire watercolor sheet. The rice paper breaks up the flat surface, making parts of its seem to have an actual tactile quality. You can see, too, how the applied paper affects the color that was originally laid in. In some places the color is deep and strong; in others it becomes more subtle and less intense. The ridges and ripples in the rocky face are partially due to the collage technique, and partially due to calligraphic brushstrokes added near the end of the painting process.

In these four steps, Brommer demonstrates how he combines traditional watercolor techniques with collage.

STEP 1. *Brommer begins by establishing the basic shapes working with very light washes. Here he uses an 11″ × 15″ sheet of d'Arches 300-pound rough paper.*

STEP 2. *Gradually he covers almost the entire surface of the sheet with a variety of rice papers. He glues the paper right over the painted surface using white PVA glue diluted with a little bit of water. The glue is brushed onto the watercolor paper with a bristle brush, then the rice paper is applied to it.*

STEP 3. *Using a drybrush technique, Brommer lays in strokes of color, first greens, then, when he has decided to explore a Hawaiian theme, brighter stronger shades.*

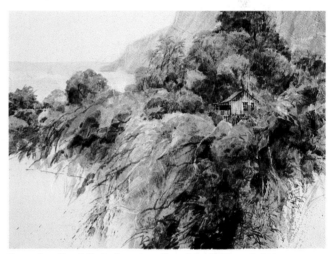

STEP 4. *Carefully he has strengthened the lights and darks, reinforced the center of interest, and established the background. The final painting has all the brilliance of traditional watercolor, and a rich textural sense created by the collage technique.*

Innovative Landscape Techniques

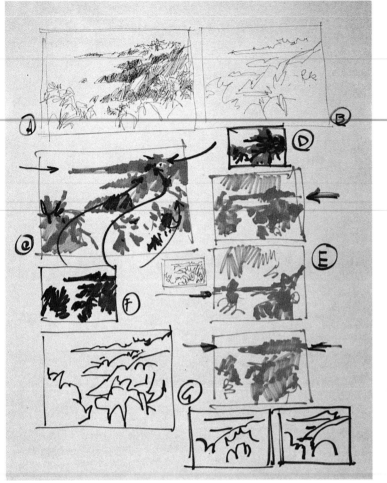

SPRING COLOR/
MONTEREY
COAST

22″ × 30″
(56 × 76 cm)
Watercolor on
D'Arches 300-pound
rough paper
Collection of Imperial
Savings Association,
San Diego, California

Spring Color/Monterey Coast *was a demonstration painting, done for a workshop class at Asilomar on the Monterey Peninsula. It's painted on a full sheet, a favorite with Brommer. Here the large size was a necessity, dictated by the forty students who watched the painting grow. Brommer's aim was to demonstrate the effect of backlighting on the rocks and on the water. Capturing the contrast between the sun that glared through a foggy sky and the bright textured surfaces in the foreground was part of the challenge, too. The method struck on was to keep the areas bathed with light simplified, and to darken the shadowy areas with grayed color and deep values. In the foreground, Brommer emphasized texture and color.*

To make the foreground the focal point of the painting, Brommer pushed the composition up toward the top of the picture plane. He surrounded the cliffs in the background with halos of light to suggest how the sun fell on them. Color selection was based on the colors of the scene.

Control of tonal values began right away. Brommer started with the lightest values, then gradually added the darks; whenever he laid in a dark stroke, he compared it with what was happening in the rest of the painting. If anything got too dark, he immediately sponged it out and lightened it.

Toward the end of the painting, Brommer intensified the shadows with blue-gray washes, then lifted out some areas to get the feeling of reflected light. To do this, he wet the areas with a nylon bristle brush, then lifted up the pigment firmly and quickly with absorbent tissue. Once the feeling of backlighting became very intense and the contrast between the glaring water and the bold, cool rocks became strong, Brommer knew that the painting was almost complete.

This 18″ × 24″ sheet of bond paper is filled with studies of the Monterey coastline, executed before Brommer began his painting, Spring Color/Monterey Coast.

(A) He began with a quick gestural drawing to get the feeling of the location. (B) Next he isolated the major elements in the scene with a simple line drawing. (C) To help set up possible value patterns and visual movement on the picture plane, and to establish the center of interest, he did a quick value sketch. (D) To determine the overall composition, Brommer next approached the scene conceptually. (E) His three quick sketches done in one value explore different placements of the horizon. (F) To help understand how backlighting influences his subject, he then did a black-and-white sketch. (G) His final drawing simplifies the linear placement of the elements. After this kind of intensive probing, Brommer finds that the painting process flows quickly and easily.

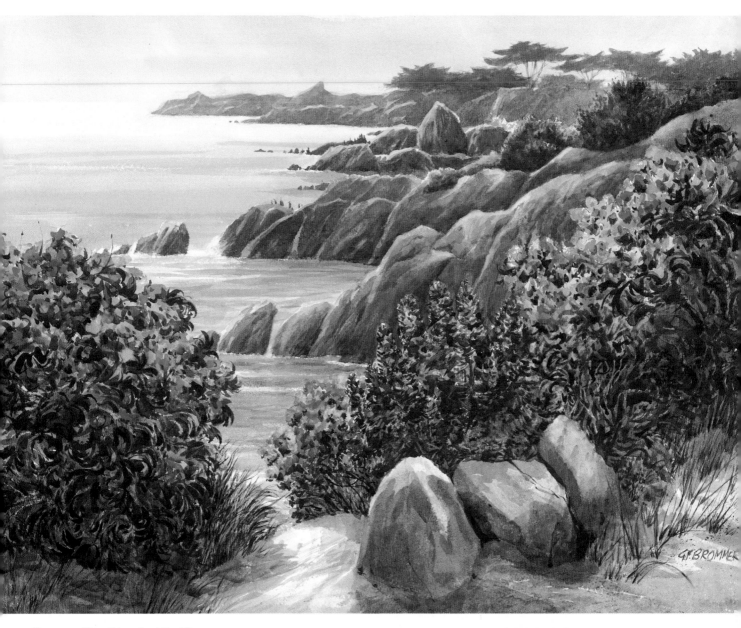

DETAIL. *Everything about the foliage in the foreground pulls it right out at the viewer. The colors are bright and clear, the brushstrokes strong and decisive, and the composition moves quickly toward the front of the picture plane. Yet the recession into depth isn't abrupt. Right behind the bushes in the foreground, the rocks are tinged with deep pink. Further back, the touches of pink become less intense, and in the distant background they are scarcely apparent. The crest of each rock mass is surrounded by a pale halo, clearly suggesting how the sun hits the back of the cliff, then reflects the light upward.*

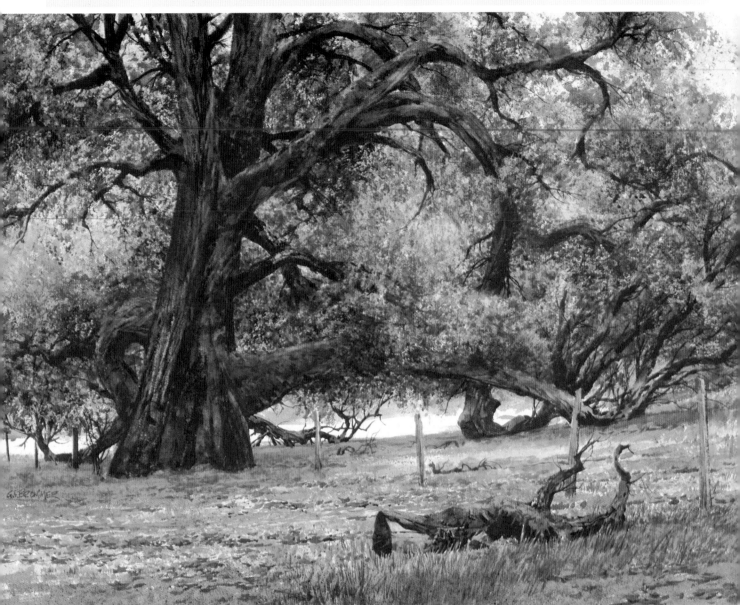

ANCIENT MONARCH CALIFORNIA OAK

22" × 30"
(56 × 76 cm)
Watercolor on
D'Arches 400-pound
rough paper
Courtesy of Louis
Newman Gallery,
Beverly Hills,
California

The concept for this painting grew out of Brommer's exploration of the area around Big Sur, California. There, he found a grove of huge old oaks huddled in a valley far above the coast. The first time he glimpsed them, they lay shrouded in fog, and bathed with an ethereal light. The quality of the light and the extraordinary textures of the trees and the ground are what got him started.

On the spot he filled over a dozen sketchbook pages with thumbnail drawings, then photographed the grove from many angles. As soon as he returned to the studio, he began work.

The colors used in Ancient Monarch/ California were selected to convey the sense of quiet strength and serenity that permeates the scene. Using Hooker's green light and olive green, as well as a variety of green tones mixed from blues and yellows, he laid in the basic areas, then grayed all of the greens with complementary hues to obtain an oaklike quality. Here burnt sienna, alizarin crimson, and some cadmium reds were laid on top of the greens; for some passages, Brommer mixed the complementary colors in the tray. The oak

foliage was begun with sponges. Brommer spattered blues, reds, and oranges onto the foliage, then washed over some of them with greens.

In the final stages of the painting, Brommer pulled washes over various areas to unify the composition and to enhance the shadowy feel of the work. Mixing ultramarine blue and burnt sienna together, he tried to keep the wash warm to contrast with the overall cool quality of the work. Next he increased the darks in the trunks and branches to make them stand out.

DETAIL. Here the rich, mottled feel of foliage has been created through the use of sponges, spattering, and drybush techniques. The irregular surface that forms the basis of the foliage was laid in over the initial wash with a piece of natural sponge; over this layer, bits of bright red, orange, and blue were spattered on with a toothbrush. To pull all of the textured areas together, Brommer swept washes over them, then completed the work with drybrush strokes. By leaving the white paper untouched in places, rich light seems to flood the area behind the tree and spill across the ground.

Suggested Project

Keep an open mind regarding painting materials and techniques. Use whatever you need to create the effect you are after. Try to find alternate ways to apply watercolor to your surface. Experiment laying down paint with crumpled tissues, various papers, sponges, your fingers, pieces of cloth, sticks, and the like. First discover what effect these devices create, then find a way to work them into a unified, finished painting. If they make the painting better, they are worth experimenting with further; if they don't, or if they look gimmicky and draw attention to themselves, they are not working for you and should be discarded for the time being.

DON RANKIN:
AN INDIRECT APPROACH

Don Rankin's landscapes are built up of carefully applied layers of transparent wash, layers that seem to float on top of one another, filling his paintings with a radiant glow that seems to come from beneath the surface of the paper. The way Rankin applies his paint to paper is based on the conviction that cumulative layers of wash are richer and more powerful than a wash mixed on the palette and then laid onto the paper.

Drawn from the Alabama countryside where he grew up, Rankin's subjects are often tinged with nostalgia. In some works, such as Winter Light, *he records the beauty and grace of buildings constructed long ago; in others, such as* Erosion Line, *he laments the ongoing destruction of the land around him.*

Rankin's painting process is slow and deliberate. Each work is made up of many layers of color. The detailed and elaborate preparation for each painting leads to a moment of great intensity, when suddenly he grasps what needs to be done and then quickly executes it. After the long deliberate preparation, it's a delight for Rankin when everything suddenly falls into place and he can work quickly and directly, rapidly refining what he has already established.

WORKING METHODS

Rankin's palette consists of vermilion, Winsor red, and Grumbacher red; new gamboge and cadmium yellow medium; and phthalocyanine blue, Winsor blue, manganese blue, cobalt blue, permanent blue, cerulean blue, and indigo.

His brushes are all high quality. Initially he uses a three-inch bristle brush to lay in the washes, then he turns to a 1½″ red sable flat; a 1″ red sable aquarelle flat; nos. 4, 5, and 6 red sable rounds; nos. 1 and 6 red sable riggers; plus oriental brushes nos. 12 to 16.

Like his brushes, Rankin's paper is the best possible—usually D'Arches 260-pound cold press, occasionally Strathmore hot press rag boards or Fabriano 140-pound cold press stock. Since his method relies on many applications of wash, high-quality, strong paper is a necessity.

When Rankin begins a painting, he works from light to dark, conscious from the very beginning of controlling the washes he applies. The first layers of wash are the backbone of the painting. They produce an overall glow that cannot be achieved through any other technique. More important, this careful application of washes allows Rankin to control the quality of light that floods his paintings. After each wash is applied, it is allowed to dry thoroughly before he moves on to the next one. Often in these initial washes, several layers of the same color are laid in, one on top of another.

After he has painstakingly built up the basic washes and established his lights and darks, Rankin's approach becomes more rapid and direct.

Erosion Line *is one of Rankin's most spontaneous works. Begun with a loose sketch on a Saturday afternoon, the painting was matted and framed by the following Tuesday. Here Rankin took a chance and gave the painting a chance to develop freely—in this case, the right decision. One of Rankin's early paintings, it reveals how he began to discover the effect layered watercolor washes could produce. More than that, it is a simple, direct response to a strong emotional tug.*

Erosion Line *was born as Rankin watched rain pour down on a patch of land that had been relentlessly cleared by bulldozers. Bit by bit, the soil was being washed away as one small tree held on tenaciously for its life. Rankin's frustration at the destruction of his land by unnecessary and unwanted construc-*

tion found its outlet in a hasty pen sketch drawn on an envelope. Looking at the scene and his sketch, he became intrigued by the strong patterns in the grass and the rocks. The rich earthy colors, too, were intensified by rain that fell on the scene. Because of his strong response to the subject, its clear abstract design, and the immediacy of the rainstorm, Rankin decided to paint his picture quickly—he reasoned that if he labored too long at it, the subject would lose its effect. As he worked, much was left to chance.

On the watercolor paper, his initial sketch was very loosely defined, consisting mostly of a few intersecting lines that traced the angle and position of the rocks. After stretching the paper, he washed the entire sheet with raw sienna diluted with cadmium yellow medium and a touch of Grumbacher red. Once this basic wash started to dry, he began to paint directly on the sheet. Moving from the center of the paper outward, he first swept a darker wash across it diagonally. On the slightly damp paper the color bled irregularly. Next, the upper portion of the grass was washed in with raw sienna and Grumbacher red using a 1" aquarelle. Next, Rankin turned to the outcrop of rocks. On the still-damp sheet, he mixed in a little Hooker's green deep, then added water to dilute the effect. The hardest part of the painting completed, he let the paper dry.

While the grassy areas were drying, he began to drybrush them to strengthen and define them. At the same time, he developed the shadowy patterns in the foreground, mostly with alternating washes of thalo blue and Grumbacher red. In a few areas near the base of the tree, he added Hooker's green deep.

Rankin developed the small tree with a mixture of phthalocyanine blue, Hooker's green deep, and Grumbacher red. A few of the fine limbs and highlights were scratched out with his fingernails. This completed, Rankin began to refine various areas of the painting. In some of the soft grass passages in the background, he pressed his arm into the paint to add texture to the surface. He strengthened the shadowy details in the rocks, sharpened the tree limbs, and worked on the shadows. In the finished painting, it's easy to see how the work breaks into three values—highlights, middle tones, and shadows.

EROSION LINE

15" × 29"
(38 × 74 cm)
Watercolor on
Fabriano 140-pound
cold press paper
Private collection

71

Innovative Landscape Techniques

MOUNTAIN
ORCHARD

13″ × 20″
(13 × 51 cm)
Watercolor on
D'Arches 260-pound
paper
Collection of the
South Trust Bank of
Alabama

On a hillside near Rankin's home, an old orchard was about to be cut down and replaced by a subdivision. Rankin's mood as he planned the painting no doubt influenced the brooding quality of the finished painting.

His palette consisted of new gamboge, cadmium red medium, Grumbacher red, vermilion, cerulean blue, cobalt blue, and phthalocyanine blue.

DETAIL. As the washes used to render the tree trunk dried, Rankin used paper towels to blot up the excess liquid that might dry with a hard edge. After laying in the shadows, he used the top of an aquarelle handle to scrape out some of the main limbs. To indicate the smaller limbs, he scratched them out with his fingernails.

Later, when it came time to add detail to the tree trunk and limbs, he worked with two Winsor and Newton no. 5 round brushes. He loaded one brush with dark wash, the other with clean water. Holding a brush in each hand, he laid in a dark passage with one brush, then feathered or blended one side of each stroke with clean water. Rankin turns to this technique when he needs the control of a direct wash but also the softness associated with wet-in-wet.

When the painting was nearly done, he worked with an X-Acto knife to clean up messy edges on the limbs and to sharpen their highlights. The same knife pulled bits of white off the trunk. When a few of these white spots proved to be too jarring, he stained them out. As a final step, he washed the trunk and foreground with cerulean blue.

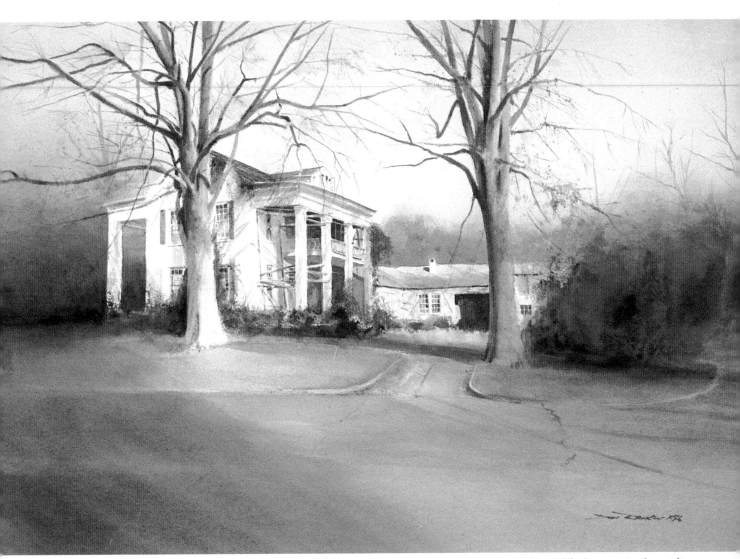

WINTER LIGHT

16½″ × 25″
(42 × 64 cm)
Watercolor on
D'Arches 260-pound
paper
Collection of The First
National Bank of
Tuskaloosa

In Winter Light, *Rankin returned to a subject he had painted once before, the Washington-Moody house in Tuscaloosa, Alabama. His earlier watercolor had generated so much interest in the building that eventually it was completely restored and placed on the historic register.* Winter Light *was executed while the restoration was in progress.*

Rankin developed the painting slowly and deliberately, intrigued by the shape of the building, the patterns formed by the scaffolding, and the brilliant reddish glow of the late afternoon sun. He started with a careful sketch in which he controlled some of the most important areas—the scaffolding, windows, and shadows—leaving others like the sky to take care of themselves once the painting was begun. In particular, he studied the shadows and how they af-

fected the mood he wanted to capture. From the start, he wanted to maximize the contrast between the highly finished portions of the house and the unpainted areas to help create the illusion of direct sunlight burning out detail as it struck the surface of the building. Here Rankin worked with a palette of new gamboge, Grumbacher red, vermilion, and Thalo blue, plus some small touches of cerulean blue. He began with very carefully controlled layers of underpainting in shades of phthalocyanine blue, concentrating on details like the windows. Each layer of wash was allowed to dry thoroughly before he proceeded. The next series of washes began with diluted gamboge that Rankin flooded over the sheet, being careful to avoid the house. These layers are cru-

cial and difficult to execute; they can't look sloppy. Round three consisted of the same pale gamboge warmed with a touch of vermilion. The wash was applied only to the areas that need the color—for example, the trees.

Next Rankin intensified the washes in the middle ground and foreground, then turned to the shadows. They were built up with a mixture of new gamboge, vermilion, and Thalo blue. Toward the end, a powerful wash was flooded across the foreground to produce a shadowy effect. Finally, to subtly indicate the area in the lower right corner where the street and driveway intersect, Rankin laid in a pale wash of cerulean blue. The cool tone defined the curb and drive without calling too much attention to that area.

Innovative Landscape Techniques

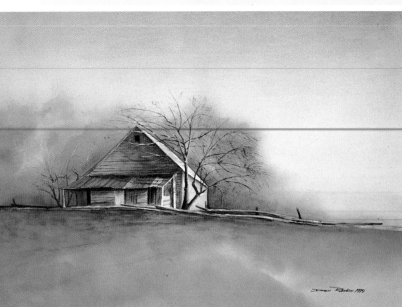

Kessler's Barn *no longer stands—it is a recollection from Rankin's childhood. When he thinks of it he can still recall the texture of the wood and the smells of fresh hay and corn in the crib. He chose to bathe it in autumn light—intense light that long ago made it seem when sun fell as though the barn were on fire.*

Before Rankin actually began to paint this scene, he washed the entire sheet of paper in several layers of yellow washes. (The first two or three are very pale—approximately a 15 to 20 percent tone). In these early washes, certain areas of the painting carry intense color while others do not. For example, the middle ground and backdrop of trees contain some rather strong passages of yellow. As the painting developed, these areas become stronger and eventually developed into the shadow areas.

KESSLER'S BARN

17" × 26"
(43 × 66 cm)
Watercolor on
D'Arches 260-pound
cold press paper
Collection of the
artist

Suggested Project

Try painting a landscape using Rankin's approach. You'll need just three colors—new gamboge, Grumbacher red, and Thalo blue—each chosen for its staining power and relative transparency. Use your largest brushes and as you work, blot up excess water with tissue. Let each wash dry thoroughly before you move on to the next one or you'll create a muddy effect.

STEP 1. Sketch the scene. Here the drawing is unusually dark to help you see through the layers of wash that will be applied. Now flood the entire sheet with a very pale wash of new gamboge and Grumbacher red. Don't be mislead by the pale color—you'll see that these diluted washes have a powerful cumulative effect.

STEP 2. Slightly increase the strength of the yellow and red wash, then lay in the wash all the way down to the horizon, working around the house. While the paint is drying, blot out a wisp of smoke near the chimney with a tissue.

It may be easier to coax the paint around the house if you cover the sky with clear water before you lay in the wash. If you choose to try this, be just as careful as you would be if you had paint on your brush. If, in the end, the sky is too pale, let the paint dry, then repeat this entire step.

STEP 3. Start by wetting the paper from the horizon up with clear water, again avoiding the house. While the water soaks in, mix a darker wash of new gamboge, Grumbacher red, and Thalo blue. Now take a large brush and lay in the trees. You can see how the color bleeds into the sky because the paper is damp.

STEP 4. While the paper is still wet, continue to develop the middle ground. Load your brush with the dark wash, then let the tip of it hit the paper where you want to add emphasis. The wet paper will draw the pigment out of the brush, then, on the paper, the color will blend. Watch out for puddles—if they start to develop, blot them up quickly. While the trees dry, lay in the shadows on the house and foreground using a wash of new gamboge and Grumbacher red.

STEP 5. Continue to develop the shadows on the house and the foreground. Here the window is painted with Thalo blue and Grumbacher red. You can see how the pale wash applied over the ground in step 4 darkens the wash that is laid on top of it.

STEP 6. This is the final stage and probably the most fun. Until this step, you've waited patiently for the washes to dry: now you can paint quickly and directly. It's time to modify the washes in the foreground and slightly darken the washes in the house.

For the chimney, use red mixed with a touch of blue. Varying mixtures of blue, pick out the planks and shadows of the house; for the darkest passages, add a little red. The darkest portions of the trees are painted with blue and red, then highlights are drawn out with an X-Acto knife. Finally, add texture to the ground with a wash mixed mostly of red and yellow, with a little blue added for the darkest sections.

Now stop and evaluate what you've done. The chances are that your work will look quite different than the painting you see here, for no one copies an exercise exactly—nor should they. If necessary, modify some passages by darkening them or lightening them. Let your own painting tell you what it needs to work.

Step 1

Step 2

Step 3

Step 4

Step 5

Step 6

Innovative Landscape Techniques

John Koser: A Non-Contact Method

John Koser's paintings bristle with life. Each one is packed with hundreds, even thousands, of speckles of paint that blend together, constantly forming new color sensations. Their freshness and appeal is largely the result of an innovative watercolor technique that Koser has developed.

Until around five years ago, Koser worked in a fairly traditional fashion. Then, intrigued by how pigments mixed together on his palette, he started experimenting with a non-contact method of painting. Koser now spatters primary colors onto a wet surface where they come together and mix. Working with just one yellow, one red, and one blue, he creates an infinite range of colors. To regulate his values, he varies the amount of water he mixes with his pigments.

When Koser began working with this watercolor technique, he thought that it would be difficult to control. Surprisingly, he quickly learned how to direct the flow of water and color. To create a strong directional sense from the very start of a painting, he flicks water and then paint in the same predetermined direction.

Control also results because Koser builds up his tonal values slowly—his first applications of wash are barely visible. If his subject demands strong contrasts of lights and darks, he first establishes the lights all over the surface of the paper, then goes on to concentrate on the darks.

Koser works with a simple primary palette. He picks one yellow, one red, and one blue from the following colors: new gamboge, Indian yellow, cadmium orange, cadmium red, vermilion, Winsor red, alizarin crimson, French ultramarine, Prussian blue, Thalo blue, and Winsor blue.

To spatter the water, then the paint, Koser begins with a natural bristle toothbrush. Next he moves on to a variety of brushes, including ¾″ and 1″ Grumbacher aquarelles and a Grumbacher 2″ no. 4614 "sash" brush, which is similar to a house painter's brush. For final touches, he uses nos. 4, 6, and 8 red sables in the conventional painting method. By running his thumb over the bristles of the toothbrush, he covers the surface with fine beads of moisture; the drops left as he flicks the other brushes are larger. What Koser is looking for in these droplets is a rich variety in size and shape.

Because of the amount of water involved in his technique, Koser almost always uses heavy paper, never anything lighter than 140 pounds and usually paper with a 300-pound weight, or an illustration board with a rag surface. Throughout the painting process, the paper is kept flat.

Koser develops his compositions in black-and-white drawings. At first he works rapidly, establishing the basics of the scene. Working at the source of his material, Koser adjusts and moves some elements and deletes others. When he's happy with his composition, he does a more elaborate drawing, one that contains all the detail that his finished painting will have. Finally, with his watercolors, he makes color notes to direct him later when he chooses his palette in the studio.

In his studio, Koser begins by lightly sketching the scene using the drawings that he has done on-the-spot as his guide. If he wants to keep some areas white while he paints, he either masks them out with liquid friskit or by cutting out resist shapes from old mat board. To keep the outside margins of the painting crisp, he masks them with drafting tape.

But before paint hits his paper, Koser prepares the watercolor page. Using a natural bristle toothbrush, he flicks and spatters water onto the paper. Next, he may use his aquarelle brushes to further wet the surface. By using different sized brushes, he lays down water droplets of varied sizes. It's these drops that pick up and carry the color; if they are all one size and shape, the finished work will look studied.

Now Koser starts to apply the paint. Beginning with a very light value of his yellow, he flicks the pigment onto the paper, first with the toothbrush, then with his aquarelles, directing the drops of color as they fall. Next he applies his red, then his blue, using the same spattering technique. As the red drops hit the yellow ones, they form orange. Blue mixes with yellow creating green. Continuing to work first with yellow, then with red and blue, in several steps Koser increases the density of the pigment, applying all but the darkest values. These he flicks in last. As he lays in the color, Koser thinks constantly of the hues he wants in the finished work. For example, if he is painting a forest scene filled with strong greens, he concentrates his yellows and blues on the foliage. If the color he is developing seems too cool, extra spatterings of yellow and red will warm up the tone.

There's nothing slapdash about the way Koser works. With each application of paint, he consciously builds up color and form. He leaves some areas light, working around them as the painting proceeds.

Part of the challenge for Koser is predicting how the transparent watercolor will dry. It's always going to be lighter dry than it is wet, but it takes practice to determine how much lighter it will be, especially since he works with so much water. Constant work has helped him intuitively know how the color will change as it dries.

Sometimes—more and more frequently—Koser works over the dry surface with fine pastels. He uses the pastels to accent and define what he's already established in the painting process. His touch is light; once again he chooses one yellow, one red, and one blue. Each is lighter in value than the original watercolor pigment.

When he has completed laying in his accents and highlights, Koser dusts the pastel passages with fixative, then signs his painting.

FOREST REFLECTION

13" × 17"
(33 × 43 cm)
Watercolor with overlay of superfine pastel on Crescent #110 cold press illustration board
Collection of Mr. and Mrs. Arthur Johnson

On a hike in northern California, Koser was drawn to these giant redwood trees and to the remote feel of the rugged terrain. To accentuate the solitary mood of the place, he excluded all paths from his composition.

Here his palette consists of Indian yellow, alizarin crimson, and Prussian blue. To underscore the color of the trees, the painting has a reddish tinge. The white areas stand out powerfully because of the surrounding dark.

In the close-up at right, Koser chose a no. 8 round brush while the paint was still wet, to define the dark background between the tree trunks. Then, as the surface began to dry, he used the end of a brush handle to scrape through the damp paint, drawing in a few branches across the trunks. Finally, when the paint had dried, he stroked pastels over the watercolor to produce texture, heighten value, and enhance the sense of depth.

Innovative Landscape Techniques

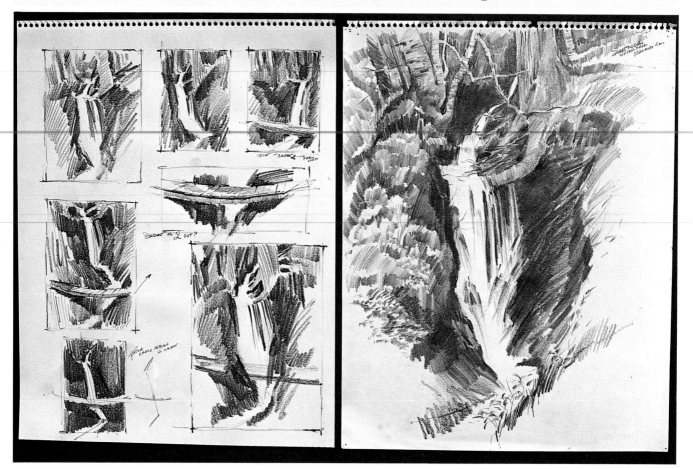

Walking alone in England's Dartmoor Forest, Koser stumbled upon this waterfall. He was immediately caught by the mood of the spot—its solitude and the rich moist air that enveloped the whole area.

Compositon was the first challenge. In a series of black-and-white sketches (shown above), Koser played about with the structure of the scene and with its value scheme. The footbridge wasn't exactly where he wanted it to be, so he toyed with the notion of omitting it. These sketches trace the path Koser made as he worked with what he saw.

Eventually Koser decided to delete the bridge. Then, when he began the painting, he reversed his decision. Changing its position slightly, he worked it into the composition.

SPRING WATERFALL IN DARTMOOR

19″ × 28″
(48 × 71 cm)
Watercolor and pastel on Crescent #110 cold press illustration board
Collection of Mr. and Mrs. William L. Stoermer

Koser wanted to execute the focal points of the painting—the waterfall and bridge—last, so he blocked them out before he started painting. He cut out resists from old mat board and fastened them to the painting surface with push pins. When he began directing the flow of the paint and water, he worked outward, away from the bridge and waterfall. Because all the color rushes away from them, the bridge and water seem to surge with energy.

Notice the rich variety of colors created from three primaries—cadmium orange, alizarin crimson mixed with cadmium red, and Winsor blue. The tiny islands of white that run over the surface of the painting are the natural result of Koser's method. Superfine dry pastels, applied with vertical strokes, highlight portions of the painting, such as the foliage behind the bridge, and reinforce the direction of the waterfall.

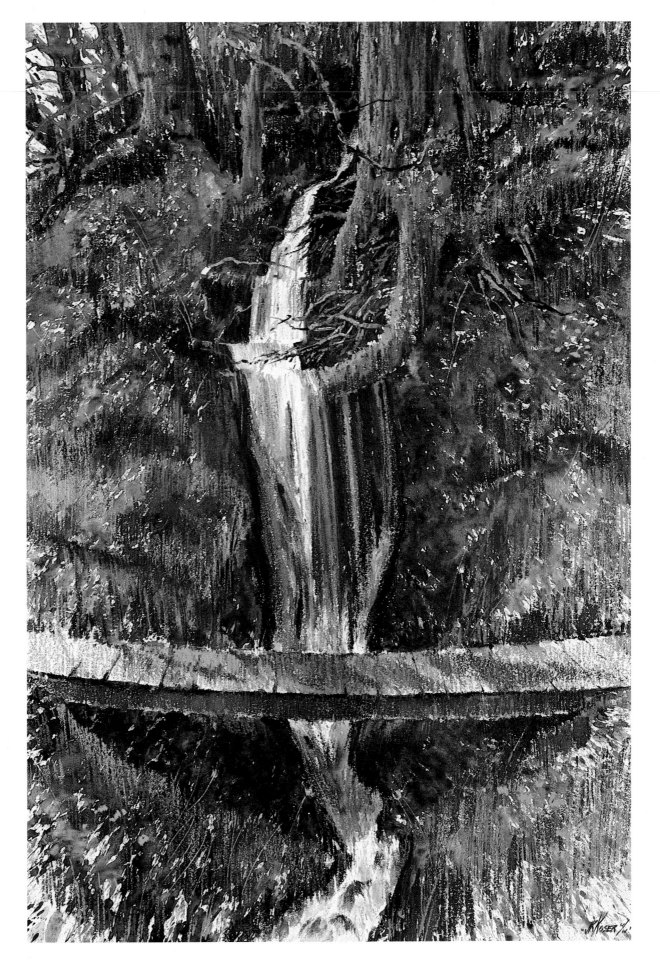

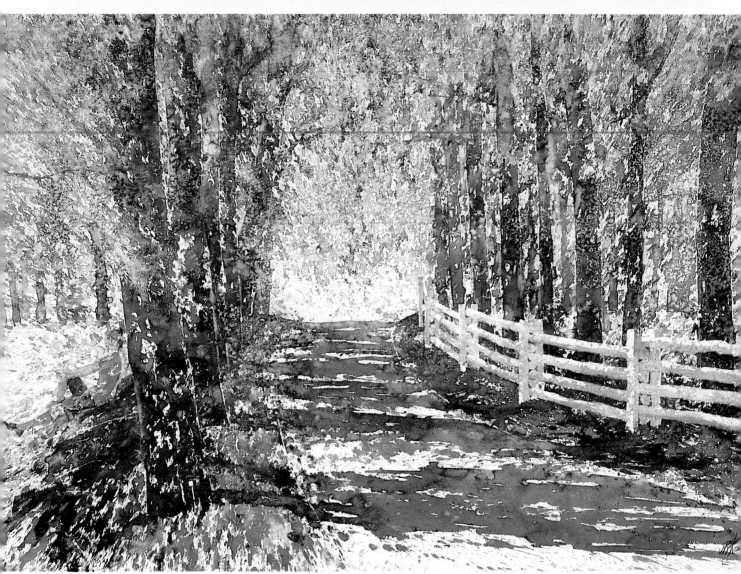

HAPPY WANDER

19" × 27"
(48 × 69 cm)
Watercolor on
D'Arches 300-pound
cold press rag paper
Collection of Mrs.
Dorri Hardin

Inspired by the glory of autumn in upper New York State, Happy Wander *is actually a composite of elements, not one particular scene. Aided by photographs, Koser began by working out his composition in black-and-white sketches. After his fifth study, he had established the basics of the scene. To capture the breadth of the subject, he chose to work on a fairly large piece of paper. The path is a simple device that draws the viewer into the painting; the figure seated at the far left was included to give the painting a personal feel. In* Happy Wander, *Koser used cadmium orange, cadmium red mixed with alizarin crimson, and Winsor blue.*

DETAIL. Koser began this painting with what would become its lightest area, the fence. After splashing it with water, he flicked very pale yellow paint onto it, then pale red and pale blue. In the finished painting, these random drops of light pigment furnish touches of local color. Next he applied a slightly darker shade of blue to the paper with a brush; this traditional method let him control the shadows cast by the sun. After the paint had dried, he covered the entire fence with liquid masking solution, then proceeded to paint the rest of the picture.

Looking at the pale, glistening color of the fence, it becomes clear how gradually Koser builds up his color. The first applications—caught here by the masking fluid—are so light that they are scarcely visible.

DETAIL. To emphasize the shimmering light on the leaves, Koser tried a new technique. While the paint was still wet, he sprinkled table salt over the foliage. As the paint dried, the salt attracted the water and pigment, creating a rich mottled effect. To further break up the foliage, Koser splashed drops of water onto the paper when the paint was almost dry.

DETAIL. When Koser decided the painting needed the personal note a figure would provide, he asked his wife to pose for him sitting on a stool. He sketched her general pose quickly, then worked it into the painting with a small brush. Like many of Koser's accent touches, the resting wanderer is hardly noticable at first, yet it strengthens the warm, intimate feel of his work.

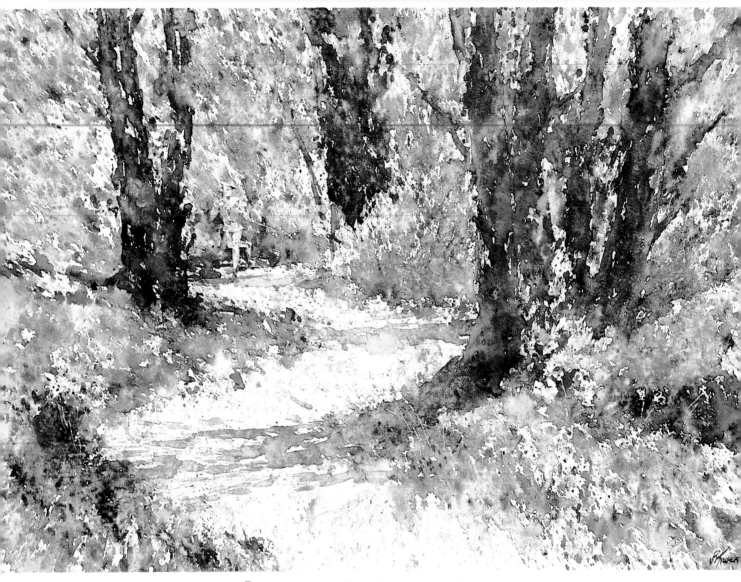

DARTMOOR FOREST

19" × 27"
(48 × 69 cm)
Watercolor on
Crescent-Strathmore
#114 cold press, rag
board
Collection of Mr. and
Mrs. Edward Ginter

Koser abandoned three paintings before he was satisfied with the effect he achieved in Dartmoor Forest. *His composition stemmed from a general concept, carefully explored in five small value studies.*

All the greens, golds, and browns in this work are derived from Indian yellow, alizarin crimson, and Thalo blue. Large areas of the white paper and splashes of bright yellow suggest the brilliance of the early morning sun. Working all over the paper, he flicked many layers of yellow, red, and blue onto the wet surface, building up the structure of the painting and working from light to dark. His first applications of wash were very pale. Gradually he added darker washes, concentrating them on the trees and tree trunks. Koser was careful to leave the sun-dappled path fairly light. Once he had captured its feel, he concentrated his applications of wash on the other portions of the painting. During the final stages, he moved some of the pigment in the trunks and branches with a wet index finger and scratched out some small branches with the brushhandle. When the paint was almost dry, he splashed small drops of water onto the large masses of foliage to introduce more variety into the painting. Finally, to capture shadows on the path, Koser dropped a muted blue wash onto it.

DETAIL. *Looking at the finished painting, Koser found an area that suggested a running figure clad in green. Using a no. 5 round brush and his three primary colors, he added details to draw the figure out. This accent adds excitement to the painting—when the viewer discovers the figure, he shares the sense of mystery and surprise that inspired Koser to paint* Dartmoor Forest.

Suggested Project

Try using Koser's techniques on a variety of surfaces: watercolor board, hot and cold press 140- and 300-pound paper, and all-rag illustration board. Tape each surface down with 1″ drafting tape.

Starting with any one of the surfaces, select a palette of three primary colors and several brushes that will produce drops of different sizes; a natural bristle toothbrush and ½″ and 1″ aquarelles are good choices. First spatter and flick water onto the surface directing the water out from the center of the page. Next, spatter a light value of yellow onto the paper, then red, then blue, again working out from the center. Note how the direction in which you hurl color creates a strong design force, and how the primary colors mix together to form greens, oranges, and purples. Next, working in the same order, apply slightly darker values of the primaries. Try to build up some specific areas with secondary colors; concentrate your applications of yellow and red on one corner of the paper to form orange. In another area, build up purple with drops of red and blue. Don't try to depict an actual subject; just get acquainted with how the splattering works.

Follow the same steps on four more surfaces. Each time, choose a different combination of primary colors and experiment flicking the water and paint in different directions. On one surface, try to have cool colors dominate; on another, emphasize warm hues. When the paint dries, see if you can isolate any sections in the paintings that contain a realistic motif.

For your sixth experiment, select the three primaries that pleased you the most in the preliminary paintings. Make a simple sketch of a floral arrangement or a landscape and decide what direction you wish the paint to follow. Flick the water and paint in that directon throughout the whole painting process. Also decide if you want the finished work to be dominantly cool or warm, and get a good variety of water droplets on the paper. When you start applying the paint, try to give shape to objects you are depicting.

After the paint has dried, remove the masking tape to create a clean, crisp edge. Then see if there are any places that need to be strengthened. Don't overdevelop these accents; use restraint to keep your painting fresh and spontaneous.

MARTHA ARMSTRONG:
DISTILLING THE ESSENCE OF A LANDSCAPE

Despite the freshness and the strong colors that pulse through Martha Armstrong's paintings, there's nothing showy about them. Each one is based on a clear understanding of the formal properties of painting and on a respect for painting itself.

In photographs her works look almost sleek; up close, though, there is a definite sense of paint lying on the canvas. The direct, intuitive way Armstrong works is apparent; looking at her works, you sense that you can discover how each one evolved.

Armstrong feels that only through prolonged exposure to a site can she begin to understand which elements in it are important. Many of her works are views from her studio, which allows her the time she needs to analyze her subjects. After a long period of engagement, she begins to grasp which constellation of information matters. Once she's fully explored a location, the intoxicating feel that drew her to it in the first place disappears. It is then that she moves her studio—something she does every year or year and a half.

In all of her paintings—the small ones and the large ones—the clarity and relatedness of the big areas pull the compositon together. Everything must work harmoniously—line, color, composition, and value.

WORKING METHODS

Armstrong's palette consists of cadmium yellow medium, lemon, cadmium orange, cadmium red, cadmium red deep, cadmium scarlet, permanent rose, cobalt violet, Thalo blue, ultramarine, Thalo green, black, and white.

To apply the paint, she uses bristle brushes nos. 6 to 10 and a palette knife.

For large works, she primes the canvas herself; she feels that it is necessary to support the weight of the paint. On the primed canvas, she does a general charcoal drawing, one that she rarely follows exactly when she begins to paint. Armstrong has found that charcoal mixes quickly with the oil paint and disappears totally unless it has been applied too heavily.

Armstrong mixes her pigment on the palette, but the colors she begins with often undergo changes once they have been laid down. To keep the painting surface fresh and to avoid stirring up the paint that is already on the canvas, she works the new color onto the surface with four or five quick strokes.

No matter how clearly Armstrong understands a subject, a painting rarely turns out the way she plans it. Paintings, she has found, simply see differently than the human eye does. Armstrong wants to translate the reality in front of her to the reality of the the painting surface. All at once, she wants to make every element in a scene vital and clear.

The smaller paintings that Armstrong does are, in part, influenced by the equipment she can carry with her. Most important, however, in working on a small surface is the ability to have quick reactions to the time of day. In many ways, the big paintings are harder. Moved to a larger space, compositional problems become much more difficult.

In North Pond—Reflections, *Armstrong tried to capture as clearly as possible the reflections in water on a still, quiet day. She mixed the basic colors she needed on her palette taking special care to distinguish between the color of the sky and the color of the water and between the color of the hills and the color of their reflections. Whenever subtle color distinctions occur in a work, Armstrong analyzes them carefully before she begins, searching for the little differences that separate large areas.*

Armstrong often goes to a cabin in rural Vermont near North Pond. The shapes and colors she sees around the pond constantly change. In North Pond — with Cloudy Sky, *the intensity of the cloudy sky was what she set out to capture.*

The composition began just as you see it here. On her palette, Armstrong mixed the dominant colors. To hold on to the tonal range, she always kept the whole painting in view, never stopping in just one area.

Once she had made a statement— when everything seemed right—she stopped work on the canvas. Editing what she had done, or rethinking or correcting it, would have ruined the spontaneity of a work whose life depends on just that.

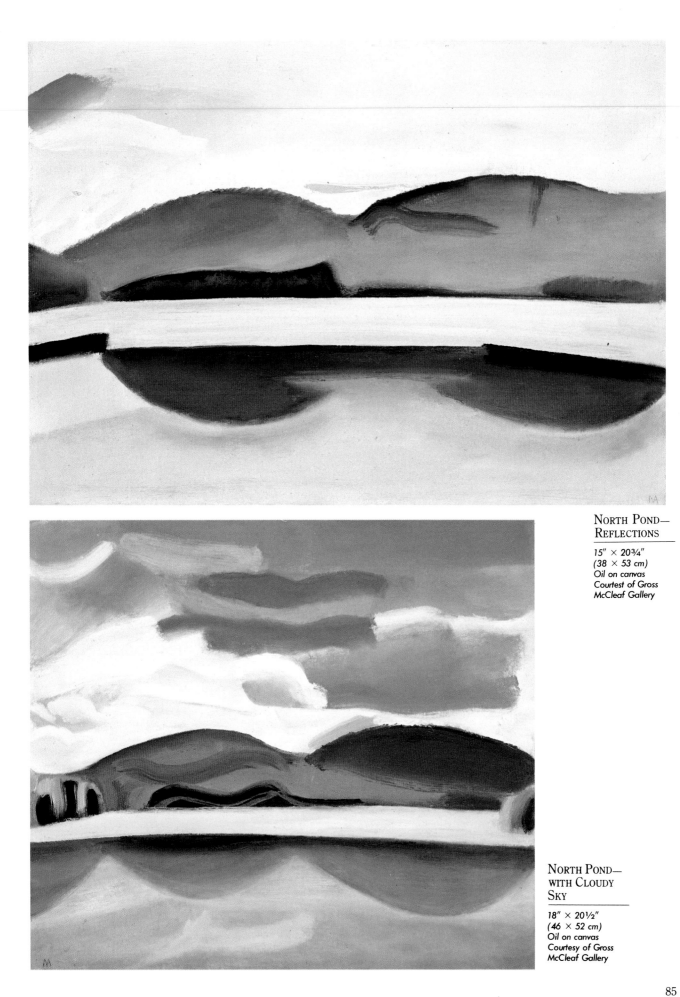

NORTH POND—
REFLECTIONS

15″ × 20¾″
(38 × 53 cm)
Oil on canvas
Courtest of Gross
McCleaf Gallery

NORTH POND—
WITH CLOUDY
SKY

18″ × 20½″
(46 × 52 cm)
Oil on canvas
Courtesy of Gross
McCleaf Gallery

**VERMONT
LANDSCAPE—
MIDSUMMER**

50" × 62"
(127 × 157 cm)
Oil on canvas
Courtesy of Gross
McCleaf Gallery

*This view lies outside the cabin
Armstrong goes to in Vermont. She
liked the horizontals and verticals of the
trees and deck and the way they con-
trast with the angle of the hill and the
studio roof. Because of the complexity of
the scene, Armstrong wanted to make a
big painting, one that she could spend a
lot of time developing. Arranging all of
the information in the scene was diffi-
cult, and many things shifted as the
composition developed. The colors in the
painting changed, too, as she worked
because the light was constantly chang-
ing. The final painting became a collage
of sorts with the characteristic color of
each area holding the work together.*

VERMONT
LANDSCAPE—
LATE SUMMER

48″ × 60″
(122 × 152 cm)
Oil on canvas
Courtesy of Gross
McCleaf Gallery

After completing the first painting of the view from the Vermont cabin, Armstrong wanted to try it again. In the process of painting the first picture, she had become intimately familiar with the landscape, and she wanted to see what would happen if she worked with it a second time. Late summer light changed the colors in the composition dramatically: the fields were more yellow than green, the trees had begun to turn, and the shadows looked different too. Working with this scene for such a long period of time brought home to Armstrong the strong character of the Vermont landscape; she finds it hard to imagine doing a light or frivolous interpretation of it.

Suggested Project

Armstrong approaches small paintings and larger ones from different perspectives. Immediacy—a quick understandng of the space—is vital in the small works while in larger paintings she more slowly comes to understand which elements are important. Try working the way she does.

First, make a small painting of a subject that appeals to you. Put the whole thing down in just a few hours. Do the same scene another day under different lighting conditions, again working on a small canvas.

Next, choose another landscape, one that you can have prolonged exposure to—a view from a window is a good choice. Work on it for a long time and select a large canvas. Have a dialogue with the painting over several days or even several weeks. Keep the whole work in mind each time you approach it: don't get locked into one corner or preoccupied with just one element like color.

Abstracted Landscapes

MARY SWEET: FLATTENING OUT THREE-DIMENSIONAL SUBJECTS

Mary Sweet's bold, flat canvases are packed with strong, richly patterned, abstract shapes. The edges of each form are sharply defined and shifts in color and value occur quickly. There is a bold graphic quality to everything she paints that flattens out the surface that she works on, yet Sweet's paintings carry with them a strong emotional impact. What seems flat at first subsequently reveals the illusion of depth.

The colors Sweet uses seem improbable at first, but she says that she just paints what she sees. It is her particular gift to be able to translate the rough, raw, stark world of the American Southwest into clear and moving images.

Sweet uses acrylic paints straight from the tube mixed on a paper palette then applied with a brush. The blues she paints are usually ultramarine and white mixed with a bit of Payne's gray or purple. The pinks are made up of Acra violet and white, once again tempered with Payne's gray or burnt sienna and/or dioxazine purple. For most of her maroon colors, Sweet uses burnt sienna and dioxazine purple and white. Yellow oxide and white and raw umber and white are mixed for the sand-colored tones. Sweet usually renders her darkest shadows with ultramarine blue and dioxazine purple. For fine lines and other details, she uses Mars black since it spreads well and usually requires just one coat.

Sweet works with round watercolor brushes. The largest is a no. 16; the smallest, a tiny no. 00, comes into play for fine lines. She paints everything freehand. To hold a sharp edge, she rests her hand lightly on the canvas or supports it with the other hand.

To make her paint spread well, Sweet mixes enough water in the pigment to keep it pliable but not so much that the pigment becomes thin. She adds acrylic medium to the paint and water to make her colors more permanent. Because her goal is to establish flat, unmodulated areas of color, she always has to apply two coats of paint. Some colors are more transparent than others and take even more coats to achieve a perfectly smooth, opaque surface.

On her trips to wilderness areas, Sweet takes many photographs and does a number of sketches—a camera and sketch pad are far more practical on a backpacking trip than an easel and paints. Working from the slides and sketches, she draws the major lines of the composition onto the canvas.

The way Sweet approaches the canvas is unusual. She begins at the very top, then methodically works downward, balancing darks and lights as she paints. When she reaches the bottom, she sometimes goes back and adds or removes lines or details. She finds, however, that if she fails to add most of the details as she works, she tightens up at the end and becomes afraid that she will somehow ruin what she's done. If, at the end, she's unhappy with any part of the painting, she redoes it—she's learned not to sacrifice the whole for the sake of a part she happens to like that doesn't work with the rest of the painting.

When a painting seems finished, Sweet moves it from the easel to her living room. There she can view it from a distance of twelve to fifteen feet. She lives with the painting for a few days; when she notices something jarring, she fixes it. Some things bother her immediately, others only gradually. Occasionally everything seems right immediately. Only when everything seems correct does Sweet regard a work as finished.

ABOVE DEER CREEK FALLS

36" × 28"
(91 × 71 cm)
Acrylic on canvas
Courtesy of Meridian Gallery, Albuquerque, New Mexico

In Above Deer Creek Falls, *Sweet captures the exciting feeling of height. The painting stemmed from a trip Sweet took down the Colorado River through the Grand Canyon. The entire Deer Creek area is spectacularly beautiful, but Sweet especially liked the eagle's view of the river that she saw once she had scaled the canyon wall. The tiny boats establish the great distance she had climbed and help convey the euphoric feeling of accomplishment that comes with reaching the top. They also point out how insignificant man's creations are compared with the grand expansiveness of the natural world.*

Because the day was somewhat overcast, Sweet used a subdued range of colors in the painting. A few bold, dark shadowy areas contrast with the dominant light blues and sand tones. Part of the river is an odd yellow ocher, an unlikely choice and one that Sweet struggled with for some time. All of the pale, cool colors contribute to the pacific, benign mood that Sweet wanted to create.

To emphasize the feeling of height and distance, Sweet carefully painted the tiny boats, rocks, and bushes at the bottom of the canvas. Elsewhere in the painting, fewer details are picked out, which helps the eye rush uninterrupted toward the water.

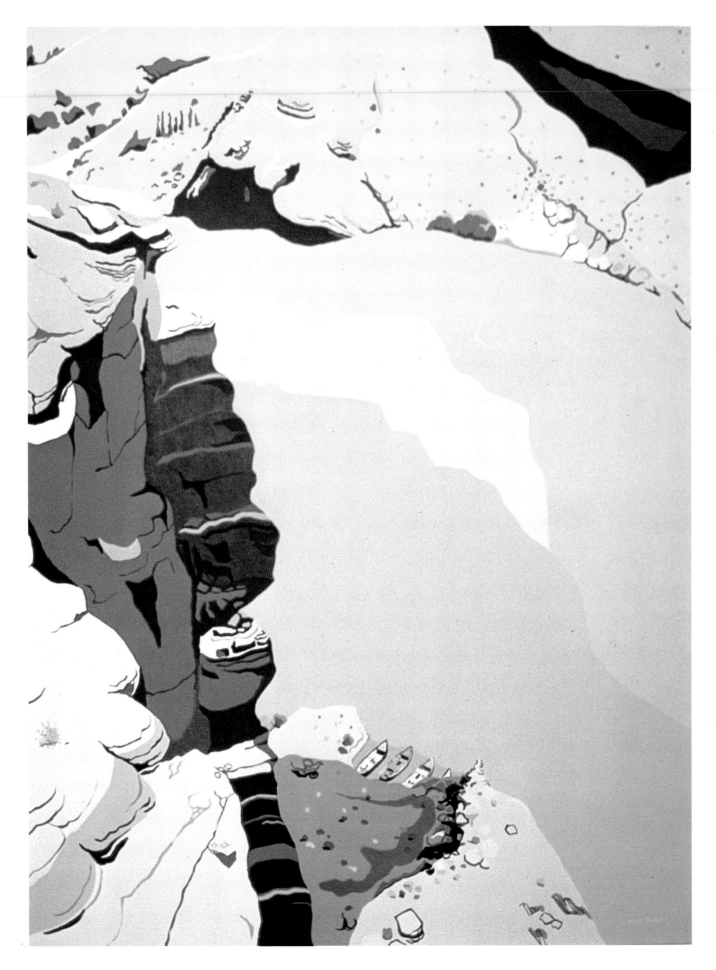

Abstracted Landscapes

SALT CANYON

36" × 48"
(91 × 122 cm)
Acrylic on canvas
Collection of the
artist

In 1981, Sweet backpacked into the Grand Canyon via an old Hopi Indian trail. The way is very obscure and involves scrambling about on loose rocks and climbing down boulders with a heavy pack—a frightening experience. As the day developed, the trail became easier while, paradoxically, the terrain grew more rugged and forbidding. The sky became overcast, making the landscape seem even more menacing. It's that ominous, frightening feeling that Sweet hoped to capture in this painting.

Sweet wanted to keep as much detail as possible to convey the power of the land so she only slightly modified the jumbled strata and piles of rocks. What simplification took place was done to prevent too chaotic a composition. Sweet chose to work on a good-sized canvas because she instinctively felt that so much pattern would overwhelm a

smaller surface. The sharp, crisp edges that Sweet paints help convey the clear light that floods the Southwest, establishing strong patterns of light and dark.

The colors Sweet selected were chosen to develop the ominous theme of the painting; the gray clouds and the gray-toned magentas of the rocks convey the impending storm. The jagged shapes and intersecting lines and planes also get across the quality of the eroded landscape.

What Sweet learned during the execution of this work was not to shy away from complicated patterns. For years, she fought her tendency to paint busy, active subjects—always consciously simplifying what she saw. Now she finds herself choosing complex subject matter again and enjoying the challenge that these landscapes present.

FROM UNKAR TOWARDS HANCE

30" × 38"
(76 × 97 cm)
Acrylic on canvas
Courtesy of Meridian Gallery, Albuquerque, New Mexico

The Unkar area of the Colorado River is one of Sweet's favorite spots on earth, a beautiful place where the hills are magical shades of red, pink, maroon, and purple. The Canyon is wide at Unkar, with an open feeling and long views in all directions. Sweet wanted to capture the unspoiled beauty of Unkar, its unusual colors, and the crisp light that washes over it. Because color and form are the most important elements of this landscape, Sweet concentrated on them.

When Sweet began, she didn't intend to emphasize pink tones. As the painting evolved, however, she found that the pinks, mauves, and maroons became more and more dominant. The sky is a pale yellow and the scraggly bushes a cool green. Bits of yellow oxide and brown figure in the details.

Sweet finished From Unkar Towards Hance without a bit of agonizing. It conveys just what she set out to show— the wonderful feeling of joy, color, and spaciousness that characterize Unkar. Unlike many of her paintings, most of the shapes in this work are soft and rounded, which helps create a feeling of peace and quiet joy.

HAVASU
CANYON

48" × 60"
(122 × 152 cm)
Acrylic on canvas
Private Collection

Havasu Canyon is known for its beautiful clear blue-green water, but when Sweet first saw it, it had been raining off and on for days and the creek was running red, swollen with mud. Suddenly in the afternoon, the sky clouded over again and thunder reverberated throughout the canyon. All at once, the creek was roaring with a flash flood; water lashed at the boats and rockslides rained down the canyon walls. The terror that Sweet experienced as she was caught up in the violence of the storm inspired her to paint this work.

To get across the drama of the scene, she chose a large canvas. Because the setting was filled with such a multitude of tonalities and taken from an unusual perspective, Sweet did something she rarely does—a small preliminary painting on paper. In another unusual step, she began painting the large canvas not at the top but with the boats. She knew they would be difficult to execute and that their details had to be crystal clear. When she finished them, she worked outward; the top of the canvas was completed last.

The largest section of water is painted with red oxide. Shades of pink indicate rays of light hitting the parts of the creek most covered in shadow, and the dark purplish tones of the rocks form a sharp contrast with the water. Sweet was especially careful to regulate values here since the scene could so easily become too dark.

Just as the colors make the scene seem cold and forbidding, the composition captures an ominous feeling. The canyon walls press in toward the boats, creating a closed, almost claustrophobic effect.

Suggested Project

Try using Sweet's method: instead of working all over a canvas and saving details for the very end, start at the top, finishing each section as you work downward. Although you may not want to stick with this method forever, it will help you look at landscape painting from another angle. Every time you begin a new area, carefully consider what color to use next and how dark or light its value should be. Think, too, about the warmth of your colors, how adjacent areas of color will work together, and how much detail each section can carry. You may discover that your finished painting is more unified than ones you've executed in a traditional way.

DAVID FERTIG:
EXPLORING THE FAMILIAR

David Fertig focuses in on what he knows the best—the land right around his home in New Jersey, and especially his garden. When he was younger, he searched for a variety of motifs and subjects. Gradually, though, he learned that what mattered most to him wasn't what he painted; it turned out to be the paintings themselves. Fertig's studio is one with doors that slide open onto the garden. For a year or so he explored the garden in a series of small oils. When he moved on to the bigger paintings seen here, he wanted them to have the same intimate feel that he had achieved in the small works.

Before he began painting the series of large canvases, Fertig had visited Florida. Mentally he carried the lush foliage that had surrounded him there back home, where it helped him to amplify the spring greens that flood these paintings.

WORKING METHODS

Fertig's palette is built of many colors, many of them imported from Europe: cadmium yellow, Naples yellow, lemon yellow, Aurora yellow, bayrete yellow, cadmium red, alizarin crimson, rose doré, geranium lake, yellow ocher, raw sienna, burnt umber, composte green, oxide of chromium, cadmium green, viridian, cerulean blue, cobalt blue, Prussian blue, rex blue, ultramarine and French ultramarine, indigo, peach black, Mars black, and three different whites—titanium, flake, and cremnitz. Although he has hundreds of brushes, he works primarily with filberts and sables. The softness of large watercolor brushes is perfectly suited to his painting style.

Fertig never uses the color right out of the tube, nor does he mix paint on the palette to get exactly the color he wants. He starts by selecting the approximate color he needs. At this point, the paint has a lot of turpentine in it. Once it's on the canvas, he uses a rag to move it about, and if it doesn't look right, he starts over.

As he paints, he intuitively adds other colors to the first one he put down. So much paint ends up on the surface, and so much erasing and covering up take place, that the first color usually disappears.

Many of the pigments that Fertig uses are expensive. Years ago he started adding paint extender to his colors just to save money. Here a matter of economics led him to an important discovery: the extender creates an easy matte surface on which to work, and it alters the way the dark areas look in the finished painting. These dark colors catch light differently, becoming less reflective and bringing an increased sense of depth to the dark areas.

JULY

Oil on canvas
50" × 72"
(127 × 183 cm)
Private Collection

July is one of a series of large paintings that Fertig executed in 1980. He had never before worked on so large a scale directly from life.

As the painting developed, Fertig struggled with the center of the composition; until he added the figure, it seemed incomplete. While he painted, his wife was working in the garden and for a few days he asked her to walk in and out of the picture. Fertig placed her in different areas. Once she was down near the bench in the lower right corner; her hat is still there in the finished work.

This painting began as a studio work; he started there looking out to the garden through the partially closed studio doors. Fertig was so happy with the quality of light he was capturing that he gradually opened the doors farther and farther, letting the view of the garden take up the entire composition.

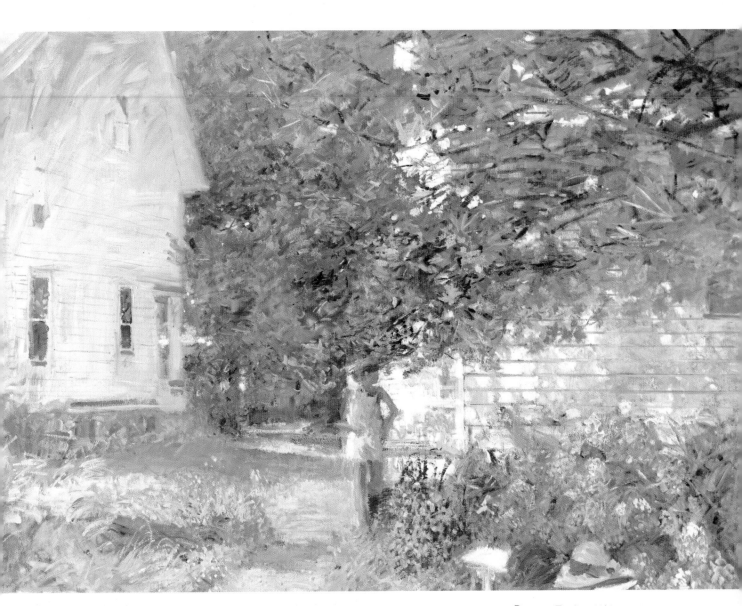

DETAIL. *Fertig added these hydrangeas to the painting to provide a strong note in the foreground. Like the rest of the work, they are built up of soft, rich layers of oil and paint extender. Because Fertig uses so much paint and because he pushes and pulls it across the canvas fluidly, very few harsh boundaries end up in the finished work. He softens even the most concrete of elements—here the hat—by gently breaking up their outlines.*

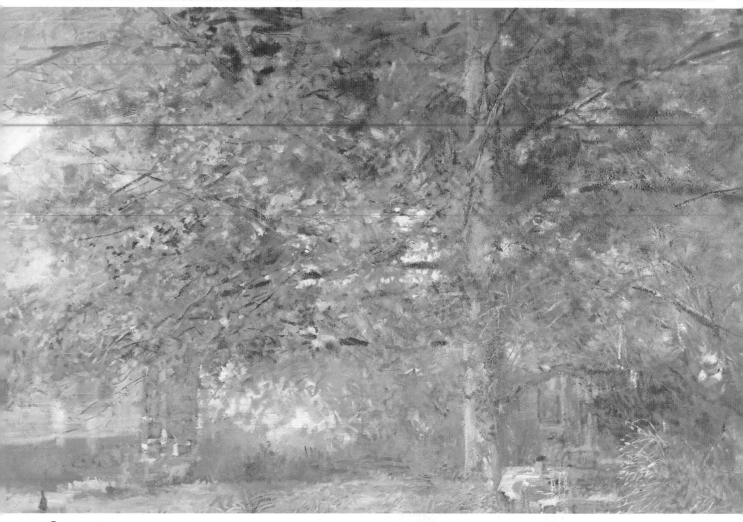

**SEPTEMBER
WEATHER**

Oil on canvas
55″ × 84″
(140 × 213 cm)
Private collection

September Weather *lost its way many times. In it, Fertig tried to get as far back as possible from his motif so he could paint almost the entire tree. The enormity of the tree turned out to be the work's most difficult problem.*

The top ten inches of the canvas just never felt right to Fertig. In fact, for a while he was tempted to crop them off, but that would have made the surface too strongly horizontal. In the end, he left the area slightly unresolved.

DETAIL. Fertig laid in this sunstruck portion of the building with thin washes of oil and turpentine early on in the painting process. As he developed the darker greens and blues that run throughout the painting, he worked around this area. As he turned to the darker colors that run into this light area, Fertig used, once again, thin oil washes, retaining much of the original light wash to suggest the one spot in the painting where the sun strongly breaks through the foliage.

SKETCHING

Oil on canvas
62″ × 76″
(158 × 194 cm)
Private collection

Sketching is the kind of painting all artists dream about. From beginning to end, everything worked out and fit right into place. When Fertig put the vase of flowers in the foreground, he knew immediately that the placement was correct. The painting took him just three days. In Sketching *and in all of his works, Fertig controls the tonal values by squinting. He believes that when you squint objects lose their identities and you can better judge what is light and dark.*

Because Fertig applies the paint with such loose, expressive brushstrokes, and because he never defines objects with clearcut lines, he is very aware of focus. Somehow he has to clearly establish the space in the painting. He finds that a strong foreground—here defined by the vase, table, and tree—makes the rest of the painting come into sharper relief.

Suggested Project

Don't be too selective about your subject matter at first. Go outside and make your hands form a rectangle. Looking through the rectangle, try to frame a view that pleases you. When you start to paint, be true to everything you see. Use a small canvas, one about 9″ by 12″.

As you work, the light will change. Don't try to capture how it looked when you started; get rid of your original conception and keep pace with changes in light and atmosphere. With a little experience, this isn't as hard as it seems. You'll start to know what changes to expect. Observe the landscape in a disinterested way; look for the large shapes and patterns of light. Start slowly, then, toward the end, speed up and capture how the light looks at that moment.

DANA VAN HORN:
LANDSCAPE RENDERED WITH PASTELS

For Dana Van Horn, landscape is a welcome, refreshing relief from the figural oils he concentrates on during the day. His pastels are direct and unstudied, rarely based on preliminary sketches. To summon up the feeling that a scene originally provoked in him, he occasionally refers to a photograph taken on the spot.

His choice of subject matter is intensely personal. Drawn to places that he would like to live in or be part of, he also prefers landscapes that have a dynamic sense of light and movement. Because of the brilliance and opacity of pastels, he finds them perfectly suited to recreating extraordinary light and color situations.

The luminosity of pastels fascinates Van Horn. Light strikes a surface rendered with pastels quite differently than it hits a painted one. At the same time, though, Van Horn finds that a work in pastels can be developed to the same degree as an oil painting.

WORKING METHODS

Van Horn uses Rembrandt pastels. He likes their feel—they don't seem to crumble as much as other brands do. Frequently he lays the pastels onto a prepared surface, rag paper treated with gesso and pumice. The pumice lies suspended in the gesso, which he usually tints with water-soluable pigment. As he brushes the mixture evenly over a piece of rag paper, what he is, in effect, creating is very fine sandpaper, a surface with enough tooth to grab the pastels.

He begins by sketching in the elements of the composition with a white chalk pencil. That done, he begins work. Pastels crumble as they are applied, depositing a thin film of dust on the paper below the area that is being worked on. To keep his surface from becoming dirty, Van Horn begins at the top of the paper, then works downward. Pastel dust, then, never disturbs an area that he has already drawn. If mistakes occur, he picks up the pigment with a gum eraser, a technique that works with all but the darkest colors. He begins working light to dark, then toward the end, works from dark to light.

At the end of a work, Van Horn decides if he must fix the pigment. If it's not too built up, the chances are that it won't sift. Usually, however, some spraying is necessary. But spraying a surface rendered with pastels changes both its color and luminosity. To get around this problem and restore the "light" to the picture, Van Horn sprays the work, then reworks the portions that have been seriously altered. As he refines an area, he sprays it again. He finds that the second application rarely affects the color as much as the first.

UPSTREAM, FALL

24" × 32"
(61 × 81 cm)
Pastels on Canson
Me Teintes tinted
paper
Collection of Mr. and
Mrs. M. Stephen
Doherty

In Upstream, Fall, *Van Horn succeeded in overcoming two of his prejudices. First, the sky is a cool, even gray, where he is usually drawn to brightly lit situations. Second, there is nothing in the foreground to grab the viewer's attention; he usually likes to have a strong element right in the front of the picture plane.*

To capture the overall color mood of the place, he chose paper tinted dark gray. Because grayish tones were so prominent in the actual scene, he de- cided to let more of the paper's color show than he normally would. Finally, he kept the value scheme closely tied to the value of the gray paper. It provided a constant reference against which he could compare all the other values.

Here most of the colors are natural earth tones. Rather than trying to find exact colors for specific areas, he quickly chose colors that were nearly correct. Later he adjusted the color relationships to make all the parts work together as a unit.

LANDSCAPE WITH OAK TREE

*38" × 50"
(97 × 127 cm)
Pastels on rag paper
prepared with gesso
and pumice
Courtesy of Southeast
Banking Corporation,
Miami, Florida*

Here Van Horn was attracted not only by the beauty of the huge old tree, but also by the way its branches framed the distant landscape. He wanted to portray the drama of being so close to a dominant form yet still being able to look through it to the vistas that lay beyond. To keep the tension built up between the foreground and the background, he used strong dark colors for the tree and less saturated ones in the background.

In the close-up, notice that the strokes used to depict the tree's branches and foliage are stronger and more assertive than those used in the distance. Each is laid down with a slightly curving motion, making the whole tree seem to vibrate with color. Instead of dragging the pastel and making lines, Van Horn tends to stipple the colors on with a series of short strokes that look like dots or commas. What he achieves is a richly textured surface.

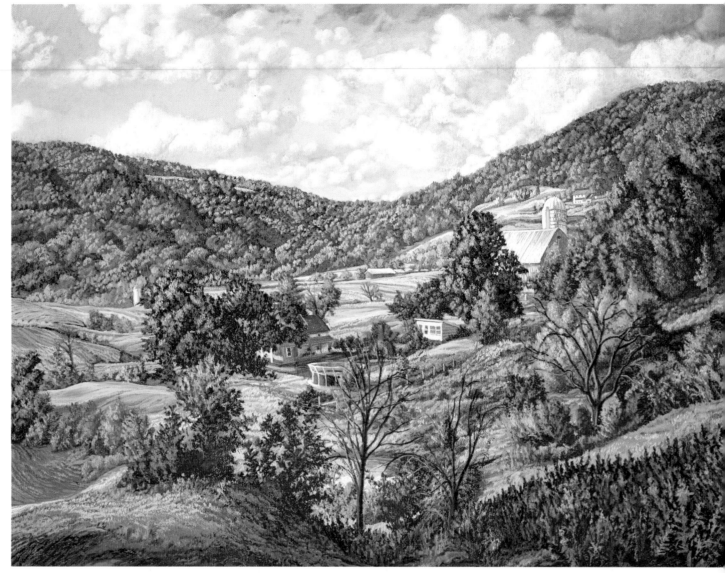

EASTON FARM LANDSCAPE

38" × 50"
(97 × 127 cm)
Pastels on rag paper
prepared with gesso
and pumice
Courtesy of Chemical
Bank, New York

This scene is based on an actual landscape, a place where Van Horn would like to live. In particular, he likes the way the barn sits on a knoll above the house, and the intimate feeling created by the trees that cluster around the house. As his composition developed, he found that, surprisingly, the above-ground swimming pool became the focus for the whole work. He added the small pond in the foreground to act as a foil against the pool and to strengthen the work's composition. Other compositional changes he made include

exaggerating the size of the distant hills to make the valley seem smaller and more intimate, and increasing the angle of the slopes in the foreground to add interest to the work.

In priming the paper, Van Horn mixed pinkish pigment in with the gesso and pumice. The toned ground that results suffuses the entire picture with warmth. More than just that, it tends to make neutral tones look greenish—important in a rolling landscape like this one.

The greens in this scene were a chal-

lenge to Van Horn. He finds it extremely difficult to be faithful to a landscape when vibrant greens play so large a role. Too often, the colors end up looking artificial. In addition to the toned ground, his solution was to gray the greens down with complementary colors.

With landscape, Van Horn prefers to work on scenes set in the middle distance. Sometimes—and this painting is an example—he forces himself to choose a panoramic scene to overcome this prejudice.

Patterns That Lie in Nature

WILLIAM MCNAMARA: BUILDING AN ILLUSION OF SPACE FROM INTRICATE DETAIL

The endless variety of abstract patterns found in nature fascinate William McNamara. Over and over again in his paintings, he explores how color, light, and shadow meld together, creating subtle yet complex designs. He chooses his subjects intuitively, rarely stopping to analyze what has drawn him to a particular spot, yet all of his works share a preoccupation with color and shadow, positive and negative space, and opacity and transparency.

WINTER WATERFALL

15" × 22"
(38 × 56 cm)
Watercolor on 300-pound paper
Courtesy of Capricorn Galleries, Bethesda, Maryland

The sheet of drawings at right traces the first steps McNamara takes when he selects a subject. Working rapidly, he tries to capture the essense of a scene—here recession into depth as well as the pattern of darks and lights. The drawing on the lower right side is more detailed than the other three. In it, McNamara explored the value scheme he would use in the painting.

Winter Waterfall was the last in a series of snow paintings that McNamara executed; in it, he used more color in the snow than he had ever attempted before. The work has a stronger sense of depth than most of his paintings, too, yet again deals with pattern; here the patterns created as light play on the uneven surface of the snow.

He began the painting by establishing the darks; he used a very pale wash of Van Dyke brown applied with broken strokes over the entire surface. Layer upon layer of broken strokes were applied on top of this underpainting as McNamara picked out forms and patterns with his brush. Here as a final step he pulled portions of the surface together with very subtle washes of pale blue.

WORKING METHODS

McNamara's palette varies from painting to painting, often depending on what he has at hand. Among the colors he uses frequently are Van Dyke brown, burnt and raw sienna, Naples yellow, lemon yellow, chrome yellow, cadmium yellow, yellow ocher, Hooker's green deep, Prussian blue, cerulean blue, cadmium orange, and Winsor red. Occasionally he adds a few purples; he never uses white or black. He works with just one brush—a high-quality red sable no. 12—on linen-rag 300-pound cold press paper.

McNamara usually begins to explore a subject with sketches. The first ones are quick action studies. Once he has grasped the essence of a subject, he spends several hours working up a more finished drawing, one that captures the compositional plan and the value scheme.

On the watercolor paper, McNamara executes another detailed drawing, one that acts like a grid for him when he starts to paint. Underpainting is McNamara's next step.

Because the drawing contains so much information about the placement of the various compositional elements, he is free to react loosely to what he sees. Typically he uses a very light wash of Van Dyke brown when he starts laying in the darks. He works all over the paper, laying down short, pale strokes, trying to achieve a balanced feeling. Once the initial underpainting is complete, he begins to add other colors, again putting down layers of soft, broken strokes of pale color. He mixes his colors on the palette, carefully regulating the amount of water he uses in each wash. He controls the water content by wiping his brush on an old diaper, usually keeping his brush dry enough for precise work yet wet enough to keep the color transparent. He always lets the color dry before he applies another layer of paint. McNamara reserves the lightest areas for last. At the very end of a painting, he sometimes pulls a pale wash over a whole section to unify it and to strengthen the color theme.

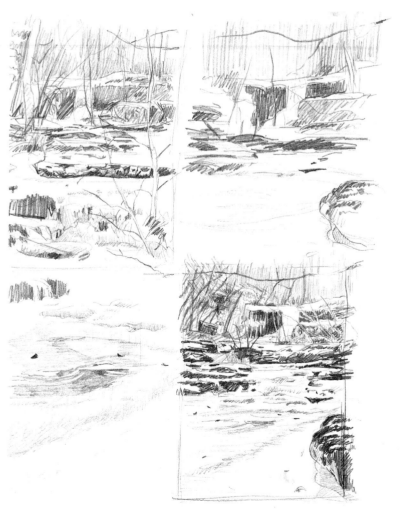

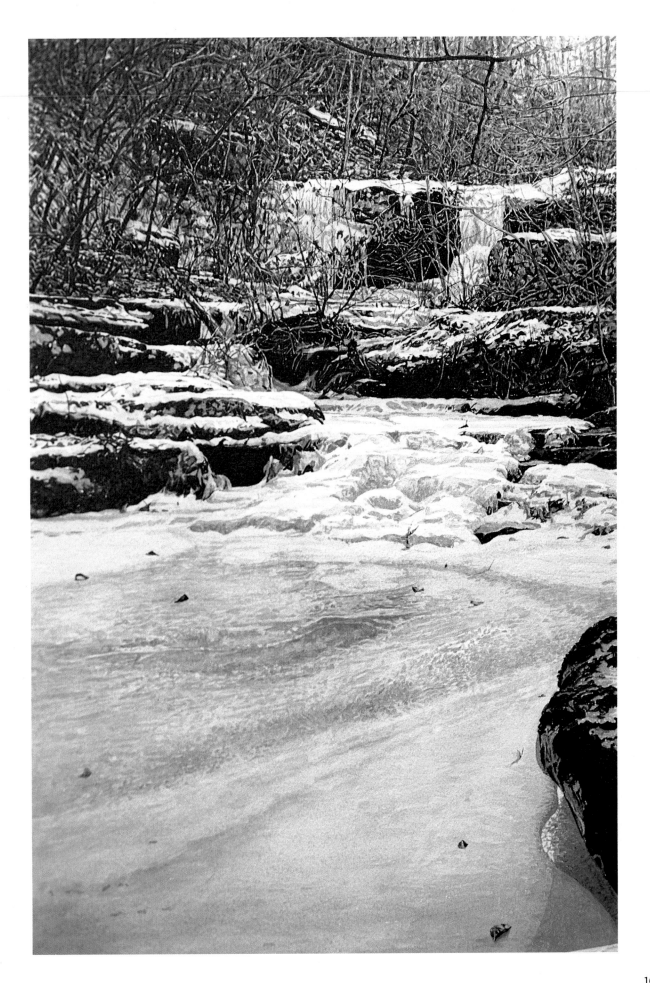

Patterns That Lie in Nature

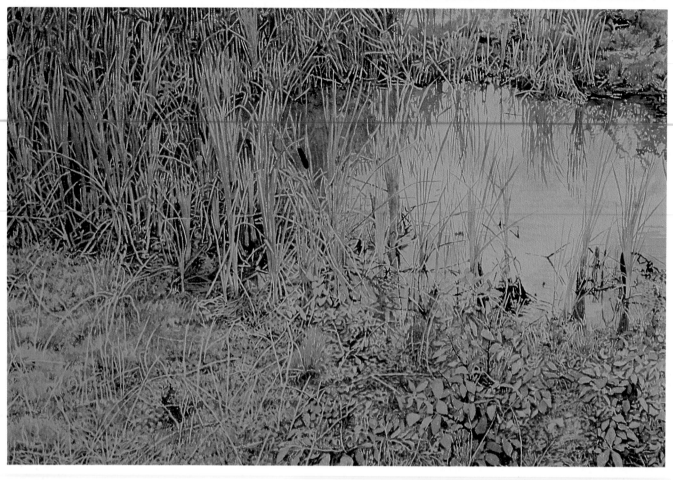

LATE SUMMER CATTAILS

*15" × 22"
(38 × 59 cm)
Watercolor on 300-pound paper
Private collection*

McNamara began this painting by laying in a light wash of Naples yellow underneath the area of water. After letting it dry overnight, he began picking out the darks with burnt sienna. The yellow warms up the blues that were subsequently added without making them turn to greenish.

In the detail, McNamara painstakingly worked around each blade of grass, leaving them pure white until almost the end of the painting process. It was the first time he had attempted to use negative space to such an extent. He finds that he can produce exceptionally fine lines by painting along both sides of a thin form rather than by painting the form itself. Very pale ocher washed over portions of the painting at the end warmed up all the cool colors and united the innumerable small strokes that McNamara had applied as he developed the painting.

EARLY AUTUMN

15″ × 22″
(38 × 59 cm)
Watercolor on 300-
pound paper
Courtesy of Moulton
Galleries, Fort Smith,
Arkansas

What McNamara thinks of as "pattern-less pattern" fills Early Autumn. *Each element in the picture—each leaf and tree trunk—is recognizable by itself. Massed together, however, they form an endless variety of complex patterns. For McNamara it would be a hopeless task to copy each detail literally. Instead he responds intuitively to the whole scene.*

After he had completed his preliminary sketches and drawn a fairly elaborate sketch on the watercolor paper, he began to lay in small strokes of very pale Van Dyke brown all over the paper, concentrating on the darks. He paid no attention to any particular detail; instead, he looked at the scene in an unfocused way, searching for grada-

tions in value. When he began to add more colors—here a large spectrum of hues ranging from pure red to pure green, with almost every intermediate combination—he was careful to work around the lights. For example, the blades of grass in the lower left corner were kept white until almost the end of the painting. As he built up the layers of washes that cumulatively make up the autumn leaves, he used a broader range of color than he had ever attempted before. Some leaves still have the fresh green of summer, others the full colors of autumn; in some places the foliage is heavy, in others the backlit leaves seem almost transparent.

Patterns That Lie in Nature

REFLECTIONS

22″ × 30″
(59 × 76 cm)
Watercolor on 300-
pound paper
Courtesy of Capricorn
Galleries, Bethesda,
Maryland

Highly refined drawings like the one at right take McNamara several hours to complete. In them, he works out many decisions that would otherwise confront him when he begins to paint. Here he established the strong darks that play so large a role in the final painting and thought through the rich patterns that rush across the whole composition.

McNamara's love of spatial illusion is revealed in Reflections, *below. Here he is depicting water that has gathered on a flat, rocky surface at the top of a waterfall near his home. The water is less than an inch deep and in spots the rocks protrude. In the painting, the patterns he has pulled together flatten the picture plane, but the viewer has enough clues to translate the flat paper surface into a three-dimensional image.*

DETAILS. *A. In the lower left-hand corner of* Reflections, *blades of grass indicate the space above the water. The floating leaves and the bubbles create the surface plane.*

B. The thin tree trunks at upper left carry the eye up and out of the painting, while the reflections of the leaves on the water and the rock that lies beneath the surface of the water bring it back down again and provide a feeling of depth. The overall patterns delight the eye and create a situation that can be played with endlessly.

Suggested Project

McNamara compares the painting process to riding a bicycle; when you are on a bike, your mind is scarcely aware of balancing it, directing its handlebars, turning the pedals, watching the road ahead, or listening for traffic. While you're negotiating all of these complex actions, you can easily think about other things. He suggests that you learn how to apply paint instinctively, without thinking too much about what you are doing. Get your hand to respond to your eye directly. Try this: Sit in front of a landscape. Looking at its center, unfocus your eyes—try not to look at anything in particular. Slowly become aware of the shapes within your unfocused field of vision. Then, looking down at your watercolor paper, draw the shapes in their appropriate places with a light pencil. Try to have the first six or seven shapes you see distributed over the paper, not concentrated in one spot. Continue until your paper is filled with forms. Now repeat the process, this time filling in the shapes with light washes of color. Don't worry about how the washes look at this stage; choose colors that are close to those that you see and work loosely and quickly. You will probably find that the color you are putting down is quite simplified compared to the focused landscape.

Now take your painting home with you and spend some time just looking at it. Try to find images among the shapes that strike you as realistic. Let your eyes play about freely, without worrying if the shapes correspond to the actual scene. Finally, bring out those images that you have discovered with your brush and paints. What you can gain from this exercise is the ability to capture the overall sense of a landscape and its patterns freely, without consciously thinking about what you are creating.

Patterns That Lie in Nature

BRUCE MARSH:
PAINTING THE AQUATIC ENVIRONMENT

Bruce Marsh is fascinated by the baffling process of perception. For the past ten years, he's painted water almost exclusively, a subject he has chosen, in large part, because of the way it transforms color, form, and light.

The complexity of an aquatic surface is extraordinary. When you look at a brook or at a tidepool, your mind receives one clear image. But when you try to record that image in paint, you come to realize how, unconsciously, you have synthesized all the bits of information you have taken in. To render it, you must analyze it bit by bit. Yet, as Marsh's work attests, the labor and difficulty of the process are well worth the effort.

Marsh begins on the most mundane level. Is an area transparent or does it reflect light? Is he working with a solid or a void? The difficulty lies in the wealth of details that must be interpreted. An entire world lies in every few square feet of water, and all its myriad details must be organized in the painting process.

This kind of complex painting obviously takes days, or more often, weeks. To crystalize one specific moment Marsh typically works from photographs. Armed with a camera, he explores his favorite sites—Pacific tidepools, a creek in California, North Carolina's streams, and Florida's rivers. At every site he scouts, Marsh looks for new situations—combinations of transparency and opacity that he hasn't seen before and that spark excitement in him.

Marsh works with a limited palette. In his watercolors he uses cadmium red light, ultramarine blue, cadmium yellow light, alizarin crimson, permanent green light, and cadmium orange. For his oils, he adds white.

The watercolors are done with just one brush, a Winsor and Newton series 7, sable no. 14. For the oils, he works with flat synthetic brushes ½″, 1″, and 3″ wide.

When Marsh discovers a promising site, he photographs it in depth. Once the films are developed, he makes his selection based on the strength of color and composition and on the clarity of information one particular image contains. When he is working in watercolor, he sometimes works from life. Even with watercolor, however, he has discovered that in complex situations under changing light conditions it is difficult to develop a work fully out-of-doors; often he finds himself unable to capture the feel of transparency or the excitement that a complex series of visual impressions arouse in him.

Both oil and watercolor painting absorb Marsh; he works on one for several months, then switches to the other. Each offers something in particular and he approaches them in a different spirit.

In oil, he begins with the entire surface. Working with a 3″ housepainter's brush, he establishes the whole composition with thin washes. It typically takes Marsh three weeks to bring all the parts of a painting into equal focus; as he works, he struggles with and adjusts color, drawing, texture, and scale.

After several months working in oil, Marsh switches to watercolor. Here his process is just the reverse of his oil painting. He begins with one specific form—a twig or a stone, for example—and then slowly builds the painting up as he accumulates details. He does not allow himself to paint light areas; instead, he forces himself to paint the darker shapes that surround it. In the end, he wants the darks and lights to weave together fluidly, with neither dominating.

RIVER WEEDS

48″ × 48″
(122 × 122 cm)
Oil on oil-primed linen
Private collection

Working from three separate photographs, Marsh begins by roughly drawing in the major lines of the composition. Translating the information contained in photographs onto a large surface can be difficult. Things don't usually fit exactly, but in the end, Marsh finds that the little differences don't matter. He has discovered, too, that changes in color always occur; the initial photograph is quite different from the final painting. In the end, the color's range and purity are much more intense in the oil.

A painting begins with enthusiasm, a delight in the possibilities that lie in store. Toward the end of the work, the painting process can be equally fascinating; the color starts to develop and Marsh slowly adjusts it. It's the middle period that is hard—the two or three weeks that lie between the initial enthusiasm and the final fascination. Then painting is a struggle; things seem as though they will last forever.

TIDEPOOL II

22″ × 30″
(59 × 76 cm)
Watercolor on
D'Arches 300-pound
rough paper
Private collection

WATERLIGHT

48″ × 48″
(122 × 122 cm)
Oil on oil-primed
linen
Private collection

Marsh's first oil washes are almost ninety-nine percent turpentine. All he is trying to establish is where the details lie. If mistakes occur as he works in these very pale forms, he can dip his brush in turp, then wash them away. This stage takes an hour or two.

Next he tries to bring all the parts into equal focus—a complicated process that lasts two to three weeks. Starting with the major dark shapes, Marsh makes three or four passes over the painting. With each pass, he gradually introduces more opaque paint. He pursues the areas that are most disruptive until he brings them under control. Sometimes he focuses in on one portion of the painting—the lower right quadrant, for example. As he paints, he constantly makes small adjustments in color, line, and texture.

After working for months with oil, Marsh finds it a pleasant change to turn to watercolor. Although the media are quite different, he's found that the lessons learned in one may translate easily to the other. In watercolors like this one, for example, Marsh works around the lights, forcing himself to recognize fine gradations in value. Eventually, he has found that he now brings the same consciousness of light and dark to his oils.

Marsh begins his watercolors with one specific form, then slowly builds up the painting with an accumulation of detail. The first washes of color are very pale; even shapes that may, in the end, be almost black, begin with light transparent color. These light washes give Marsh great flexibility; he doesn't become locked into a value scheme right away. The interplay between warm and cool colors was of paramount interest in this work.

Patterns That Lie in Nature

DOUGLAS ATWILL:
WORKING WITH LARGE-SCALE PATTERNS

Douglas Atwill is attracted to situations in which totally different elements meet head-on. He prefers to paint locations where meadows collide with woodlands, where snowfields run into areas of grass, or where rocky outcrops stand against streams coursing with water. For Atwill, the strong and unexpected patterns formed in these areas are far more interesting than those he might encounter in a dense forest or an endless field of grass. The land around his home in Sante Fe, New Mexico, provides him with a wealth of this subject matter.

In most of his works, the horizon line is set high on the picture plane. References to the sky may occur in a reflection in the water or a wedge of blue in an upper corner; sometimes he even adds a section of sky to a painting long finished, just to give the eye a way out of the canvas.

Atwill often executes a series of paintings based on one motif that he has captured in photographs. Typically he shoots several hundred exposures of a single scene. He crops the pictures, sometimes focusing on just the center or one side, changing anything that he thinks will strengthen his composition.

Atwill's paintings are bold and meant to be seen from a distance. Looked at too close, their overall patterns disappear and the fresh, unexpected way he frames his compositions is lost.

WORKING METHODS

Atwill's palette consists of almost every color available; including all the earth colors, all yellows, Hooker's green deep and light, permanent green, bright red, all the cadmium reds, napthol red light, and dioxazine purple. Up to this point, he has found little use for the phthalocyanines or for black.

His brushes are of all sizes and shapes. Before he begins to paint he fills up to ten jars with water so he can thin his paint quickly when he needs a transparent wash. Atwill lays his acrylics onto canvas or linen. For the past few years, he has favored three general sizes. For small works, he chooses a 12- or 16-square-inch surface. This size is well-suited to quick, spontaneous sketches in acrylic; he uses a fairly large brush here to keep his strokes loose. For medium-size paintings, 40″ × 42″ is ideal—it's easy to work on without raising and lowering the easel. Atwill often finishes a 40″ × 42″ painting in a single morning. Right now, his favorite surface is 54″ × 58″, a substantial size for a painting. He likes the slightly off-square size and feels that it's suitable for most of his motifs. Turned on its side, this size has a strong horizontal feel, while left upright, it appears almost neutral, much more so than a perfect square.

Working from a photograph, Atwill uses a flat brush and a mixture of ultramarine and burnt umber to sketch in his design on the canvas. Next, he lays in his underpainting. In snow scenes, he usually underpaints the snow with deep violet or bright blue, or even a bright pink or brownish-yellow if he wants a warmer final effect. For the remaining colors in the composition, he underpaints darker or brighter tones than those he will eventually want. This first stage looks almost like a negative image of the final work.

As he builds up the painting, Atwill washes the areas of snow with translucent white tinted with various colors. If the underpainting is blue or purple, he preserves it to depict shadowy areas. Next, he tries to bring all the portions of the canvas up at the same time. He lightens some darks, subdues the brights, and in places changes the actual hues.

For large transparent washes, he thins his acrylics with water; for a glossier feel, he mixes acrylic medium in with his pigment. In the final painting, he wants the finish to vary from area to area. Some parts should be slightly glossy, others very flat. He never varnishes his works.

Atwill always begins work at the top of a canvas. He paints with a mirror on the wall behind him and often turns the canvas upside down to complete the top half. He finds that by viewing the image backwards or upside down he can see patterns more realistically. Often he discovers some patterns that he had missed when looking at the work straight on.

BIG TESUQUE
SNOW I

Acrylic on linen
26″ × 26″
(66 × 66 cm)
Private collection

The size here—26-square inches—was a new one for Atwill, one dictated by the remnants of three rolls of linen; with the linen he had on hand, he could stretch about ten small surfaces this size. Because the painting is fairly small, it was finished in one session. Atwill worked from several photographs and a small sketch. As in many of his works, the strength of the composition is poised on the strong diagonals that dominate its design.

DETAILS. A. The lower left-hand surface of the painting was left relatively flat and undefined. On top of the grayed-down tan color, Atwill laid in bold strokes to suggest movement and direction.

B. Atwill painted the trees in the background with a flat, dull shade of brown. He laid them in quickly, using a fairly dry brush; in places, the white of the snow that lies beneath the trees breaks through, giving his strokes a rapid, calligraphic quality. When Atwill had finished the brown trunks, he accented them with touches of the darker and glossier acrylic that figures so prominently in the foreground.

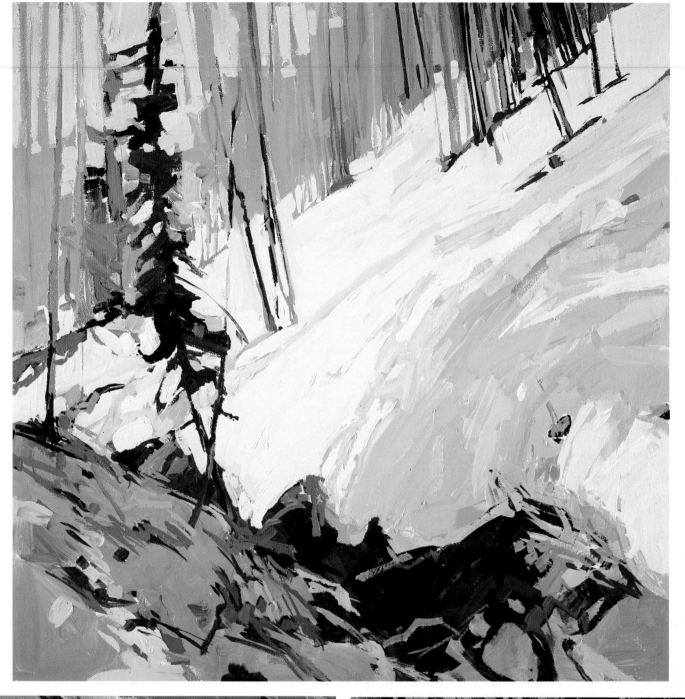

A

B

Patterns That Lie in Nature

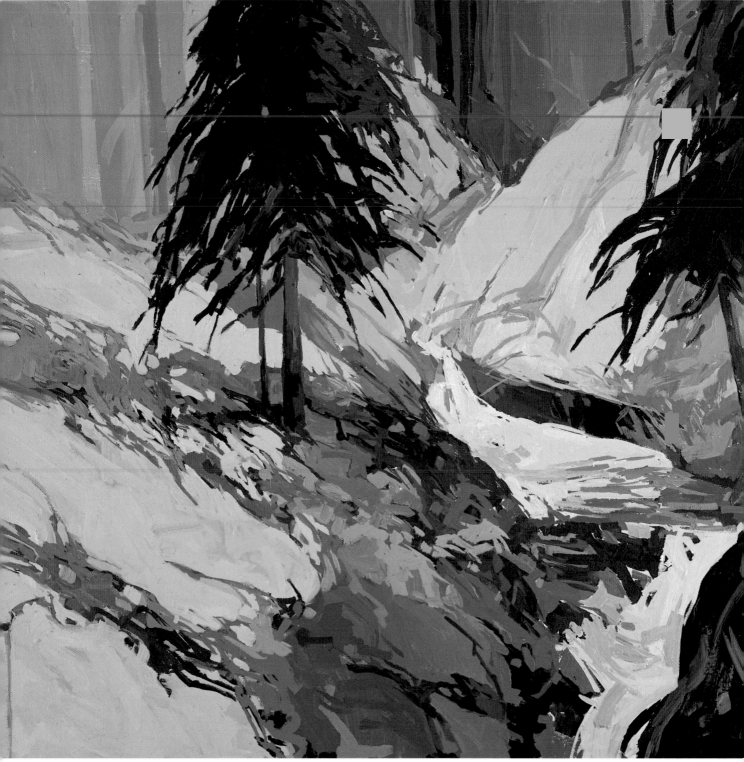

WOODLAND
WATER VI

Acrylic on canvas
40" × 42"
(107 × 107 cm)
Courtesy of Gallery
at Nichols Hills,
Oklahoma City

This painting is taken from one Atwill previously did, a diptych measuring 84" × 144" (213 × 365 cm). What you see here is what formed the center of the larger painting. The attraction for Atwill was the strong red outcroppings in the center of the composition. To dramatize them, he accentuated some of the actual colors and simplified the background.

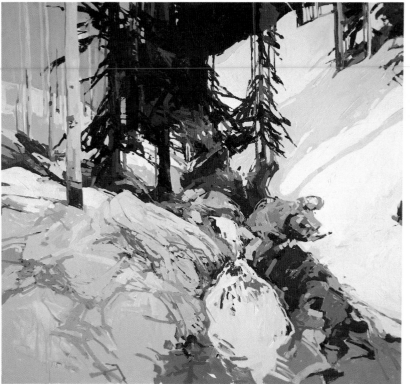

Painted in the spring when the snow on southern slopes is beginning to melt filling the streams with rushing water, this work is one of a series done in Big Tesuque Canyon in the mountains above Sante Fe. It is one of Atwill's favorites—everything in it worked right from the start. Often, he finds, the paintings that take the least amount of time to finish are the best. This one took about four hours one morning and two the next.

SNOW/BIG
TESUQUE
CANYON I

Acrylic on linen
58" × 54"
(137 × 137 cm)
Courtesy of DuBose
Gallery, Houston

On the left, Atwill washed in a warm orange tone over the white of the snow. Calligraphic brushstrokes rendered with stronger shades of orange, tan, and even purple articulate the entire area. He often mixes several values of one hue and works all over the canvas with them before he moves on to the next color.

The clean white snow emphasizes and strengthens the other colors in the painting. These white sections began with a strong underpainting of violet, which can be seen in the middle ground at right.

Atwill began the rushing water with a deep cerulean blue, then laid in white on top of it. In spots, the dark underpainting breaks through strongly; elsewhere it slightly influences the white overlay, giving it depth and resonance.

Suggested Project

Atwill feels strongly that contemporary artists should break away from what he calls the "tired old sizes" of standard stretched canvases. Gallery-goers have seen so many works painted on surfaces 16" × 20", 20" × 24", 24" × 30", and 30" × 40" that they've become accustomed to them. It's a battle for an artist to fill these canvases with anything new or diverting.

Instead of choosing a traditional size for your support, try one that is unfamiliar. Atwill recommends a canvas 21" × 27", 12" × 19", or 57" × 62". Simply by altering the size of your canvas, you will have introduced a fresh note into your paintings. You may find, as Atwill has, that proportions can work for you, not against you.

Capturing the Unexpected

ALLEN BLAGDEN: AN UNUSUAL VANTAGE POINT

Working with traditional watercolor techniques, Allen Blagden creates remarkably fresh and exciting landscape paintings. In some works, he captures unexpected glimpses of familiar subjects. In others, he isolates the focal point of a painting against a stark, uncompromising background that gives his subject unusual power and mystery. There's always enough visual information in a painting by Blagden to draw the viewer back again and again, each time to discover touches that go unnoticed at first. In one, Noon Glare, *the richly patterned foreground and carefully rendered shed are set against a harsh, shimmering, hazy backdrop. The light pushes the building and rocky ground into sharp focus; only after continued viewing does a mysterious reddish-orange form in the lower right corner spring into view.*

Blagden's paintings have long been set in the rural world, but lately he has started to transform cityscapes into landscapes. By emphasizing universal forces such as falling snow, he has managed to point out special moments when nature makes a crowded city seem as hushed as an unpeopled country field.

WORKING METHODS

Blagden's palette leans heavily toward the earth tones. Over and over again he finds himself using Hooker's green light and dark, olive green, burnt sienna, sepia, warm sepia, yellow ocher, Indian yellow, Naples yellow, cerulean blue, Prussian blue, scarlet lake, cadmium red, Davy's gray and Payne's gray. For large expanses of water or sky, Blagden chooses a flat 1" brush. For detailed work, he uses nos. 1 to 5 watercolor brushes.

On location, Blagden makes numerous sketches of a subject and detailed color notes to guide him when he starts to paint. One watercolor may take him two weeks to complete; the development of a subject is very gradual. Whenever it's possible, he returns to the site for additional information while he is working on a painting.

Blagden's preliminary drawings are strongly detailed. He explores a subject in full before he ever starts to paint. The architectonic framework he constructs in his drawings then becomes the basis for his watercolors.

Blagden almost always works light to dark. Using a large, flat brush, he lays in the sky or water. Next, he puts down the middle tones. Finally, he establishes the darkest values in the painting, the bold notes that bring everything into focus.

Blagden's carefully structured work never relies on special effects, though they do occasionally come into play. There's very little masking involved in his painting process and he rarely uses white paint, preferring the crisp white of the watercolor paper. Occasionally he lifts some of the dry paint off of a surface with an eraser or restores the white of the paper by scraping at it with a razor blade. When he splatters paint, he does so just to add touches of color to areas that have already been carefully rendered. The final result that Blagden achieves is a masterful body of work built from a thorough knowledge of watercolor technique and a natural sympathy for his subject matter.

WINTER LIGHTHOUSE

22" × 30"
(56 × 76 cm)
Watercolor on hot press 140-pound paper
Courtesy of Kennedy Galleries, New York City

In January, driving in Maine, Blagden was struck by the snow-covered meadows that lead up to the Portland lighthouse. Since it was far too cold to work outdoors, Blagden sketched the scene from inside his car, noting the colors he would use when he began the painting back at his studio. He wanted to evoke the lonely mood of the day—the cold, dark, monochromatic mystery of the scene.

Blagden typically works on paper 22" × 30". He has found that it's the biggest size he can handle while controlling an image mentally. Before he started to paint, he did a detailed drawing of the landscape on the watercolor paper. He began sketching the lighthouse, placing it high on the horizon. Next he laid in the sky with Davy's gray, then he turned

to the building. The white of the snow is the watercolor paper; Blagden finds that the paper is always more brilliant than white paint. Finally, he added the sprigs of grass and the touches of golden brown wash that speckle the foreground.

The simplest area of the painting, the sky, turned out to be the most difficult. Blagden had to execute the consistent gray tone that floods the sky three times before he was satisfied with it.

When Blagden knew that the painting was almost finished, he tightened up a few details such as the grasses in the foreground and the panes of glass in the lighthouse. Instinct usually tells him when a painting is finished, especially when he has a clear idea of what he wants to accomplish in the first place.

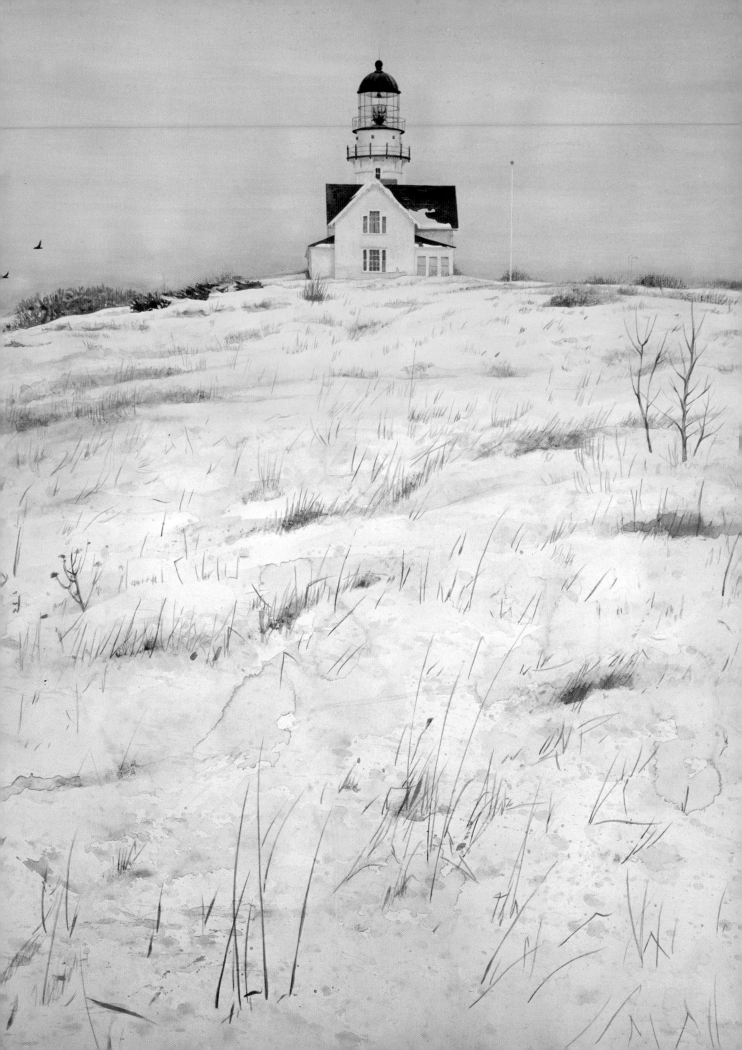

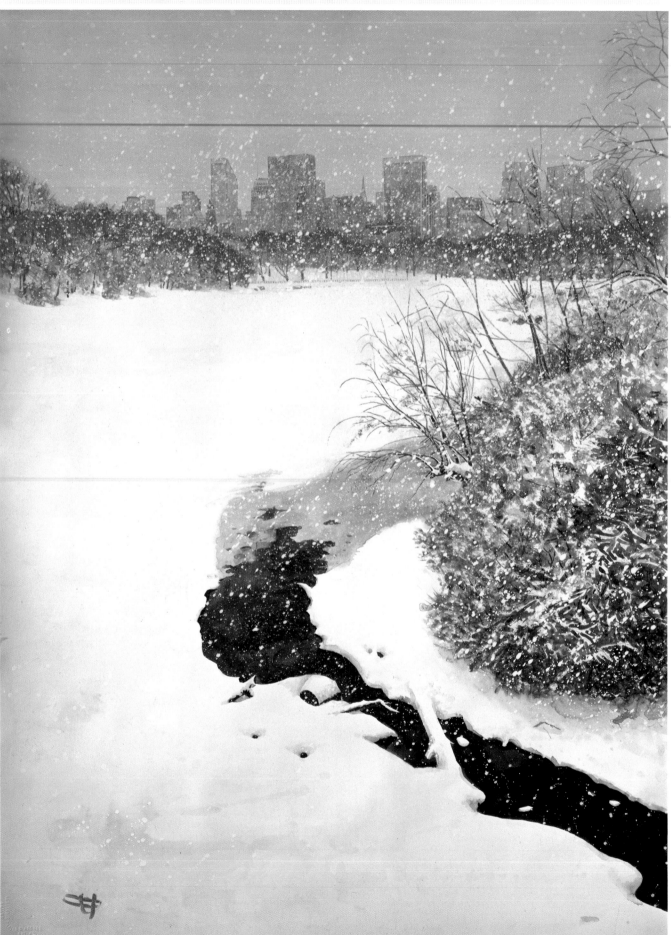

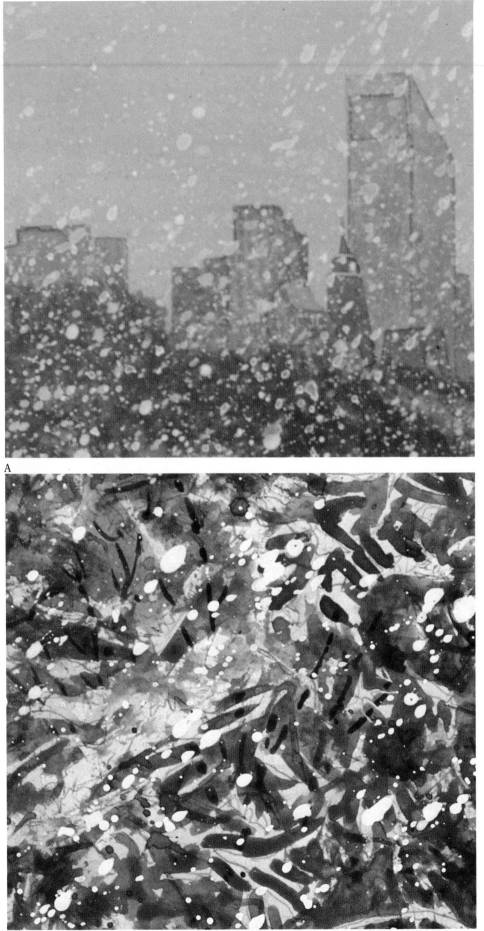

A

B

CENTRAL PARK

22″ × 30″
(56 × 76 cm)
Watercolor on hot
press 140-pound
paper
Courtesy of Kennedy
Galleries, New York
City

Ever since Blagden moved to New York City, he has been waiting for the city to inspire him to do a landscape painting. This view of Central Park proved to be the scene that let him transport his feel for rural subject matter to the urban scene.

The falling snow transformed the park, giving it a hushed, almost Oriental quality. Even though the backdrop here is formed by masses of skyscrapers, the buildings are obviously secondary to the cold and the snow. In planning the composition, Blagden wanted to contrast the horizontal line of the cityscape with the curves of the lake.

DETAILS. A. Blagden created the snowy effect by flicking white opaque paint onto the paper. The white paint not only obscures the line of monochromatic buildings that he had previously painted, it also changes the entire mood of the painting. A city isn't often quiet, but here it is. There is a hushed, subdued, still quality to the painting that summons up those rare moments in the snow or rain when all the the noises of the city are muffled.

B. Spatters of white paint obscure the details of the bushes. Using opaque white was an unusual step for Blagden; he almost always prefers to let the white of the paper form the lightest portions of the painting. By directing the spatters toward the left and by keeping them fairly large, he created the realistic feel of thick, wet, falling snow.

Capturing the Unexpected

NOON GLARE

22" × 30"
(56 × 76 cm)
Watercolor on hot
press 140-pound
paper
Courtesy of Kennedy
Galleries, New York
City

When Blagden saw this lobster shack on an island off the coast of Maine in the warmth of an August summer, he was struck by the quality of the light and how it set off the building. He wanted to convey the shimmering, hazy light on the water and how it made the sea seem to sparkle. In planning the composition, he deliberately made the shack two-dimensional, seen directly from the front. For Blagden, it was almost like a stage set. He wanted to have the sky merge with the water, defined only by the bit of land that juts out along the horizon line. More important than the land mass or the shack was the quality of the atmosphere; the glaring midday light is the actual subject of the painting. Blagden did the entire work on the spot.

After he sketched the scene, he began painting the sky and water. Next he did the shack, knowing it would be the central presence in painting; then he worked out the definiton of the rocks. The building was rendered with Davy's gray and Payne's gray, with some burnt umber added later. For the sky and the water, Blagden used Davy's gray, then he scratched out the glare of the sun on the water with a razor blade. The grass is primarily olive green and warm sepia and the rocks are Payne's gray. To create highlights, Blagden again scraped the paper with a razor blade. As always, he worked light to dark. Since the scene was set right against the glaring noon sun, Blagden used a limited number of colors to keep the stark, bare feel of the place intact.

Blagden did some experimenting in this painting, mostly in scratching and scraping out details in the foreground, then flicking touches of cerulean blue onto the surface to suggest wildflowers. To spatter the paint, he used a toothbrush and before beginning to flick the paint, he carefully covered the sky. In the end, the texture of the foreground contrasts sharply with the gentle, lyrical mood of the sky and water.

Months after Blagden completed Noon Glare, he suddenly became convinced that it needed an accent of color and added the spot of reddish-orange to the rocks at the lower right side. He meant for it to be an undefined object, an accent that added to the composition's diagonal strength.

BLUE CANOE

22″ × 30″
(56 × 76 cm)
Watercolor on hot-
press 140-pound
paper
Courtesy of Kennedy
Galleries, New York
City

Early in the morning, when the water was still and the mist rising, Blagden did this painting. To convey the hushed feel of early morning, he planned the composition very simply, emphasizing placid horizontal lines. He worked in the pale sky, water, and background before he added the dark tones of the trees. By consciously limiting his palette, Blagden also added to the still atmosphere; the only spot of strong color in the work is the figure clad in red paddling the canoe.

To focus attention on the figure and the canoe, Blagden made sure that the diagonal lines formed by the mass of the pine trees on either side of the painting were strong and clear. Before he settled on the final composition, he moved a paper cutout of a canoe around the painting once or twice. After the paint

was dry, he used an eraser to scrub some of the color from the sky to create the feeling of mist. With a razor blade, he pulled out the strong white line created by the wake of the canoe.

Right from the start, Blagden knew where this painting was headed. About the only experimentation that took place came with laying an extraordinary number of light washes—sometimes up to nine or ten, using various sized brushes—over each other, especially as he painted the reflections in the water.

Blagden is satisfied with this painting; it successfully transports him to another time and place. Over the years, though, he has learned that it is never right to rest when one painting turns out as one hopes. Moving on to the next challenge is the important thing.

Capturing the Unexpected

WILLIAM DUNLAP: A MIXED-MEDIA APPROACH

The panoramas captured in William Dunlap's paintings could only have been painted in the second half of the twentieth century. Not unlike earlier American painters, Dunlap is celebrating the unique sense of time and place present in the American landscape and in much of American painting. Instead of viewing it from a mountain top or a field, however, he's looking at it through a car window as he barrels down the interstate.

Dunlap likes to call the concept behind his painting "hypothetical realism." None of the scenes that he paints actually exist, although they well might. What Dunlap creates are visions of how the landscape could look and how, in fact, it does look to so many members people of his generation.

Most of the images that fill Dunlap's paintings are derived from actual places. He freely mixes the different elements up, using them, he says, like pieces on a chessboard. The same group of buildings may turn up in any number of paintings. He feels he owns these motifs; they are his because he has used them for years.

The magic that runs through everything Dunlap paints may, in part, stem from the balance he achieves between an intimate and grand view of the land. This broad expansive landscape seems to spread out endlessly along the horizon, but there are always seductive areas of detail for the eye to wander into and discover clues as to how the painting was made.

WORKING METHODS

Dunlap leans toward earth tones when he paints, though hot reds, warm yellows, and rich greens are appearing more frequently in his work.

He works in opposition to what is normally done, by using acrylics on canvas or oil on paper—both of which dry almost immediately. Though unconventional, these two diverse approaches seem to fit his spontaneous approach and preference for materials that dry quickly so he can get on with the process. Dunlap applies the paint in a true mixed media fashion. Sometimes he brushes, rolls, pours, spatters, or throws paint onto the surface. Nor does he limit himself to traditional paint. A typical work could include graphite, ink, powdered pigment, and colored pencil. Fingers, brushes, tissues, towels, sticks, rags—anything at all that is in the studio comes into play to apply the paint and the various mixed media. A completed work of this sort is either sprayed with a high-quality, non-yellowing fixative or acrylic medium thinned with water to form a durable surface. Dunlap usually works on two or three paintings at the same time to keep him from overworking any one and to prevent him from letting too much energy loose on a single work. When he's satisfied with one—when it seems to have reached a definitive state of incompleteness—he abandons it.

Seen up close Dunlap's paintings have a loose, open quality. Despite their cool, clean look, they are filled with a lot of loose touches—drips and splatters and expressive squiggly lines. Long ago he learned that paint has a tendency to drip, splatter, and run, and he likes to let it do just that.

Working in an expressive way while trying to keep a painting tight is a high-risk activity. Because experimentation plays so big a role in his work, Dunlap loses a lot of paintings. But that's part of the fun, too. Not knowing exactly where a painting may go makes the whole process exciting and challenging and keeps Dunlap alert and absorbed.

LANDSCAPE AND VARIABLE—DOG TROT

46" × 92" (117 × 234 cm) Acrylic and mixed media on canvas Collection of the artist

Dunlap began work on this canvas in the late 1970's by spraying in with acrylic the sky and the green ground that runs along the bottom. He then typically put it aside, figuring that someday he would get back to it. About five years later he started in on it again. What he wanted to do was change the way he had been using space. The freely painted green paint bleeds into the sky and also establishes the horizon.

In the finished painting, the dogs in the foreground seem to be standing on real ground, and the farm lies behind the buildings in the background. All have a clear-cut position in the painting despite the fact that they actually have been laid in on an abstract, loosely painted ground.

Dunlap's paintings are packed with geometrical elements, which is in part his response to the imposition of the grid on the American landscape. Line interests him much more than color and he considers himself primarily a draftsman. This preoccupaton with line is clearly seen not only in the clean figures and buildings he paints but also in abstract elements like the blue lines that arc across the sky and the subtle square in the upper-right corner of the sky.

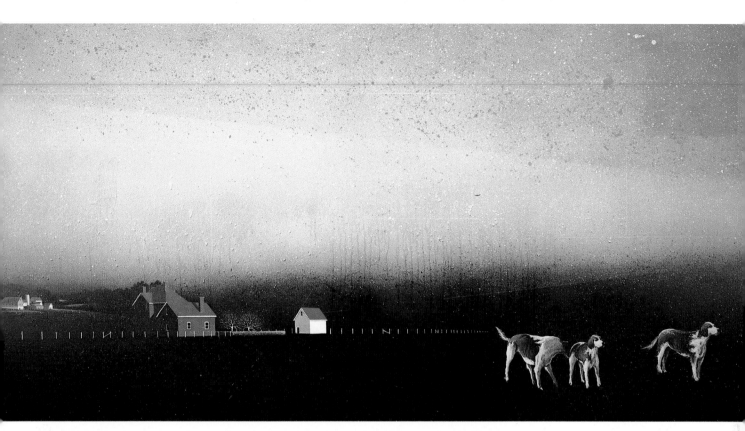

DETAIL. This close-up graphically illustrates Dunlap's diverse use of paint in a single area. The fluid drips and runs in the sky give way to the subtle suggestion of a hill or a tree line, then turn dramactically into the well-rendered brick walls and tile roofs of the building.

Capturing the Unexpected

SPRING STORM— VALLEY SERIES

Diptych: Each panel
48″ × 96″
(122 × 244 cm)
Acrylic on canvas
Collection of Oliver
T. Carr

This site-specific work was commissioned for a modernist building in Washington, D.C. For Dunlap, the commission presented an opportunity to work on a heroic scale in a contemporary structure and to evoke a sense of natural landscape in an urban area. The format he chose—a diptych–posed special problems.

When a painting comes in two parts, there must be enough visual energy present in the center to bridge the gap between the two. At the same time, each panel has to work separately. For Dunlap, it's like a high-wire act. He has to bring the two panels up at the same time, maintaining a delicate balance and visual diplomacy because even-

tually they must live together.

What makes these panels work together? In part, it's the dark mountains pointing in at each other, directing the eye toward the center. The information in the foreground matters, too. The bands of green and yellow tie the two surfaces together.

While the painting was being planned, Dunlap made a road trip down to the mountains of North Carolina. Driving along the Blue Ridge Parkway, way above the cloud line, he witnessed an incredible phenomenon— a sea of clouds settling in to the nooks and crannies of the mountains. When he got back to the studio, the foggy clouds settled into his painting.

Suggested Project

Look back over your early paintings and find the things that work for you—compositional devices that make sense, buildings that you like, or even brushstrokes. Take what it is that you do best, then move the parts around experimenting with them. Treat them like what they are, actors in your visual repertoire. This cool, dispassionate approach will result in new and interesting arrangements.

Next, make an elaborate work based on what you've selected. Once you've found something that speaks to you, that is obviously your own vocabulary, start to invent with these elements. What you will be creating isn't a place that actually exists. Instead, it will be a hypothetically real situation, one that exists solely in your mind and in your art.

Summoning Up the Spiritual Through Landscape Painting

SIDEO FROMBOLUTI:
CREATING ATMOSPHERIC EFFECTS WITH OIL

The mystery and excitement that Sideo Fromboluti finds in nature transports him to another world, a world that seems to him almost religious in feeling. He thrills to what he feels are the unknown forces that envelope him when he watches the secrets of nature unfold.

Understanding his natural environment is vital for Fromboluti, and is the basis for his particular vision. For twenty years he has summered in Cape Cod and has a strong feeling for the ocean there, and for its land and ponds. Many of his paintings are set at the Cape.

Once, traveling through Italy, he painted a landscape. Despite the fact that his subject was a brilliant, colorful spot, his finished painting had the look of a gray setting in New England. The lesson he learned in Italy was to only work with the landscape he knows best. What Fromboluti strives to achieve is not just a recognizable image of a particular area, but a rendering of the complex order of nature.

Fromboluti loves to work with thick, dense paint, and to do so successfully he has discovered that he must restrict his palette to colors that dry evenly. He usually simplifies his palette as much as possible, preferring to work with five or six primaries and white. For example, he may use light, medium, and dark cadmium yellows and cadmium reds and a variety of blues. All of these colors dry at the same rate, preventing any cracking or curling of the paint. Experience has taught him to avoid earth tones and black because they dry more rapidly than the other colors that he uses.

Oil paint is the medium that Fromboluti loves. He compares acrylics and oils to formica and marble. With acrylics the light bounces off the surface; with oil, each layer produces a deeper, more resonant surface. Because of the quantity of pigment that Fromboluti uses, he relies on plain turpentine; there is already enough linseed oil in his paint. He never uses varnish since it can easily build up and curl the paint.

The size of each canvas is influenced by Fromboluti's ambition at the moment he starts a work.

Fromboluti begins his paintings out-of-doors, but soon goes into his studio to avoid the distractions of the changing light outdoors. He begins a work by roughly laying in the subject. He is never really sure where the composition will take him and relies heavily on his own sense of order. Buried knowledge also guides the forms in his paintings, their color, and the overall sense of space in each work.

Because his approach is so intuitive, Fromboluti's paintings lose their way many times. Occasionally he becomes so angry that he wants to abandon a work. He has learned, though, that giving up on a painting creates a profound depression in him, one that carries over to his next painting, usually harming it.

Fromboluti considers a work finished when he feels that it is convincing and that there is no way left to improve it. Finishing a painting initially creates a bouyant, exciting feeling. Over the next few weeks, he begins to doubt that he has accomplished what he wanted to do. Slowly Fromboluti comes to accept the painting again, and eventually even to like it once more. He is never completely happy with a painting and he hopes that he never will be.

MOON ON HIGGINS POND

60" × 50"
(152 × 127 cm)
Oil on canvas
Collection of the artist

In Moon on Higgins Pond, *Fromboluti explores the kind of atmospheric effects that move him the most strongly. Here moonlight floods across the surface of the painting, uniting the sky and the water and washing over the trees and their reflections in the pond. The canvas is richly textured with thickly applied oil, creating an almost three-dimensional feel. The blues, purples, pinks, golds, and greens all overlap, making the painting seem almost like a mosaic.*

Summoning Up the Spiritual Through Landscape Painting

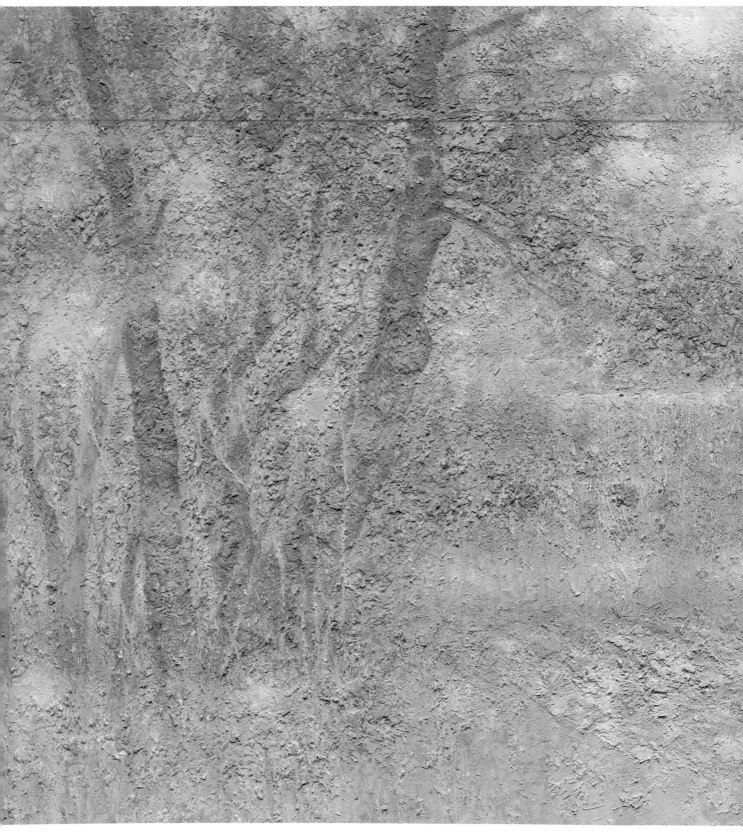

FOG ON HIGGINS POND

*60" × 70"
(152 × 178 cm)
(each panel)
Oil on canvas
Courtesy of Gross
McCleaf Gallery*

LEFT PANEL. In Fog on Higgins Pond, *the mist moves in and out of the trees, sometimes in front of them, sometimes behind them, inviting the imagination to play with positive and negative space. What Fromboluti has* done here is to translate the concrete information in front of him into abstractions—mist, fog, inside, outside—then to make the abstractions again concrete. Naturally, as he works he has *to abandon some of the sensory information available to him as he concentrates on what seems most important, here the mysterious mood created by the fog.*

RIGHT PANEL. The left and right panels hang together tightly even though the one on the right is lighter and less complex than the one on the left. The long line of trees that runs along the horizon in both panels and the spit of land that juts out into the right panel unify the overall scene.

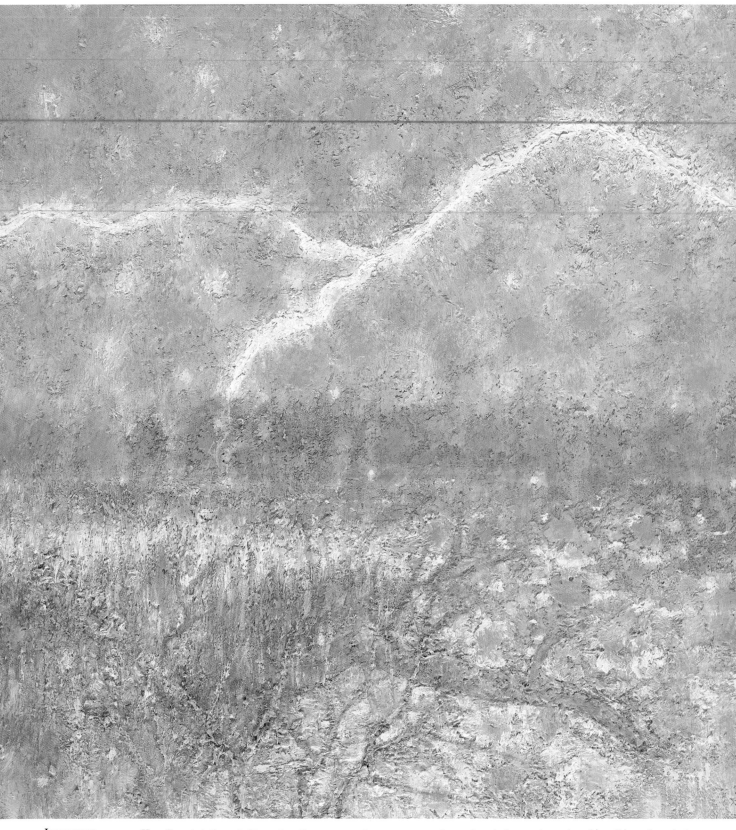

**LIGHTNING
OVER HIGGINS
POND**

*60" × 70"
(152 × 178 cm)
(each canvas)
Oil on canvas
Courtesy of Gross
McCleaf Gallery*

Here Fromboluti wanted to capture the feeling of power and awe that one experiences at the very moment that lightning strikes. Instead of viewing lightning as a decorative or romantic element in a narrative setting, he wanted to summon up the stark, primitive feeling that lightning evokes in everyone.

Fromboluti's goal is to paint what he experiences with all five senses, not just what he captures with sight alone. It's not easy to achieve this goal, and at times the frustration of trying seems overwhelming to him. He has found, however, that in the process of exploring nature deeply, his spiritual sense becomes immeasurably enriched.

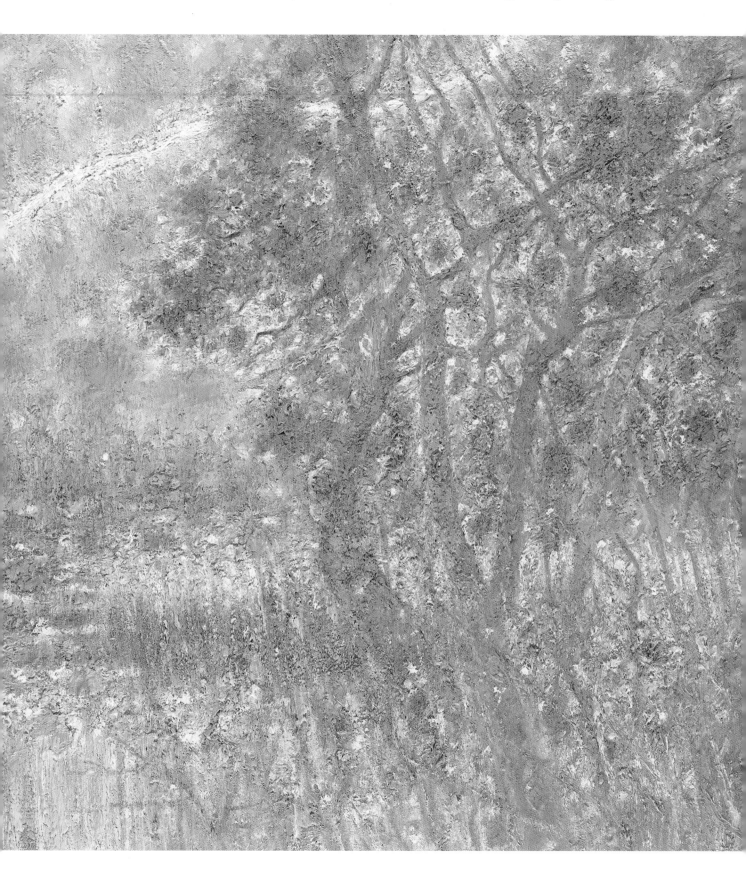

Summoning Up the Spiritual Through Landscape Painting

NORA SPEYER:
BUILDING A TACTILE, SENSUOUS SURFACE

Nora Speyer's lush canvases are soft and ephemeral yet strongly moving. She applies her paint thickly, building it up layer after layer. The results are rich, sensuous surfaces that have a dramatically textured feel.

Speyer is drawn to oil paints because of their incredible flexibility. Using them, she can put down heavy globs of paint or use oil washes like watercolor. She also likes the fact that it can be an additive or reductive medium. She can build it up or wash it out, dig into it or dribble it, or create thick, scaly textures. Like nature itself, oil is full of the unexpected. Speyer tries to make the most out of its surprises.

Speyer begins each landscape by going outdoors with her easel, paints, and canvas. She sets up before a chosen site and works there until she has gotten down on canvas the basic elements of her painting. This can take a week or two, then she retreats into her studio.

As Speyer works in her studio, she continually goes outside to refresh her memory and to study particular details—individual trees or flowers, or how a branch grows out from a tree trunk. These studies are done in charcoal and used as notes for the painting in progress. If a work contains flowers, she works with cut flowers in front of her, which enables her to study their specific structure.

Speyer sorts out her thoughts in her studio. She finds the ever-changing outdoor light distracting, making it difficult for her to focus her attention. Alone in the studio she can work more abstractly and have a greater command over her canvas.

When Speyer begins a painting, she works straight on, putting the pigment onto the canvas and drawing in forms as quickly and boldly as possible. She lays in a series of colors that conjure up her feelings about the landscape. Her immediate problem is to find an equivalent in paint for the light, colors, and masses she sees before her. She develops her works by adding layer upon layer of color on top of one another. To get the rich, thick feel she likes, she applies the paint with a large brush or a palette knife. Once the paint is on the canvas, she moves it around quickly, again with a large brush or knife, working wet into wet. This technique not only produces the tactile quality that she likes, it also creates a sense of subtle, interlocking planes that move in and out dramatically. Since the middle tones are the basis of her work, she establishes these first before adding the drama of the darks and lights.

The colors that Speyer uses change as she works. She may start out with the concept of doing a green painting, then, as the painting develops, change her mind and let a completely different hue become dominant. This kind of change is done instinctively, and not even Speyer can explain what motivates her as she paints.

FLOWERS IN THE FOREST

50" × 50"
(127 × 127 cm)
Oil on canvas
Courtesy of Gross
McCleaf Gallery

In Flowers in the Forest, *the strong vertical tree trunks act almost like a trellis supporting the loosely structured flowers that fill the painting. Even the forms that seem most tangible—the tree trunks—are actually a rich mix of broken strokes of paint. The way Speyer applies the paint, pushing it back and forth over the canvas, results in the highly textured effect that is obvious in this work. Because she applies the paint wet into wet, nothing is harsh or sharply defined. Each passage flows smoothly into the next.*

The strong hues Speyer uses to depict the flowers in the foreground make them stand out against the rest of the painting. In these flowers, it is easy to get a sense of how she works. Even the darkest and most vibrant bits of paint are softly defined and blend into the areas surrounding them. All of the strokes are bold and fresh and have nothing fussy or studied about them.

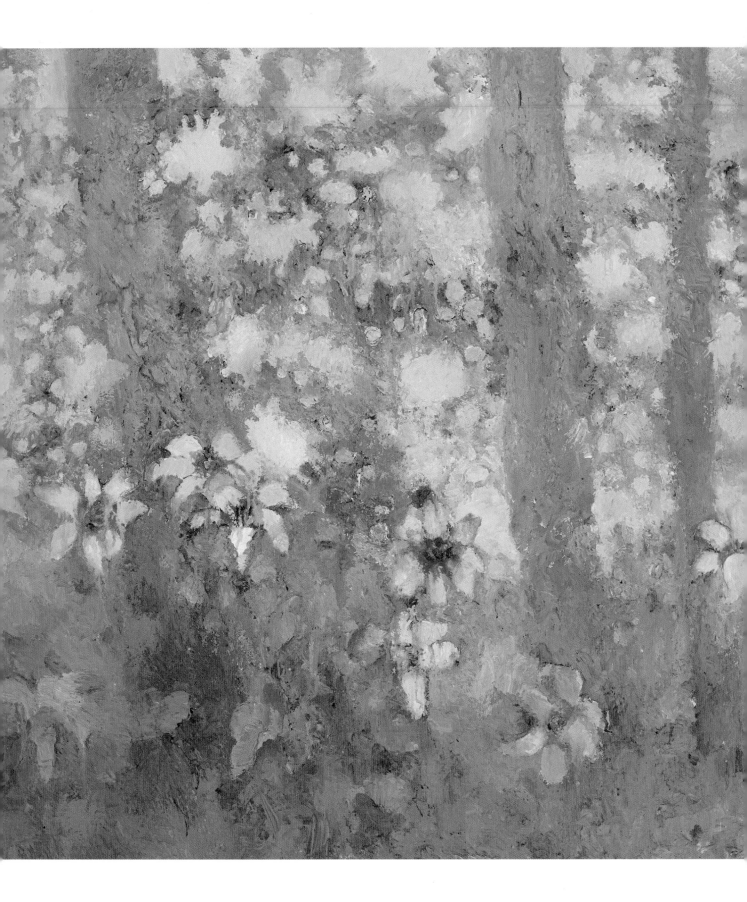

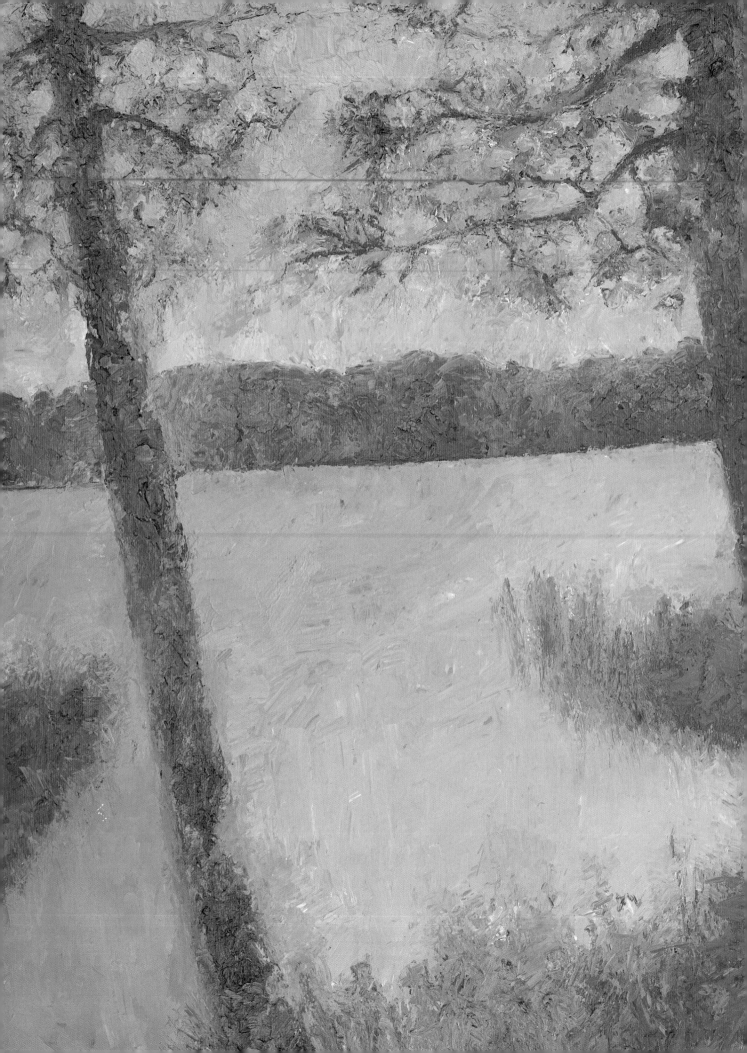

TWILIGHT

50″ × 50″
(127 × 127 cm)
Oil on canvas
Courtesy of Gross
McCleaf Gallery

The freedom with which Speyer manipulates paint is influenced by the Abstract Expressionists. The philosophy of the movement gave her a feeling of great liberty and helped her shed her artistic inhibitions. Her actual painting technique is built from years of experimentation and play.

Speyer works thick and thin simultaneously. After she has built up thick, heavy patches of pigment, such as the tree trunks in Twilight, *she begins to add thin glazes and to move bits of the paint around with a brush. Juxtaposing the two techniques results in a rich, sensuous surface.*

Speyer considered Twilight *finished when her knowledge of the subject was exhausted.*

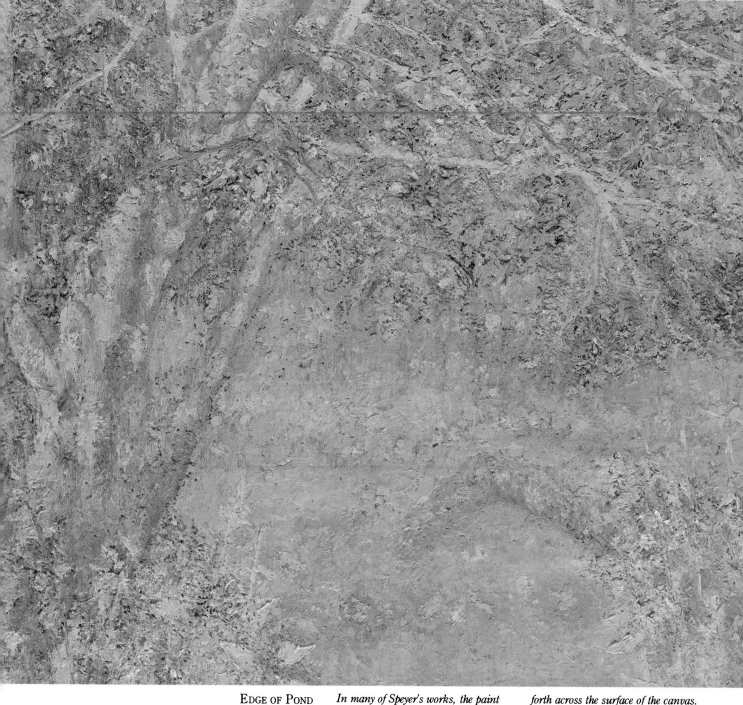

EDGE OF POND

50" × 60"
(127 × 152 cm)
Oil on canvas
Courtesy of Gross
McCleaf Gallery

In many of Speyer's works, the paint has an actual three-dimensional quality, which is especially evident in Edge of Pond. *The ferns growing around the tree trunk and the foliage of the tree actually stand out against the flatter passages. Speyer frequently manipulates the paint with a palette knife, pushing it and scraping it back and forth across the surface of the canvas.*

Here very subtle shifts in color and value separate the leaves from the branches and the branches from the growth in the background. The purples and greens that dominate the composition weave together so intricately that every inch of the painting is tied to those that surround it.

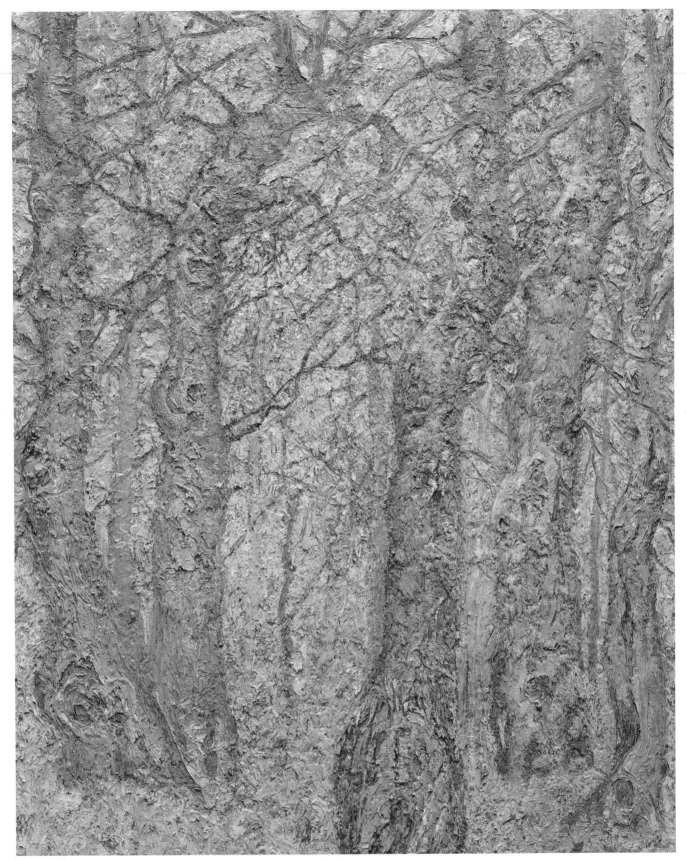

TUPELA TREES

60″ × 50″
(152 × 127 cm)
Oil on canvas
Courtesy of Gross
McCleaf Gallery

During the summer, Speyer lives on Cape Cod. Her house there is on a pond surrounded by groves of tupela trees that are gnarled and twisted in a dramatic, almost ghostly way. Speyer wanted to emphasize the primitive nature of each tree as it struggled by itself and the rotting roots that climbed onto each other in order to survive. Her feelings about the trees quickly established the painting's structure. Since she wanted to present a closed, primeval feeling, she chose a tall thin canvas and arranged the tree trunks so they looked almost like bars.

137

MORRIS BERD:
SIMPLIFYING A COMPLEX SCENE

For more than fifteen years, Morris Berd has been drawn to the farmhouses in Lancaster and Chester counties in Pennsylvania. In them, Berd sees a unique quality of design and a simple dignity that act as an antidote to the hectic and nervous lifestyle that he finds in America's urban and suburban areas. The well-kept, well-ordered, and efficient Mennonite and Amish farms have given Berd a visual answer to his protest against today's urban scene. Through his paintings, Berd tries to prophesy a better world.

WORKING METHODS

Although today Berd works with both acrylics and oils, when he began painting he used only oils. The switch came when he was asked to test acrylics; he rapidly discovered that they gave him a certain freedom that he had never achieved with oils. For instance, when Berd is doing a large landscape painting, the quick drying time of acrylics proves to be a great advantage. For large areas like skies, Berd chooses big flat brushes. He renders details with smaller ones.

The sizes of Berd's canvases vary enormously. Some are as large as 6′ × 6′ while others, mostly studies, are just 8″ × 8″. Before he starts to paint, he executes a pencil sketch on the canvas. Berd has tried to do the sketch with charcoal but he finds that for him, it tends to dirty up the paint. In his acrylics, he always begins with the sky, then works downward. In his oils he starts at the easiest point technically.

Berd's method of landscape painting actually begins when he confronts a chosen site, intensely studying the subject. Armed with sketches in charcoal, pencil, and watercolor, plus photographic documentation of the area, Berd returns to the studio where he makes the final painting. When he is investigating a new site, he often photographs it from as many points of view as possible, trying to record all the visual information he will need when he starts to paint.

The subject from which he draws his ideas goes through many changes in color and composition as the needs of the picture take over. At times the painting accurately reflects the appearance of a specific site. At other times it may be a composite of many places.

Most often, Berd finds himself deleting details as his compositions develop. Progressively they tend to become starker and cleaner, with all unnecessary elements removed. In each painting he attempts—and, in his opinion, not always successfully—to capture a perfect or magic moment when everything seems to fall into a preordered place.

LANDSCAPE WITH COW

42″ × 48″
(107 × 122 cm)
Acrylic on canvas
Collection of the artist

In simple landscapes like this one, Berd strips away all unnecessary visual information to reveal the essence of a scene. Most of these paintings are based on the Amish and Mennonite farms found near his home in Pennsylvania. Berd delights in the beautiful proportions of the buildings and in the way they are kept in prime condition. The land itself is well used yet never depleted.

In Berd's farmscapes, the viewer becomes aware of a tough sparseness. There is nothing fancy or superfluous in them, just a simple pervading sense of calm order and purpose. Berd manages to convey how the Amish and Mennonite farmers view their world—their love of the land, pride in their work, and respect for their few basic possessions.

As Berd was finishing up Landscape with Cow, *an airplane passed overhead. Its vaporous trail inspired Berd to include its curved form in the sky area. The dramatic, angular curve to the left—away from the barns—counterbalances the shape of the shadow in the grass area. These two curves help define the spatial composition of the painting.*

Berd reduces all the elements in a scene to their bare bones. Here the buildings are built up of stark, simplified planes of color; even the shadows have a geometric elegance to them. Berd lets very little evidence of the painting process remain in the finished work; no obvious brushstrokes call attention to themselves or to the fact that one is looking at a painting. What results is a sense of the inevitability of the moment he has captured.

GRAY DAY

30" × 42"
(76 × 107 cm)
Oil on canvas
Courtesy of Marian
Locks Gallery,
Philadelphia

Paintings such as Gray Day *are the culmination of a long transition that took place in Berd's work, beginning with a series of paintings and drawings of plants and trees viewed from the interior or close up. In these early studies, the space was congested and the forms full of nervous energy. Each picture became a compulsive maze of tangled shapes that seemed hyperactive and discomforting. In retrospect, Berd sees in these works his frustrations with hurried, urban life.*

Slowly the paintings changed. The

subjects became more distant, the gestures less violent, and the spaces more open. He feels that unconsciously his attitudes about his work were changing. Instead of allowing his paintings to reflect the nervous freneticism of modern life, he had begun to depict visions of how the world might be. The choice of Amish and Mennonite farms seemed to Berd to closely symbolize a kind of order and a way of life that challenges what he feels is the shabbiness of today's world.

EARLY SPRING FARMSCAPE

**30″ × 40″
(76 × 102 cm)
Acrylic on canvas
Private collection**

The magic moments Berd searches for are often created by a special time of day or time of year, a time when the light falls in a particularly pleasing way and everything seems to be in perfect harmony and order. In Early Spring Farmscape, *Berd found just such a moment. Unlike many of his compositions, in which he combines elements from different sources, this one remains remarkably true to nature; in it, Berd made very few changes in composition, light, or color.*

Berd strongly feels that one learns to paint by painting and that there is no "right" method or technique of painting any particular subject. For Berd, the

problem the landscape painter faces is never that of duplicating on canvas or paper what they see. Rather, it is to put down what they feel and think about the subject in an organized manner.

Berd's own transition from frenzied canvases filled with active brushstrokes and areas of thick impasto to the tranquil, ordered, and smooth works shown here reveal how difficult it can be to find the style that's right for you. What they also reveal is that when subject matter and style interact smoothly, they create far more than just the sum of two parts—paintings have a vigor and strength that can strongly reveal the philosophical bent of the artist.

Biographical Notes

Martha Armstrong was born in Cincinnati, Ohio, and educated at Smith College and the Rhode Island School of Design. She has had numerous group and one-artist exhibitions; her latest solo show was in 1983 at the Gross McCleaf Gallery in Philadelphia. In 1982, Armstrong was Artist-in-Residence at the Kansas City Art Institute; in 1983 she was Guest Artist at the Maryland Art Institute. Armstrong's work is represented in private and public collections, including the Allentown Art Museum in Allentown, Pennsylvania and the Atkins Museum in Kansas City.

Douglas Atwill was born in California and received his undergraduate and graduate degrees from the University of Texas. He has had over twenty one-man exhibitions, primarily in Houston, Dallas, Denver, and Santa Fe; and is represented in sixty corporate collections throughout the Southwest. Atwill's work is also part of several museum collections, including the New Mexico Museum of Fine Arts in Santa Fe and the Houston Fine Arts Museum. He is currently affiliated with the Munson Gallery in Santa Fe, New Mexico.

Morris Berd was born and raised in Philadelphia and has been an instructor of adult painting at the Philadelphia Museum of Art since 1949. He has traveled and painted in Italy, Mexico, France, Austria, and Spain. The recipient of several competitions, Berd was awarded the Philadelphia Print Club's Katzman Prize and the Philadelphia College of Art's Alumni Award. His work is featured in many private and corporate collections throughout the Northeast.

Allen Blagden began his artistic training with his father, Thomas Blagden, an artist and art instructor at the Hotchkiss School in Lakeville, Connecticut. From 1965 to 1977, Blagden had eight one-man shows at the Frank Rehn Gallery in New York City. Since then, he has been featured in numerous solo and one-man shows, including a solo 1984 exhibition at the Kennedy Galleries in New York City. Blagden is married and the father of two daughters. He lives in Salisbury, Connecticut.

Gerald Brommer is a California watercolorist and author of fourteen books concerned with secondary art education. A former high school teacher, he is past president of the National Watercolor Society, a winner of numerous major awards, and juror of many national exhibitions. Brommer's work is in over two thousand collections in forty American states and in nine countries overseas.

Daniel Chard has been painting and teaching in New Jersey for twenty years. He has had two one-man exhibitions with more than 180 paintings placed in private and corporate collections. Despite the demand for Chard's paintings, he maintains a commitment to his teaching as a professor of art at Glassboro State College in New Jersey. In 1984, Chard is featured in a solo exhibition at the O.K. Harris Gallery in New York City.

William Dunlap a native Mississippian, divides his time between the mountains of North Carolina and McLean, Virginia. He has been concerned with the landscape since the beginning of his career and his works are in numerous public and private collections in this country and abroad. Dunlap's diptych *Early-Light—Fog Bound* was included in the Smithsonian Institution's traveling exhibition, "More Than Land and Sky." His work *Spring Storm—Valley Series* was recently purchased by the Corcoran Gallery of Art in Washington, D.C.

David Fertig lives in Palmyra, New Jersey. He received a bachelor's in fine arts from the Philadelphia College of Fine Arts and a master's from the Chicago Art Institute. Fertig's paintings have appeared in several group exhibitions in the Philadelphia area. His most current solo exhibition was in 1983 at the Marian Locks Gallery in Philadelphia.

Sideo Fromboluti was born in Hershey, Pennsylvania, one month after his parents emigrated from Tuscany, Italy. He went to the Tyler College of Fine Art in Philadelphia, where he met his future wife, artist Nora Speyer. Fromboluti's work has appeared in both group and one-man exhibitions in this country and in France. His latest solo shows were held at the Gross McCleaf Gallery in Philadelphia and at the Longpoint Gallery in Provincetown, Massachusetts.

Michael Hallinan lives in Laguna Beach, California, but travels extensively in Mexico and Hawaii in search of tropical landscapes. He describes his work as being loosely impressionistic; the French Impressionists, especially Gauguin, influence him greatly.

John Koser is a native Californian. He has had ten one-man shows, the most recent in 1981 at the Museum of North Orange County. Koser has been a technical illustrator for the University of Southern California School of Dentistry since 1964. He has lectured before the San Diego Watercolor Society, the San Bernadino County Museum, and is a guest lecturer at the College of the Redwoods. Koser's works are in numerous private and corporate collections. In 1982, his painting *Our Heritage* was selected for a limited edition print to commemorate the Akiyama Printing Process.

Bruce Marsh was born and educated in California, but has lived in Florida since 1965. Since 1969, he has been a professor of art at the University of South Florida in Tampa. His paintings have been featured in numerous one-man and group exhibitions, most of them in California and the South. His work also appears in corporate collections in California and throughout Florida. Marsh is currently affiliated with the Joyce Hunsaker Gallery in Los Angeles.

Alex Martin was born in Albany, New York and is now living in New Paltz, New York. He was educated at Buffalo's Albright Art School, the University of Buffalo, and at Tulane University in New Orleans. From 1970 to 1980, his work was featured in one-man and group exhibitions at the Graham Gallery in New York. Martin has also had two retrospectives of his work at the State University of New York campuses in Oneonta (1980) and New Paltz (1977). His paintings are included in the permanent collections of the Whitney Museum in New York and the Neuberger Museum in Purchase, New York.

William McNamara is a native of northern Louisiana. He attended Centenary College of Louisiana where he studied art under Willard Cooper. He received his Master of Arts from New Mexico Highlands University. After traveling and studying in Europe for a year, he returned to Centenary to teach for five years. In 1976 he moved to the Boston Mountains of northwest Arkansas near the Buffalo National River where he lives with his wife and two sons. McNamara has exhibited and competed in numerous regional and national shows, including the Butler Institute of American Art Annual Mid-year Show, Watercolor USA, the Delta Art Exhibition, Arkansas Art on Exhibit and the Louisiana Watercolor Society. McNamara is represented by Capricorn Galleries, Bethesda, Maryland and by Moulton Galleries, Ft. Smith, Arkansas.

Roger Medearis was born in Fayette, Missouri, but for many years has lived in Marino, California. He studied art at the Kansas City Art Institute from 1938 to 1941 under the tutelage of Thomas Hart Benton and John S. deMartelly. His works are exhibited widely, including the Metropolitan Museum of Art, the National Academy of Design, the Butler Institute of American Art, and the Frye Museum in Seattle. He is featured in *Who's Who in America* and *Who's Who in American Art*. Medearis is represented by Capricorn Galleries in Bethesda, Maryland.

Don Rankin, a native Alabamian, is well known as a regional watercolor painter. A lecturer, teacher, and juror, his works have been widely circulated through various exhibitions, publications, and limited editions.

Mary Salstrom attended Pratt Institute, Brooklyn College, and Skowhegan School of Painting and Sculpture in Maine. She studied with Lennert Anderson, Joseph Groell, Mary Buckley, Al Blaustein, and the late Willard Midgette. Salstrom has taught at Brooklyn College, Pratt Institute, and St. John's University, New York. Miss Salstrom lives and works in New York City and spends summers painting in northern Illinois. She currently exhibits her work at the Prince Street Gallery in New York City.

Lee Seebach was born in Waterloo, Iowa. He is a graduate of the American Academy of Art in Chicago, where he studied with Douglas Graves, Irving Shapiro, and Bill L. Parks. Seebach is now located in Taos, New Mexico, where he is concentrating on painting the beauty of northern New Mexico.

Nora Speyer was born in Pittsburgh, Pennsylvania. She, along with her painter husband, Sideo Fromboluti, studied art at Temple University's Tyler College of Art in Philadelphia. Speyer's work has been exhibited in group and solo shows throughout the Northeast and in Paris. Her latest one-person exhibition was in 1983 at the Gross McCleaf Gallery in Philadelphia.

Mary Sweet was born and raised in Cincinnati, Ohio. She received her bachelor's and master's degrees in fine arts from Stanford University, where she studied with Daniel Mendelowitz, watercolorist and author of *A History of American Art*. Since then she has lived mostly in California and New Mexico, and has exhibited her works in group shows in Ohio, California, Illinois, Colorado, Texas, and Arizona. She is a founding member of Meridian, a contemporary artists cooperative in Albuquerque, New Mexico.

John Terelak was educated at the Vesper George College of Art in Boston. He received three years of additional training in commercial art and studied with realist painter Don Stone for two years. Terelak has won over twenty major awards, including the Ranger Fund Purchase Award, National Academy of Design, and the Mary S. Litt and M. Peasley Award at the American Watercolor Society. He is currently president of the Boston Watercolor Society and is the founder and director of the Gloucester Academy of Fine Arts.

Dana Van Horn received a master of fine arts from Yale University. He served as an assistant to the realist painter Jack Beal on four paintings on the history of labor in America, which was commissioned by the U.S. Department of Labor. His own work is exhibited in private and public collections throughout the country. Van Horn is represented by the Allan Frumkin Gallery in New York City.

George Wexler taught art at Michigan State University from 1950 to 1957 and since then has taught at the State University of New York in New Paltz. Wexler began his career studying the kind of art termed "social realism" at WPA art schools during the 1930s. From social realism, Wexler moved through several "schools" of art, including abstract expressionism, to arrive at the romantic realism that describes his work today. Wexler is married to the sculptor Thyra Davidson and has three grown sons.

Index